CW01024521

In Defence of Leisure

ABOUT THE AUTHOR

Akshi Singh is an associate editor at *Parapraxis* and deputy editor at *Critical Quarterly*, and is the editor of a special collection of *Critical Quarterly* presenting new writing on Marion Milner. She collaborates regularly with the Derek Jarman Lab, and writes for the *London Review of Books*. Singh moved to the UK from India to study for a PhD in psychoanalysis and literature with Jacqueline Rose. She is currently training to be a psychoanalyst at the Centre for Freudian Analysis and Research.

In Defence of Leisure

*Experiments in Living
with Marion Milner*

AKSHI SINGH

JONATHAN CAPE
LONDON

1 3 5 7 9 10 8 6 4 2

Jonathan Cape, an imprint of Vintage, is part of the
Penguin Random House group of companies

Vintage, Penguin Random House UK, One Embassy Gardens,
8 Viaduct Gardens, London SW11 7BW

penguin.co.uk/vintage
global.penguinrandomhouse.com

First published in Great Britain by Jonathan Cape in 2025

Copyright © Akshi Singh 2025

Akshi Singh has asserted her right to be identified as the author of this
Work in accordance with the Copyright, Designs and Patents Act 1988

Penguin Random House values and supports copyright. Copyright fuels creativity,
encourages diverse voices, promotes freedom of expression and supports a vibrant culture.
Thank you for purchasing an authorised edition of this book and for respecting intellectual
property laws by not reproducing, scanning or distributing any part of it by any means
without permission. You are supporting authors and enabling Penguin Random House to
continue to publish books for everyone. No part of this book may be used or reproduced
in any manner for the purpose of training artificial intelligence technologies or systems.
In accordance with Article 4(3) of the DSM Directive 2019/790, Penguin Random House
expressly reserves this work from the text and data mining exception.

Typeset in 13/16.2pt Garamond Premier Pro by Jouve (UK), Milton Keynes
Printed and bound in Great Britain by Clays Ltd, Elcograf S.p.A.

The authorised representative in the EEA is Penguin Random House Ireland,
Morrison Chambers, 32 Nassau Street, Dublin D02 YH68

A CIP catalogue record for this book is available from the British Library

HB ISBN 9781787335059
TPB ISBN 9781787335066

Penguin Random House is committed to a sustainable future
for our business, our readers and our planet. This book is made
from Forest Stewardship Council® certified paper.

For Jacqueline Rose and Eve Dickson,
with love and gratitude

Contents

I

Seascapes

March 2017. Tomorrow, I'll be twenty-seven. Suddenly, a total desire to be by the sea. I know I must act before sense intervenes. I buy a ticket to Margate, pack my toothbrush and a change of clothes into my small yellow rucksack. There is a book on the windowsill, next to a lamp. Rain comes through the window; the cover is stained and the pages are beginning to curl. The book goes in with my things. There is just enough time to collect my ticket from St Pancras Station. I've been living in England for four years, but I haven't once visited the sea. I must go to the sea alone. The mind will admit no other thought. I am summoned by gulls and salt.

I board a train in a rush, not entirely sure if it is the right one. The displays are scrambled. The train, the afternoon, even the man who comes to check tickets – they all seem to belong to a dream dimension. Announcements through the tannoy. Reassured that I am on the right train, I look at a map of the coastline, and decide to leave the train early, at Ramsgate. The name evokes something. A childhood

memory of standing by the bookshelf, reading out loud from Virginia Woolf's *To the Lighthouse*. I wanted to, but could not make sense of the words. Their sound brought pleasure, as did the shape of the sentences in my mouth. So I will go to the town in the novel. The next day I remember that the story is set on the Isle of Skye, and the family is called Ramsay. Ramsay, Ramsgate. Oh well. I have surrendered to the associative drift of the dream.

Were I in a Muriel Spark novel, the train would be heading in the direction of something sinister. But the mood is gentle and I fall asleep with my head on the table.

Ramsgate, twilight. My phone is out of battery. I study a map on the station wall and walk in the direction of the marina. Identical houses. Not many people are out, too-quiet streets. Did I make a mistake in coming here? And then, boats in a crescent. Ribbons of gold-silver on the water. I stand looking at the sky and sails till the remaining light fades. Painful to lose sight of this scene. A garret room in a bed and breakfast, £40. The 'sea view' is porthole-sized, but I can hear the waves.

The journey to the sea and my walk under the white chalk cliffs the following day are saturated with colour in my memory now. Why do I still remember the curly-haired dog that ran up to me and sniffed my leg? I can see the sand on its black nose, the background of two blues, sky and sea. A woman smiles at me. The nibbled chalk arches at Botany Bay. The weather changes, bright sunshine, cloud. The rain is light and doesn't soak through my brown leather jacket

and running shoes. The ground is soft beneath my feet; it has the satisfying give of foam. Sometimes I still feel like I am running my hands over the shape of that day, as though it is a flat rock or seashell or some other kind of beach treasure. It seems significant, like it means something, but I couldn't say what. I keep it close, it is precious, it means something to me.

Is there anyone else eating at this Italian restaurant? A flourish of napkins. 'L'Amore Perdonera' playing. I open my rucksack and pull out the book I brought with me from London. *This book is the record of a seven years' study of living.* My pasta arrives, and I carry on reading, fork in one hand, book in the other. The book claims to offer a way of finding out what one truly likes or dislikes. Some weeks back, I had been ordering in a coffee shop with a friend, and after what felt likes ages of hesitation I said: 'I'll just have what you're having.' Later I felt ashamed, not because I set much store by which drink I'd chosen, or not chosen; rather, that moment of indecision seemed to capture something of the quality of my weekends and evenings, times when I wasn't working or committed to doing something with another person. I read on. *It is possible to handle ideas with apparent competence yet be utterly at sea in trying to live one's knowledge.* The moments of recognition were accumulating as I turned the pages of the book. *What is really easy, as I found, is to blind one's eyes to what one really likes, to drift into accepting one's wants ready-made from*

other people, and to evade the continual day to day sifting of values.

At the age of twenty-six, Marion Milner, the author of the book I was reading, began searching for *a method for discovering one's true likes and dislikes, for finding and setting up a standard of values that is truly one's own and not a borrowed mass-produced ideal.* She kept diaries, made lists, doodled, and observed her childhood memories and everyday experiences to become better acquainted with her mind, her wishes and desires, often finding herself surprised by what she found. She called her book *A Life of One's Own,* and it was published in 1934. I was the same age as Milner when she started her project. It was almost as if the book had been written for me. The coincidence felt like a reward for the following of impulses, for sitting alone in an elaborate but decrepit Italian restaurant in Ramsgate. *It was gradually dawning on me that my life was not as I would like it and that it might be in my power to make it different.*

My brother was twenty-four when he died, I was nineteen. With each passing year after his death, our shared time was pulled asunder. I grew older than my older brother. I exchanged clocks and calendars for another measure of time – his absence. It felt like the last thing that happened to me. Like what did you do yesterday? When I try to think of myself in the years after his death, it is as though my mind can only find representation in images of bizarre buildings, an architecture of desolation. The roof and outside walls

are intact, but someone has scooped out the interiors. A block of flats is balanced on a single stilt. A house is sliced like a pie. Somewhere inside myself, there was a wrecking ball, an explosion, a fire. What was that burnt piece of wood? Where did that door lead? Who lived here? For the most part these scenes were unbearable. I didn't want to look, or understand. I closed my eyes, turned away. And then that was intolerable too. So it was back to sifting, and picking up, living with ashes on my fingers.

My brother was dead, but *dead* is hard to make sense of. It felt like my brother was missing. In the years after he died, when I lost something, a pencil or scarf, there was no rest till it was found. Bags emptied of their contents. Rooms turned inside out. But why should I believe any more in the possibility of return? Irretrievably gone things bring acute distress, every lost and broken thing was the brother who had gone and didn't return. With my brother went the language I spoke with him, a two-person dialect with its own lexicon, gestures and idiosyncrasies. I only became aware of it when there was no one left to speak it with. One evening we had a guest. I was laying the table for dinner, realised we were missing a chair. Surely there are five of us? No, there are only four. Clocks, numbers, calendars, they all melted.

My brother was missing, and it felt inexplicable that I was still here. And while it was possible to throw the duvet to the floor in search of a lost earring, or to call friends to ask if my wallet was at their house, there was no obvious

course of action when it came to searching for the parts of myself that had gone missing with my brother. It didn't help either that I had no clue what I was looking for, and for the most part wasn't even aware that I was searching. In a memoir written after his wife's death, the theologian and writer C. S. Lewis notes, with surprise, how grief feels 'so like fear'. I couldn't have known that my grief would feel like a burning shame, something to be kept secret.

This shameful feeling came with me to London in 2013 when I arrived here four years after my brother's death. It stood between me and the world, between me and those who might have been friends or lovers. In those first months in the metropolis, I found the listings for a season of the Belgian feminist film director Chantal Akerman's films at a cinema near Trafalgar Square. A long bus ride took me there from my student halls, and week after week I took my seat in the welcome obscurity of the cinema. In the films, women ate from bags of sugar, wept, played the cello, made love. Watching them, I was less alone, and I took that feeling of companionship with me on the journey home in the fading evening light.

My grandmother believed that crows were omens for visitors, and that the return of someone longed for could be hastened by feeding crows. Many of her stories were about women waiting for husbands who were away fighting in battles, women who scattered food for crows in the hope their husbands would soon return. Inevitably, the stories ended with the women unfulfilled, then dead, often by

their own hand. These tales left me troubled, as though they carried a curse, as if women's lives were somehow doomed. Crows, I liked though, even more the idea that by feeding them I could summon someone who was away. I didn't know it then, but in watching Akerman's films, in walks through parks and cemeteries, in long hours drifting through London's museums, I was scattering bread, asking the crows to bring me back to myself.

Years later, everything about that time in London comes back to me on a visit to the Royal Academy. I am looking at Käthe Kollwitz's *Woman with Dead Child*, an etching based on sketches she made of herself holding her seven-year-old son Peter in her arms. I am looking at the etching and the world is spinning around me. The woman of the title crouches with her legs crossed. She clutches a body to her, the child. The child's head is tilted back, aglow. I look at the etching, there are people standing around me, and I am convinced that I am going mad. I turn away, look at other works on the gallery's walls. Then I come back to the etching and, once again, a feeling of vertigo, a consuming madness. *Where is the woman's face?* At the centre of the painting is the unbearable. Where the woman's face should be, where I would expect a face, there is nothing. I can make out the hair on her head, individual strands carefully drawn. And then what? Is that a forehead? Where are her eyes? Where is her mouth? It is as though her face has melted into the neck of the dead child. Have I forgotten

how to look? Have I forgotten how to recognise a face? Or at the centre of the etching, unrecognisable, dissolved, do I see my own mind?

But there was a before. A before my brother died. Outside, there were eucalyptus trees that shed tiny yellow cones, each one smaller than my smallest fingernail. Everything smelt dry. The heat drained the world of sound. Or so it is in memory, anyway. Within the house, the dog, quasi-maternal figure from childhood, glued to the cool cement floor. Inside me, metamorphosis. The assured angularity of my body was gone. What to do with roundness? Sanitary towels, wrapped in newspaper, passed under desks to the girl who has forgotten. Still, the blood gets everywhere. We wore white skirts to school, uniforms of colonial fantasy. This was the Jaipur of my childhood.

Summer holidays. But this time, with the internet. I was offered some copy-editing and content-writing work that year, with the understanding that my mother would look over what I had written. I was fifteen, and the work paid too much money for someone my age to earn. The money wasn't coming to me, but I had a new sense of my worth. All through the summer holidays I was buoyant with secret pride. The work itself was tedious, hours of looking at a glossy document produced by an international aid agency, teenage libido poured into desiccated words. It was the summer that I learnt, and grew to hate, the word *stakeholder*.

The summer passed. I began studying for my school

leaving exams. My mother and I were sitting together. She said I should consider working as a copy-editor when I grew up. That magical place: *when you grow up*. You could work at home, she said, it wouldn't interfere with your family life. I was quiet, but bristling. Was this all she expected of me? Is this how little she knew me? I had imagined for myself some sort of unspecified achievement, and excellent clothes. Romance. My daydreams were made of snow peaks and log cabins filled with books, a fireplace. Family? Nothing so mundane had crossed the threshold of consciousness. All the adolescent shock and rage comes back when I remember the conversation. The anger pours into the gap between my mother's opinion and my ambition. How could she not have known? Why didn't she ask me what I wanted?

But there was nothing exceptional about this conversation. The general drift of education was to tell me what I should do, what I should want. It was an early lesson: there is something dangerous about a woman's desire. No one said it in so many words, of course. A fact, nonetheless. Learn it like times tables. Remember the woman who decided she wanted to be a Bollywood star? Against everyone's advice she took a train to Bombay and then a few years later she was seen in a film, dancing as an extra in a short skirt. Her thighs were too fat for those clothes, unfortunate girl. It was a matter of urgency, the duty of a devoted parent, that I somehow learn this. That I learn to keep myself safe from the terrible fate of desire.

Wrapped inside that warning about womanhood was another set of messages. Failure would be mocked. Everyone seemed nervous – it was hard to say over what – other people, the future, life itself – all this was threatening. They held their scorn close, like it was protective. If someone was trying something out, then they deserved their quota of suspicion. Maybe they related to life as they did to the English language – carefully reaching for the correct pronunciation, afraid of tripping up, laughing at those who did. Maybe if you're afraid of language the fear seeps into everything else, into posture, the cut of clothes, the gaze of fathers looking at mothers speaking to their children.

All the exemplary women around me had taken someone else's desire as their own. A parent, a husband. They had been known for their style at university, but now they dressed to please their husbands' parents. They'd given up their favourite foods, their social life, opportunities for travel. Nothing was praised quite so much as sacrifice. They were happy. I was often reminded of how happy they were. They were also so good at doing things on the side, pursuits that were easily suspended, successful demonstrations of skill and talent swiftly packed away when guests showed up unannounced for dinner. And if a woman did happen to have that thorny thing – a career – well, then she was first and foremost an excellent wife, a devoted mother.

My mother's speech was split. She drew attention to these women, pointed out that they were ideals. Perhaps

unintentionally, she also managed to convey that she found them utterly boring. She sketched out the woman I should be, but kept asking me to read Emily Brontë's *Wuthering Heights*. Told me she had to give up music after her marriage. And singing, playing. There wasn't a single instrument in that house. That house? The one she married into, my father's house. As a child, I found these complaints unbearable – why *did* you have to stop? Why didn't you start again? Why didn't you buy yourself a harmonium with your schoolteacher's salary? I was aware of some kind of message coming my way but I didn't want to understand. I played dumb, I didn't want to learn these lessons. Today I'm grateful for her discontent. Glad for the ways in which she was disloyal to her beliefs. My mother is ambivalent. This drives me crazy. My mother is ambivalent. This gives me a way out. My mother's dissatisfaction equipped me for rebellion. Poor Mother. She had been supplying arms for a revolt against herself. All us girls being told: you don't know what's good for you. Who did? Who could have known better than us? What kind of life are you expected to have when you're raised with such little faith in your own judgement?

When I was in school what interested me most were novels, films and music. They provided me with a substitute for things that I longed for, but found missing – the possibility of youthful love that could be acted upon, teenage hedonism, an exploration of the sexual desires that made me fancy the boys and girls I saw on the sports

fields. But I was acutely aware that the present satisfaction of my desires would jeopardise their future fulfilment, and so I made a bargain with myself. I would be good (no sex, excellent grades), and when I went to university I would be really, really bad (lots of walks by myself, sex, communism, street food). I left school at seventeen with the grades I needed to secure a place for myself at university in Delhi, and gave off enough of an impression of compliance for my parents to agree to my living away from them in the national capital, a place of glamour, temptation and worldliness, notorious for a culture of sexual violence and aggression on the streets.

I fell in passionate love with Delhi, and the freedom it promised. My college only admitted women, and I had a coveted place in university housing, which meant I was subject to strict rules about who I could see, where and when. Male visitors were strictly forbidden, I needed special permission to leave university after half five in the evening. It was a coercive and controlling environment but inadvertently it opened up space for me to live out my desire for women, in friendship and sex. This also endowed men with the mystery of the forbidden, turning them into shiny objects of fantasy. I studied English literature, I had access to all the books I wanted, and I was learning from friends and teachers about protest and politics, which, like sex, had also for the most part been conversational topics that were off-limits in my family home.

And then, at the start of the final year of my studies,

my brother died. I had the vague sense that after university I would do something politically useful. Law seemed the most obvious translation of this wish, so I found a place on a law degree. I was in a haze of grief and going through things somewhat automatically, but the week before I started classes I abruptly remembered how much I preferred reading and interpretation. I transferred to a postgraduate degree in sociology, where one of the courses on offer was based almost entirely on the works of Karl Marx. My mother was unconvinced by my choice of either law (you'll have to wear black and it isn't your colour) or sociology (you'll lose all your softness by studying such hard things), but I just took this as a sign of the growing distance between us. I had a boyfriend at this point, and it felt like an obvious commitment to queerness and Marx and feminism to have an open relationship, so I also felt free to fall in love, again and again. But I wasn't really there. Something in me had gone missing and I didn't know what it was. I had little sense of what I wanted from my life.

Someone suggested I apply for doctoral studies after finishing my postgraduate degree. I wasn't certain what doctoral studies meant but it seemed like a good way to have time to read while putting off the question of marriage. I was still interested in Karl Marx, but I had started reading Freud and was particularly taken by the work of British feminists like Jacqueline Rose and Juliet Mitchell who wrote about psychoanalysis in a way that helped me understand myself and my circumstances. It was

then that I first came across mentions of Marion Milner, but I couldn't find her books, and in any case I was soon preoccupied with trying to write a PhD proposal. Some of my Marxist peers seemed suspicious of psychoanalysis, considering it a bourgeois and Western affectation, and it was partly their questioning that prompted my interest in the colonial history of psychoanalysis, which then became the topic of my doctoral studies.

I approached my doctoral studies in London with near-complete ignorance of the norms and conventions of academic life, and a massive overcommitment to my research project, which had become a container into which I deposited all the questions and feelings that came from grieving my brother. My work was supervised by Jacqueline Rose; she understood immediately that my studies were a piece of intellectual work that was important to me on its own terms, and as she got to know me better she could also see that it was thinking and writing born of grief. I didn't quite understand this myself, but she did, and with a combination of considerable tact and incisive directness she witnessed and facilitated the unfolding of a difficult intellectual and psychic work.

For all the ways in which my doctoral studies were a form of self-discovery, they were also a postponement of a more direct reckoning with questions about what I wanted, and how to live, questions which had for some time felt suspended, and in many way necessarily so, because grief needed its due. Towards the end of my doctoral studies,

when I went to the seaside at Ramsgate, I thought I was just doing as I wanted. Waking up on my birthday in a small room by the seaside felt like a pleasant and welcome departure from routine. I walked thirteen kilometres, alone. I ate some chips, bought postcards. Yes, I felt the intimations of something significant but I wouldn't have been able to say what. It is only now that it seems clear to me that in going to Ramsgate on the eve of my twenty-seventh birthday I was separating from the space–time of grief in which I was all mixed up with my brother. In that sense it was a departure and break, but it was also a return of questions and impulses that had been present when I was younger, in childhood and adolescence, which had been held suspended by the consuming work of mourning.

Sitting in the restaurant in Ramsgate reading *A Life of One's Own* was not my first encounter with Milner. Over the years, I'd seen her series of five books, with their green Virago spines, in charity shops and second-hand bookstores: *A Life of One's Own, An Experiment in Leisure, On Not Being Able to Paint, The Hands of the Living God* and *Eternity's Sunrise.* They had such compelling titles, and each time I saw one I felt a kind of excitement. In a box outside the London Buddhist Centre in Bethnal Green I found an American edition of *On Not Being Able to Paint*, Milner's book about barriers and obstacles in the way of creative processes. For a few weeks I imitated Milner's experiments in free drawing. Sitting in the kitchen of my

student flat I'd draw the aloe on the dinner table in various unlikely colours. Then I began to feel stupid – I don't know how to draw! – and stopped. I also dipped in and out of *An Experiment in Leisure* and *Eternity's Sunrise*, both books in which Milner continues the autobiographical project begun in *A Life of One's Own*.

Maybe it was something to do with the setting, or how I was feeling that day, but beginning *A Life of One's Own* on the eve of my twenty-seventh birthday I realised the book would be important in my life. I didn't know it then, but that evening in the restaurant marked the beginning of seven years of reading Milner, a process that was not conscious or intentional at the outset, but which became my way of asking how I could have a life of my own. I found my questions refracted in Milner's writing, and I began to rely on her words to help me navigate my life and solve the puzzles of how to earn a living, who to love and how, and what really mattered to me.

When I visited Ramsgate I was living in a flat with three other people. I was looking forward – if such a phrase can be used to describe a process so fraught with anxiety – to academic life. I was single; I expected this to change at some point. I went for psychoanalysis three times a week, travelling across London to speak about myself in a room with a slanted ceiling in Golders Green. I had a feeling of having fallen into my life. Little did I know that in the coming years reading Milner's work would become a practice that would draw into itself all

aspects of living: relationships, work, creativity, dreaming, chores and politics. I couldn't have anticipated the ways in which each of these scenes of living would be illuminated and unsettled. I often wonder what would have happened if I hadn't taken Milner with me on my seaside expedition, since picking up her book before my train that day was such a quick act, an impulse that felt more accidental than intentional. But I've come to accept that sometimes these small, quick acts carry within them the force of years of thinking, feeling and wishing, and sometimes in the moments when our actions are most mysterious to ourselves we are able to do or say something that is truthful, urgent and necessary.

Marion Milner was born in 1900, in London. As a young person, she wanted to become a naturalist, and taught herself about newts, birds, plants. She was fourteen at the start of the First World War, and nearly an adult when it ended. Milner studied psychology at University College London, and began working in the fields of industrial relations and education. I've read her work over the course of many years and her writing still surprises me. I love Milner above all as a writer – for her style, her experiments with form and her extraordinary ability to hold the reader's attention. After publishing two books of memoirs – *A Life of One's Own* in 1934 and *An Experiment in Leisure* in 1937 – in which she used her own notebooks like an archive, with quotes and commentaries, Milner began her

psychoanalytic training, cycling to seminars and supervisions while bombs fell on London. Her next book, *On Not Being Able to Paint*, published in 1950, brought together her interests in painting and psychoanalysis with her distinctive style of memoir writing. *On Not Being Able to Paint* is a creative work that challenges categorisation – it is a memoir, and a work of psychoanalytic theory, and it is also a remarkably avant-garde piece of experimental art. Running alongside Milner's writing was her distinguished career as a psychoanalyst, and her pursuit of many interests – painting, dancing and travel.

Sometimes I think it is precisely because Milner gave such free rein to her creativity, because she worked with such skill and verve across genres and forms, that she has not received the attention she deserves. Her oeuvre poses a challenge to a culture that still suffers from a tendency to fix women in place, and nothing about Milner's work lends itself to being tidied away. In her psychoanalytic writing, which includes the book-length case study *The Hands of the Living God* and a volume of collected essays titled *The Suppressed Madness of Sane Men*, she is somehow able to hold contradictory thoughts together, allowing her to describe some of the most mysterious aspects of our psychic lives in language that is both precise and ordinary. This, and the fact that she writes from the position of someone who is searching and questioning rather than someone who has the answers, makes her explorations of creativity, attention and bodily awareness some of the finest

in the psychoanalytic literature. In contrast to other psychoanalysts who set out to establish a school of followers, or wanted to leave behind a set of theories that would be associated with their name, Milner remains a writer and artist in her psychoanalytic writing, by which I mean that her work is open and experimental rather than didactic or jargonistic. She invites her reader to construct their own interpretations and meaning rather than telling them what to think.

All this is not to say that Milner's work is lost or forgotten. She wrote nine books, and when she died aged ninety-eight she had just finished her final book, and was found with the corrected manuscript by her side. Her work continues to be important to psychoanalysts and academics, and has inspired responses in writing and art, as well as remaining influential in the practice of psychoanalysis. Still, I remain surprised she isn't better known, and all too often, before I can venture into an enthusiastic account of her ideas, I find myself having to explain who she was. I believe this needs to change, as the approach to living and desiring that she elaborates in her writing has much to offer us now. In its invitation to pay attention to the texture of our experience, to become familiar with those parts of our mind that feel objectionable and shameful, to consider our wants and longings, Milner gives us a nuanced and expansive vocabulary which can enrich our lives.

I read Milner with complete disregard of the careful distance cultivated by academic training. If Milner's first

book, *A Life of One's Own*, issued a rallying cry, an invitation to attend to my life and my mind, then her second book, *An Experiment in Leisure*, became a way of figuring out if I should leave my boyfriend. *On Not Being Able to Paint* was a confrontation with my disavowed creative ambitions. I read Milner's psychoanalytic writing filtered through the experience of my own psychoanalysis, and when I decided to embark on a psychoanalytic formation myself, I read and reread *The Hands of the Living God*, Milner's account of psychoanalytic work with a patient she saw for over twenty years. *Eternity's Sunrise*, her book about going on holiday, confronted me with the entanglement of leisure, history and politics. These were the books by Milner that were most important to me and, in the chapters that follow, I discuss each in turn, occasionally also drawing on her last book, *Bothered by Alligators*, and the essays collected in *The Suppressed Madness of Sane Men*.

As my interest in Milner grew, I began visiting her archives with the notion of making a study of her work. Milner's handwriting is difficult to decipher; the volume of material held in her archives is also copious. I spent many weeks among her papers, expecting to write about her in a scholarly fashion. But I soon became aware that I was taking questions about my life to the fragile and yellowed paper of her diaries, and that the journey to the archives in Maida Vale from where I lived in east London had all the quality of a pilgrimage made to an oracle. Like any message from a sibyl, what I got from Milner sent me seeking in

the obscure reaches of myself. What oracles say is rarely obvious or comforting, and reading Milner has turned my life upside down. Things I took for granted don't seem secure any more, and I keep stopping in surprise at my ability to muffle my wants and desires, and the unedifying motivations underlying so many of my decisions.

In *A Life of One's Own* Milner warns that no one should embark on the experiment in living suggested by her book *who is not prepared to find himself more of a fool than he thought*. Well, she was right, because I have found myself to be a fool. With the discovery of this foolishness has come a new capacity for risk, and freedom in thought and action. This is not to detract from the excruciating feelings that accompany the discovery of one's own stupidity – but like Milner, I too have discovered that a familiarity with the embarrassing and baleful parts of my mind brings with it feelings of relief and possibility.

None of this would have been possible without leisure – the time to think, make mistakes, try things out. This book is both the product of and a plea for leisure. But leisure also in the way in which Milner conceptualises it, as the setting for encountering the powerful, cataclysmic forces which live inside us, and by which we are lived. Milner's account of leisure is daring, disruptive, sometimes angry. Leisure is time when something can be discovered, where certainties are called into question, where lives change. It is not a commercially endorsed practice of consumption or escape, and certainly not the regimented forms of compliance that

make up so much of what passes as self-care. Milner is profoundly interested in rest, relaxation and the value of the accidental, but alongside these she imbues her account of leisure with a revolutionary urgency.

The chapters in this book are separated by short fragments on activities that have helped me understand something about my experience of leisure. They are fragments because leisure, in my life, as most likely in that of many other women, is an interlude between demands and obligations. Writing in fragments is also what made this book possible – during the writing of it I rarely had time to write something as consistent or unified as a chapter, and I would have been daunted if it was not for the possibility of writing in fragments, then arranging them together much like a quilt, square by patchwork square. The fragments that are interspersed between the chapters preserve the initial form that my writing took, in acknowledgement and defiance of the sharp scissors that cut the joyous and revelatory time of our leisure into pieces. I hope they are a reminder, to myself as much as anyone else, of the desire, freedom and expansive release that can be the gift of leisure.

Gathering

After eating dinner, the three hundred or so girls I lived with in university housing would collect in each other's rooms. Someone might bring out a snack from home, or plug in an illegal electric kettle (we weren't permitted our own electric equipment, with the exception of hairdryers and laptops, and I kept my kettle concealed in a laundry basket, nested between clothes in need of washing). If I was lucky someone might oil my hair and give me a head massage, or sing me a song. There was rarely a purpose to this time together, except the pleasure of company. I learnt so much in those gatherings – about how other people's families were different from mine, and the ways in which I was careless and inconsiderate and how it was possible to be otherwise. I learnt about politics and history, methods of hair removal, people's cousins, and remedies for constipation. But anything I learnt was incidental, because the point wasn't education or improvement; the point was something I would come to recognise as leisure.

In meandering long hours spent with friends I often have the welcome feeling of having drunk to my heart's

content from a deep well. I associate such time with the replenishment that is possible in leisure, without effort or agenda. Reading Milner helped me recognise an interior experience, which shares something with the quality of such time spent with friends. I feel it when I can let my thoughts and feelings gather instead of trying to dig them up to subject them to the harsh glare of investigation, or chasing after them to know exactly what they were. What surfaces out of such a gathering is sometimes unexpected, at other times mundane. An intention can take shape, a fear lose some of its intimidating quality, or I may just feel a bit more rested than before. In the privacy of one's mind, as well as in the company of others, there may be some things that lend themselves to scrutiny and purpose, but there are others best encountered at leisure. It isn't possible to reach them by means of expedition or pursuit, much better to issue an invitation, extend a welcome, and let the guests gather.

2

The Most Comfortable Chair

Leisure is often accompanied by fear. We may look upon the things we associate with leisure – free unstructured time, a reprieve from obligations, some moments of solitude – and want to avoid them altogether. In fact, we may be making arrangements to bypass these experiences even as we are longing for them. In reading Milner, I've come to think that this may be a response to how leisure is an opportunity to encounter the myriad and expansive complexities of our minds, an experience that can confront us with what we've tried to forget or that which we want to ignore.

But even before I could embark on my own experiments with leisure, I experienced this paradoxical feeling of desire–avoidance in relation to Milner's writing. It was present right at the outset, as I sat in the Italian restaurant in Ramsgate. *A Life of One's Own* was a charity-shop purchase, long unread. I felt an attraction towards Milner's books, but underneath that was some kind of barely conscious fear. Confronting this fear–attraction, I had to face something about myself. It was a sense of feeling

unmoored, of having lost my internal compass. Was this feeling produced by the cumulative erosions of grief? Or the busy, lonely years of settling into a new city? I couldn't quite tell. Reading Milner, I would find myself suddenly distracted, unable to take in what she was saying. It was only much later I realised that I couldn't read Milner's writing without facing the facts of my own life, and oftentimes this was not something I was willing to do.

A Life of One's Own begins with Milner's discontent – *going about my daily affairs in a half-dream state*, sometimes optimistic, at other times miserable. The book was written over a long period of time – she drew on diaries written between the ages of twenty-six and thirty-four to compose the book. This was a period of professional and personal change in Milner's life. She went to America on a Rockefeller scholarship, she got married to Dennis Milner, an engineer and playwright, and at the age of thirty-three she had a baby. But Milner was acutely aware that behind the appearance of competence there could be *a gap between knowing and living*. She felt like she was always *looking for something*, not sure about what she wanted, dependent on the opinions of others and living in a *constant dread of offending*.

She considered the solutions available to a woman of her means and education. She could devote herself to good causes, *forget myself in trying to lessen the troubles of others*. Or she could give up her own privileges and adopt a life of poverty (*caution and cowardice prevailed*). Psychoanalysis

seemed *too privileged a way out*. And then she says some-
thing which brings to my mind all the evenings I would
spend alone in my bed, swiping left and right on a suc-
cession of dating apps: *Would taking a lover be a cure-all?*
Was I to trust the general assumption amongst a certain set
of my own generation that it would, or was I to believe in the
standards I had been brought up with and be shocked at the
very idea?

Milner is discreet about her love life, but it will come
as no surprise to women of my generation that my own
sense of discontent, which fluctuated from vague to acute,
was left unresolved by the apps, by drinks at anonymous
bars, by the promise of passion, the cold shock of sudden
ghosting. Despite the bureaucracy of present-day forms of
dating, and a whole grim terrain of exploitation and risk,
I still thought of romantic love as a kind of resolution,
though I would have been hard pressed to describe in any
detail just what I was hoping to remedy. I was trying to
solve my problems without wanting to consider what they
were, and the ways in which I was afraid of my own mind
didn't make the situation any easier.

Oh I want to let go, to lose myself, Milner writes, and the
sea provides her with a language for her desire: *to feel life*
pulsing through me, the big tides sweeping in, till I'm one with
the immense surging fullness of the sea. Her writing is imbued
with the sense that there is something oceanic under-
neath our awareness – *depths below us where queer things*
grow and swim silently. Her attempt to find the contours

of herself is always alive to this uncharted seascape. Years before the start of the experiment that was to become *A Life of One's Own*, Milner had once again turned to the sea to find an image for what she was reaching towards. In a diary entry, she described an island where shipwrecked people are stranded, because *fear will not let them put out to sea*. The island dwellers, Milner writes, are obsessed with logic, counting and knowledge, but through all of this runs their *fear of the sea*.

What might it mean to imagine the mind like the sea? The depths, the unpredictability, the unknown? Sometimes I notice something inside of me, drifting, an ice floe. Unknown to myself something has congealed, a zone of frozen feelings. Thoughts become unthinkable. The simultaneous excitement and hesitation I felt in relation to Milner was born out of a fear of my own mind. I was discovering that I couldn't read her work without being thrown into the depths of myself. Where would it take me? Surely the island dwellers that Milner describes with such disdain were the sensible ones? I was afraid that there was something in my mind which could drown me.

Milner arrived at her project after the failures of self-improvement. She had signed up for a course on mental training, taught via correspondence by the Pelman Institute in London. Claiming to help with all kinds of problems – forgetfulness, procrastination, depression – it didn't do very much for Milner. So she took a step back: *instead of trying to force myself into doing what I imagined I ought to do*

I began to enquire into what I was doing. A correspondence course in self-improvement sounds almost quaint today, when everywhere I turn there is someone offering ways to train, manage, improve and harness the mind. There is no dearth at all of directions and rules to live by, and whenever I get caught up in them I find I am either completely distracted, or turning an anxious, overwrought attention onto myself.

These exhortations to improve oneself cast into relief the radicalism of Milner's approach. In choosing to be curious about her mind and life instead of doubling down on efforts at self-improvement, Milner asserts that there is something interesting, and important, about the particularities of one's own mind and life. Questions about what we want from life, or the discontents that unsettle us, she suggests, can be addressed not by coaching ourselves to become someone else, but through a greater familiarity with ourselves and our circumstances.

I see Milner as someone who wanted to have her own mind, someone with the courage to ask what it would mean to come to know herself. Women aren't always asked what they want. We aren't encouraged to learn to pose that question either. All too often, this goes hand in hand with force and violence. But even in less fraught situations, the question is easily eclipsed. At least for me, it was never obvious how to ask this question of myself. Somewhere along the way, I had learnt to assert myself successfully enough to prevent my life from being entirely subjected

to the will of other people – like the assorted aunties and acquaintances who, after I finished university at the age of twenty, had begun to suggest I should marry, and who would have been only too happy to pick my partner.

Women married young in the city where I grew up, and most people around me thought this right, and weren't shy to say so. I'd wrenched myself away from the warnings of 'you'll live to regret it' or accusations of making everyone unhappy, depriving the elderly of their portion of joy, disrespecting the course of nature. The resolve I found could at times feel like ruthlessness, and it wasn't till years later that I realised that breaking away came at a price, which was different from what I'd been warned about. Regret, a cold bed, madness – these were threats in the service of intimidation. The real cost was more subtle. The stakes of asserting myself felt so high that I found myself becoming overly cautious, afraid to take risks or experiment, because I was too scared to do anything that might jeopardise my independence. This landed me in a bind – I was trying to preserve my independence by curtailing it, and though I had great sympathy for the mistakes and missteps in other people's lives, I couldn't seem to allow myself any.

Going to Ramsgate on my birthday meant following an impulse – a rare enough thing in my life at the time. While I felt a sense of exhilaration in surrendering to a part of my mind that didn't present reasoned arguments, I knew I didn't have such strong impulses all the time. I was capable of rebellion and defiance and protest – these had shaped

my life – but I didn't need them every day. Most days I had commitments and responsibilities, a hundred small decisions, the days bleeding into one another. To ask the question of what I wanted, and what I could risk, as part of quotidian life was something of a puzzle to me. After all, leisure confronts us with the question of what we want, even in the most everyday iteration of what we might wish for from a free afternoon.

A man that is born falls into a dream like a man who falls into the sea. This line from Joseph Conrad is from the epigraph to the first chapter of *A Life of One's Own*. Conrad says that those people who try to climb out into the air are drowned, and the way to survive is to *make the deep deep sea keep you up*. I was perhaps in some kind of indeterminate position. I felt like someone who has learnt successfully how not to drown, but who hasn't yet figured out how to swim. Like Milner, I too found that my mind was *something quite unknown* to myself, and in Milner's urgency to become *more familiar with its habits*, I found courage.

Milner started her project of finding a life of her own by keeping a diary, often noting her thoughts through the day. There was something weird, and uncomfortable, about being confronted with the contents of her own mind, but she carried on. Then, her approach altered. She thought she would write about everything that made her happy (*Flowers, light and colours; The patience of cart-horses; The abandon and moods of dogs*), and then she'd know what

changes to make to her life. But writing and experience were slippery. She was changing as she wrote, and the experiences that she described transformed when she observed them. There was something about feelings and experience, and the process of writing, that resisted aims and purposes.

In trying to become familiar with her mind and life, Milner felt *swept in all directions by influence from custom, tradition, fashion, swayed by standards uncritically accepted from my friends, my family, my countrymen, my ancestors.* Other difficulties were more interior. Recording her thoughts in her diary, she felt interrupted. *Exhortations were continually in the back of my mind*, she writes, *as a criticism and a reproach: 'Think less about yourself'. 'Don't be so self-absorbed', 'Think about other people and you'll have no time for your own worries.'* These were values Milner had *absorbed from childhood*, which prized unselfishness and equated it with being good. Unsurprisingly, she had spent many years *trying to force myself to think more about other people*.

Milner discovered that this injunction not to be interested in one's own self gave rise to isolation: *I had only grown more and more shut in within myself.* She'd absorbed this code without examining it: *I do not think I ever critically considered just what I meant by unselfishness, but now the word awakens a picture of continual restlessness in which someone is always half rising from the most comfortable chair in the room and saying, 'Do sit here.'* Instead, she refused the awkward disinterestedness that was meant to constitute

'good' behaviour: *I could not vanquish my egoism by running away from it.*

A Life of One's Own is an epic, it is a quest and a journey, with accompanying moments of terror and sublimity and exhilaration. But consider the materials from which it is made: a series of notebooks, often small and sized to fit into a woman's pocket and handbag, the details of everyday work and domestic life, lunch breaks and weekends. Because I picked up the book and was immediately convinced of its relevance, because it speaks to the day-to-day of my life, and because of its unassuming, wondering and questioning voice, I didn't quite recognise just how radical it is as a piece of writing. Pay attention to your life, I hear it saying. Something important is happening here, amid the tea and washing-up, and it is yours to notice and claim, it is yours to interpret and understand. Whatever it is, it matters, it has dignity.

Having begun to write as a means of becoming better acquainted with herself, only to discover that writing out her experiences was *having an influence on their nature*, meant that Milner's project kept shifting, not least because she brought to her writing questions about her professional life, the experience of falling in love, and feelings about her marriage. There seemed to be no direct way to discover what made her happy. Even the animating questions of her endeavour – finding out how to have a life of her own – began to seem less important. As she met herself on the page, something about the activity of writing became an

end in itself: *I felt an urge to go on and on writing, with my interest gradually shifting from what to do with my life to how to look at it.*

Milner's method of working with her own diaries, in *A Life of One's Own*, allowed her to attend to everyday wanting and wishing. She may have wanted a new hat, or for people to admire her at a party, and she may have found these wants and wishes awkward, but she let herself think of them, they were the raw material from which she began. Her writing was a reminder to me that ordinary wanting and wishing is important, because *every attempt to formulate desires, however incoherent, is a step forward*. Milner's book suggests that whatever shape a wish takes, however embarrassing or everyday, it is worth noting. If a wish seems stupid, or unreasonable, it may just be that the words, or worlds, in which it can be expressed haven't been found yet. It dawned on me that if I didn't admit my wishes to myself, I would never allow myself the opportunity to respond to them, whatever the response may be – pursuit, denial, realisation.

I had written diaries too, starting when I was about twelve years old. I kept them all, but I never looked back on what I had written, and wouldn't have been able to say what my stacks of notebooks contained. I left all my diaries at my parents' home when I moved to London, bringing with me only one clothbound notebook, in which I was writing at the time. As the years passed, I realised I had grown another stack of notebooks, the pages covered in

my handwriting. Living in London meant moving flats often, and sometimes when packing I considered throwing them away, but something stopped me. So strong was my resistance to looking at them, that even when I was reading Milner's diaries, or reading the books she wrote based on them, I didn't consider opening my own notebooks. It was only when I had started working on this book, and one day found myself confined to my university office because of the heavy rain outside, with no battery on my phone and no working computer at hand, that I opened one of the cardboard boxes in which I'd stored my diaries. As soon as I had looked inside one, I knew I would need to read them to write this book.

Like Milner's diaries, mine also record how I parsed every conversation, even with people whom I knew only slightly, endowing every exchange with an excruciating importance. At twenty-two, I wrote: 'wanted to note I have begun reading Christa Wolf's *In the Flesh*. Why avoid writing? The eighth was so utterly miserable. Walking for hours in the Calcutta sun, getting lost, lost, lost. Unkind and cold email from F in response to a lovingly composed birthday message from me . . . And then, yesterday. Woke up with a leaden body – mostly because of the F email.' What the diary didn't say was that I had only met the person whose email left me so distraught a handful of times. The email probably reflected that distance, rather than any 'cold' or 'unkind' intent. Such concern with other people was disastrous, and sometimes I was aware of it. A

year older, at twenty-three, I wrote: 'feel like tinsel, insubstantial and cheap. I suppose this is what happens when one tries to love oneself through the opinion of others.'

It was excruciating to return to my diaries, even though I was accustomed to talking in psychoanalysis. Encountering myself on the page was a different proposition to speaking about myself to another person. In light of Milner's later career as a psychoanalyst, *A Life of One's Own* is often read as an example of 'self-analysis', of what can be done in the absence of access to a psychoanalyst. I had taken this reading at face value, but I realised that writing and psychoanalysis may work in ways that are not substitutable for each other, or even commensurate. Writing something and deciding to make it public feels riskier to me than what happens in psychoanalysis, which remains private. But to write, and to write in the first person as Milner did, is also to lay claim to one's interpretation of life and its varied circumstances, to quite literally put one's weight behind one's words. Like Milner, I began to feel things shifting and moving inside me when I started reading my diaries and writing this book. The upheavals and dislocations in my life, as a consequence of writing, could not have been anticipated by my psychoanalysis. And so it happened that the process of finding a life of my own became more and more intertwined with writing, as though my words were trying to give birth to a life that felt like it was truly mine.

*

As an academic, I had become adept at thinking, at constructing arguments. But accompanying this fluency was another state. From time to time I was submerged in a bleak stupor, weeks where I didn't want to leave my bed or see a single person, where making and eating toast felt like inordinate exertion. All of this lent itself to my life as a graduate student, slowly writing a long thesis. Libraries were as suited to hiding as they were to thinking. But by my twenty-seventh birthday my time as a student was drawing to a close, and unknown to myself I was beginning to crave something else, another way of being in the world.

In *A Life of One's Own*, Milner writes about how she found it hard to stop thinking, and to stop thinking of herself in relation to others. There was often a judgemental voice lurking inside of her, chattering away. She found that on occasion this voice could be stilled. These were moments in which she was too tired to think, let alone think what she ought to think. On a Sunday visit to a busy art gallery, Milner describes stopping in front of a painting by Cézanne – *green apples, a white plate and a cloth*. She was tired and distracted, and sat looking at the painting, not really thinking about whether she liked it or not. In this inattentive state, something happened – *I became aware that something was pulling me out of my vacant stare and the colours were coming alive, gripping my gaze till I was soaking myself in their vitality.*

Finding that it was the absence of internal effort and expectations, and an accepting attentiveness that most

allowed her to enjoy her own company and the world around her, Milner set about exploring how she could encourage a gentle receptiveness in herself. But was this something that could be attained through effort? She noticed a particular kind of social relationship being reproduced in the psyche: *It seems as if I had been used to treating thought as a wayward child which must be bullied into sitting in one place and doing one thing continuously, against its natural inclination to go wandering, to pick one flower here and another there, to chase a butterfly or climb a tree. So progress in concentration had at first meant strengthening my bullying capacity.*

But she was curious about another way of existing in mind and body, one that was less guided by plans and intentions. Like Milner, I too was curious to explore the possibilities of such a state, but I didn't quite know how to access it, except by accident. My default way of being was much closer to the schoolteacher-like way of asking myself to focus, do my work, concentrate. I was becoming conscious of reproducing, in relation to my own self, ways of being that I would have found intolerable were they to be enacted on another person, a scolding, punishing relation to the self, a system of deprivation and reward (I'm allowed this really nice thing if I work really hard), a form of self-motivation through fear and intimidation. Milner was right to call it bullying.

To think about these states of mind Milner describes a scene where a *lonely policeman* tries to pit himself against

a *surging crowd*. She is asking us to think of the will as the policeman, and the crowd as thoughts. Instead of policing her thoughts, Milner asked herself, what if she cleared a space in which they could emerge? *Why had no one told me that the function of will might be to stand back, to wait, not to push?* This could happen in leisure, where thought had the opportunity to be both wayward and unpoliced, exploratory and energised. I was struck by how, in a moment when she was imagining new possibilities in psychic life, Milner turned to a vocabulary that immediately brings to mind a political scene. Crowds, like thoughts, surge; the interior scene has become exterior. It is as though imagining a new relationship to the mind brings with it the possibility of imagining a different world, a reworking of the relationship to authority.

Leisure, Milner contends, reacquaints us with our wishes and wants, even if these take us by surprise, and allows us to rework our relationship with ourselves, so that we can be more accepting of our edges and ineptitude, kinder to the ways in which we may feel bruised and sensitive, and also indignant, bolder and more confrontational when faced with the many injustices of the world. Such pursuit of leisure may sometimes be a solitary practice, but it is in no way an individual project. By its very nature leisure draws the social into itself. In reading Milner, in writing this book, I have constantly come up against the political and economic conditions that produce and limit our experience of leisure. I find that there is something

about leisure, in the way in which Milner imagines it, that has the potential to bring into sharper focus, and undermine, the tight corners that we are coerced into by work, gender relations, racism – all the forms of prejudice and injustice that underpin the appalling conditions which are presented to us as 'the way things are'. Leisure is where the order of things is interrupted, where it can be reimagined. There is a revolutionary force to leisure as Milner imagines it, both at the level of psychic life, and in the field of the social and political.

If the question of how we experience ourselves and our minds is connected to leisure and its absence, as I think it is, then leisure is also profoundly and inevitably also a matter of politics. When I first arrived in England, at Heathrow Airport, I carried an X-ray of my lungs in my hand baggage, to show at the border. The X-ray, and the accompanying certificate, proved that I wasn't harbouring tuberculosis inside me. This requirement captured something about Britain's seething anxieties around migrants – it was a demand so saturated with symbolism that it was difficult to think of as simply a public health measure. It was as though the migrant was carrying something deadly inside her, and it only followed that she should be met with fear, anger, distrust.

Over the years, in conversations with people who were upset about migration to Britain, I was often told that the objection wasn't to me. As they saw it, I had arrived

legally. (I had my doubts about whether being *legal* was the same as being *welcome*.) The real objection, though, was to the others, who unlike me were opportunistic dangerous criminal fanatics. They were *illegal*. The words were everywhere. Legal, illegal. Deserving, undeserving. It was in those conversations, in the news reports and in political speeches that I came to recognise myself as a migrant. As I wrote this book, that consciousness only grew sharper, as forms of state-funded and legislatively sanctioned cruelty proliferated. With each draft of this book, I have had to reckon with heightened racism and anti-migrant sentiment, which take up an increasingly prominent place in the politics of the United Kingdom.

It was the year of the referendum on Britain's membership in the European Union. My train had just pulled into Highbury & Islington Overground station. I was standing next to a young couple, a man and woman. He said: 'She thinks she's still in India.' It was summer, I was wearing a sari. He said it loud enough for the entire carriage to hear as I stepped off the train. Why recall this particular racist encounter, when there are so many others? No good reason – in a fundamental way they are all the same. There is a claim that racism makes, to know you better than you know yourself. You may think you are any number of things, you may find that you are contradictory or muddled, a bit lost. But the racist knows better. They know, for example, that you're dirty. Or that you don't speak English. That you're driving house prices up, and that you've come here

to have your babies on the NHS. When a train is over-crowded, or a queue is long, they know it's your fault. Your employers, the bank, the government expect you to tell lies and forge evidence. So you travel during storms. While you're sick, you allow a large man to run his hands over you and shine a flashlight in your ear just so that you can prove that you're not lying. The man on the train claimed to know what I thought. He wasn't an exception.

It puts a strange sort of pressure on the mind. I have found myself in long internal arguments against the imputations, gathering evidence and demonstrating why I am *not*, only to realise after many lost hours that I had nothing to disprove. Still, a shadow can remain. Am I she? There is an impulse towards a certain kind of legalism, the construction of a case for the defence, arguments polished and ready to be deployed. But what if you don't want to live in a court-room? You could try developing a kind of impermeability – just don't care. Or a kind of perfectionism – let me be irreproachable.

In drawing attention to these conditions, in protesting them, I found that it was more than likely I would be called crazy. And that I find difficult, because there is something about it which is true. There are parts of my mind that feel unknown, mysterious, unpredictable – I could say they feel mad. But how do you refuse the appellation of irration-ality and madness, while also holding on to the enigmas of the mind? There is a lot to be said about the ways in which being called crazy for pointing out a harm done

can produce a very mad feeling indeed. But I also regret the ways in which suggestions of craziness, and madness, can force a flight into the presumed safety of sanity, a wish to be an unruffled, even surface. I've needed Milner, and I've needed to be able to write to find a way of living with this contradiction, of making a claim to both – reason and madness.

In a racialising society, the loss of love, regard, work, patronage can all be consequences of showing yourself to be someone other than a grateful, accommodating person who is nothing but humorous and generous when confronted with ignorance and denigration. In wanting to have friends and lovers and job security, it can feel like too much of a risk to experience one's own jealousy, ambivalence, ambition and anger, because there is an uneven social distribution of who is allowed to reckon with these emotions – who is given the space and support to work through, and work with, these feelings. To be a migrant in a climate of hostility is also to be subject to a pressure to shrink my mind into something safer and more compliant. Reading *A Life of One's Own* has been a powerful reminder of the absurdity of such an endeavour, but also of the violence it would entail. In its exploration of Milner's work, and in its defence of leisure, my writing has been propelled by the wish to be allowed – to allow myself – to experience my mind and life in their full complexity.

Reading

I'm three years old, and the bed is vast, covered in razais. My mother is reading to me, from little hardback books with glossy pages and colour illustrations. I should be at kindergarten but I am sick. My mother has to go, she has something else she must attend to, but I want her to carry on reading. When she leaves, I pick up the book she has been reading from, and discover that the words still tell a story, even with her gone. I am content. On her return, at first she doesn't believe me, but when I read out to her she is excited, and promises to bring me more books. My mother works in a school, and she comes home with a stack of Ladybird children's books. When she goes to work, I stay in bed and read my books, one after the other. When my mother returns I am happy to see her, so that I can tell her about my books, and when she leaves I am happy, because I can read.

Lying in bed reading – this is perhaps my first experience of leisure. An obligation put off, a time that is my own. Even now, this is the first thought, the first wish that comes into my mind when I think of leisure. When I read *A Life*

of One's Own, when I became aware that I was following Milner's project, I thought I would follow her example in not looking for answers in books other people have written. And then I realised the futility of this, not least because my involvement in Milner's experiments in living had come about by reading, failing to read and rereading her work. Not just that. In my words, I hear the echoes of other people's words, and sometimes they are more myself than anything I could say.

Time Lived, Without Its Flow is a book by the poet and philosopher Denise Riley about her son's death that considers the impact of grief on the experience of time. She writes of a literature of consolation. I read her essay the year my brother died, on my laptop in a pirated online edition. It was one of the first books I bought when I moved to London. When I started psychoanalysis, I asked my analyst if he would read it. He did. It was a book that took what for me had been a painfully inarticulate experience, and made it into something that could be thought and communicated, and so offered to the loneliness of my grief the salve of understanding.

More often than not, it is other people's words that bring me to my own. I can't help but turn to books to figure myself out. But the books I've brought into my own writing aren't the same as the ones I've read to appear clever and well read. They often aren't what I *should* have been reading. These are the books of consolation, yes, but also of companionship, pleasure, good counsel and risk-taking.

And because Milner always belonged to this category of private books – writing that gets mixed up in living – I could never treat her solely as an object of research. Her words had a way of taking me to my words. I spent days in her archives, trying to make out her elusive handwriting in the many boxes of diaries and papers that she left behind, and in the end it led me to the unopened boxes in which I had stored my own diaries over the years. It has been impossible not to get all mixed up with her.

In *A Life of One's Own*, Milner describes different qualities, or styles of attention – a narrow focus, and a wide attention that wasn't fixed on any particular object. The narrow way of focusing was valued – from school to university to work, everyone spoke about concentration and working hard and discipline. At thirteen, I tried to cure myself of daydreaming by crawling under my desk every time I caught my thoughts drifting off. That's what the school counsellor had told us: 'Do something uncomfortable when you find yourself daydreaming to break the habit.' In contrast, wide attention was a way of paying attention with one's body and mind without channelling that attentiveness into an obvious focus. It was a way of being both relaxed and present.

Many times in my life, visiting a bookshop has meant that I have been able to start again, and it is often in bookstores that I feel something like ordinary hope – that I am not alone, that something else is possible. I like eavesdropping on conversations that shoppers have with booksellers,

because there is something inherently sustaining about witnessing people paying attention to each other, and booksellers often listen with curiosity and an openness to complexity that may be difficult to find in a doctor or a therapist. Like other people and institutions that play a vital role in our society, bookstores and booksellers are romanticised even as shops close down or workers are denied a living wage. The form of floating, diffuse attention–inattention that I associate with reading in bed, with browsing in bookstores, pulls against imperatives of productivity, of use. But I too have felt the pressure to turn it into something more utilitarian.

A few years back, I noticed myself feeling some kind of resentment or annoyance when I was in second-hand bookstores. This was weird, because I've always loved second-hand bookstores – they've always made it easier to try out a new writer, or a new hobby, because the stakes of trying something out are lower when it is inexpensive. It was in these bookstores that I found and bought copies of Milner's books as well as illustrated cross-stitch patterns and cookbooks by Elizabeth David. So what was my gripe? I felt that the bookstores weren't *ordered* enough, they didn't have catalogues, the books were miscategorised, something that was memoir had been shelved under psychology. I was busy, I only had my lunch break, I wanted to find what I was looking for! There is nothing wrong with second-hand bookstores, of course. The way I was feeling was a symptom of my life. I had too much to do, I had

forgotten how to take pleasure in leisure – or rather, I had wanted to make my leisure efficient, and thus I destroyed it.

I have come to realise that browsing in a second-hand bookstore provides a symbol, an exemplary experience of leisure as a mental state. Once I'm inside the shop, I am often reminded of interests and preoccupations that I have forgotten. I remember that I care about things, ideas, people that have nothing to do with my immediate concerns. I find that if I go to second-hand bookstores looking for something, I often leave frustrated. But when I go without expectations, I can be delighted and surprised. Before I knew it, or found the words to describe it, second-hand bookstores in every city that I've ever visited gave me a chance to experience the wide attention that Milner describes, the leisurely opportunity *to attend to something yet want nothing from it.*

3

On Becoming His Mother

After completing my doctoral studies, in the summer of 2018, I was desperately willing to fall in love, and did so successfully – sometimes with passion, at other times with diligence. Working in a series of casual jobs, I put in application after unsuccessful application for an academic job. On my twenty-eighth birthday I went for an afternoon walk with a man I'd met on a dating app. I invited him back to meet my friends for my birthday drinks later in the evening. He came, and in the following weeks we became a couple. We didn't know any people in common, and I can't remember much of our first date, except my immediate and visceral hatred of the coat he was wearing.

A few months in, we started to look for a flat to rent together. We weren't having much luck, till one day a viewing in Stoke Newington came through. The 'flat' was the top floor and attic of a Victorian house, with other tenants living on the floors below. The carpet was a worn rust brown, with a pattern of stains. The whole place was stitched together with stairs, every room on a different

level. One of the landings led onto a small flat roof. 'You can't step out,' said the man showing us the place, 'the whole thing might give way.' 'Can the cat go out?' '*No one* goes out – I'm going to put a lock on that window.'

What kind of roof can't hold five kilos of cat?

Next to the kitchen sink, there was a door to a storage cupboard. Opened, it revealed a bath. Above it dangled a cord for an exhaust fan, because there are no windows in cupboards. We said yes to the flat, and just as we were leaving I asked if it would be possible to change the carpet, and was surprised to receive an affirmative answer. We never met our landlady but she had an old Hollywood name and liked phone calls. She lived with her cat, and mailed us two contracts to sign. The second was brief and made out in the name of my cat. I felt touched by the recognition offered this former stray, and spent some moments considering if I should dip his paw in ink to 'sign' the contract. Then I looked at the new carpet around us and was reminded that he too was subject to contractual obligations – in the form of payment for any damage caused the flat by tooth or claw. The new carpet was a grey or beige depending on the light, with a surface of looped threads. The cat was endlessly occupied with getting his claws into the loops, and pulling up lines of thread. This brought me to my knees, pushing the threads back into the carpet with a needle (when I was fastidious), or with the point of a hairpin or chopstick (such an ugly carpet anyway). Clearly this was the wrong carpet for the cat.

I could see the neighbour's garden from one window in the flat. The attic bedroom looked out onto a jumble of roofs and chimney stacks. I have a memory of parakeets in the tree by the kitchen window. I loved every view in that flat, and though the cat and I looked at the roof with longing, the window leading onto it now padlocked, I didn't mind too much. There was so much sky to look at, I felt like I could live on light alone. I had a flat to myself. Though not quite to myself. I was insulted, but tried not to show it, when a friend described my domestic arrangements as a 'London move-in'. People in London couldn't afford independent housing, so once you were in a couple you tried to move in together as soon as possible. Or you were forced, by housemates, mice or regular weekend train cancellations. In these circumstances, desires for a room without damp, for guiltless baths hours long, were sublimated into romantic cohabitation, often with the result that romance fled and contracts remained. I was insulted because no one likes being accurately diagnosed as conforming to social type.

My father came from Jaipur to help me assemble an IKEA Nyhamn three-seat sofa bed in the new flat, though I insisted on calling it a futon due to an ideological opposition to sofas. In truth, he came to watch me wear a robe and graduate with a doctorate. We posed for a photograph in front of a canal bright green with algae bloom. A narrowboat cut a channel in the neon surface. In an act of

infidelity to my curly hair, that morning I had gone to the salon for a blow-dry. Where is your hair from? the hairdresser asked. Is it Brazilian? Happy to not be asked where *I* was from, I imagined my hair making its autonomous journeys, picking up the phone to book flights.

My father left. My boyfriend and I had an argument, sitting on the futon. He said he wasn't convinced by the idea that we all had an unconscious. In that moment, I couldn't remember, or articulate, what I even meant by unconscious, but I felt a strong attachment to the idea that we were in many ways unknown to ourselves. The thought of living *without* an unconscious was utterly dismal. My boyfriend was talking about choices. You *decided* what happened in your life. A year after I was born, the Indian government *decided* to open the economy. All through my childhood a debutante ball of new kinds of toothpaste. My brother coming back from a sleepover saying 'They had Pringles!' Did it make anyone happier? I was eleven at the time of the American invasion of Afghanistan and Iraq. That imperial excess left me with an aversion to what, at university in Delhi, the comrades called 'the American discourse of choice'. Freedom and choice weren't synonyms to me.

I realised I was not the kind of woman who could leave her boyfriend because his vision of the human psyche felt impoverished. How would I justify this? How would I tell my friends who didn't like him anyway? How would I tell my father who helped me assemble the futon? How would I tell my mother who probably thought I was living

in shame even though she didn't say it? The futon felt like it had much more of a claim to material existence than my thoughts or wishes. It had a click-clack mechanism for converting into a bed. It had a grey cover. The cover was washable.

If I had opened the diaries that were stacked on the lowest shelf of my baby-blue bookcase, I might have found a way to acknowledge to myself that my present situation was the product of my belief that romantic relationships were more necessary and fulfilling than my own sense of dignity or comfort. At twenty-four, I had written: 'Tomorrow he is meant to return and I know that I will torture myself over every day he takes to call me', and, 'Last night was an exercise in power by H. I will touch you, and draw you in, to establish that I have power over you, and then I will draw back – and seeing you in pain will reassure me that I have power over you because I can cause you pain.'

But I didn't open my diaries, because I found them, and myself, embarrassing. So I couldn't learn from my own moments of clarity or self-questioning: 'Men – seemingly self-sufficient but their use of me seems rarely to imply that I am separate from them, from their fantasy world of objects. And then I spin around and ask myself – what makes you the bread that waits to be fallen upon?' I had absorbed a cultural idea that the thoughts of young women are somehow cringey; I was trying very hard to leave the younger me behind, so I couldn't learn from her experience or observations. That's what I thought it meant to grow up.

I told myself that having signed a year's rental agreement with a six-month break clause, there were some things I couldn't afford to know.

Once I went to a Halloween party – I didn't have time to prepare a costume, but I hadn't done my hair for three days and decided it looked enough like snakes to claim I was Medusa. Sometimes the unconscious felt like Medusa's snakes, coiled and writhing strands of things I didn't want to know, was about to know, couldn't bear to know, couldn't avoid knowing. But the snakes weren't in my head. I think my *unconscious* was somewhere between my ribcage and pelvis, pressing up against my diaphragm. It wasn't abstract, intellectual or up for debate. It was an intensely physical knowledge. In other words, a gut feeling. And what was I doing with it? Pretending it didn't exist.

Soon after moving into the Stoke Newington flat, I took up a research position at a university, and thinking back to my pleasure at reading *A Life of One's Own* by the seaside, I made plans to study Milner's work. With my new research allowance I bought copies of all her books in academic editions, and began reading her again. Though I found pleasure and excitement in reading her work and discussing it with my colleagues, I also found something about her ideas slippery and hard to grasp. After struggling for some time with *A Life of One's Own*, I decided to move on to *An Experiment in Leisure*. I didn't fare any better. A fog would come over my mind when I tried to read this second book

of memoir. To make myself pay attention I started putting neon sticky tabs on every part of the book I found interesting, made a colour-coded index of themes, and diligently transcribed extracts. With its Post-its and sticky tabs, the book began to resemble a rainbow porcupine. I had visual evidence that I had read the book, but I would have struggled to say what it was about.

In diaries written before Milner published *An Experiment in Leisure*, she describes feeling *guilty in relation to myself, to my own preferences, if it put people out in any way*. As regards people she found powerful, she would *become what they want me to become or what I think they think I am*. Described by Milner as a continuation of *A Life of One's Own*, her second book was written in a period when Milner travelled by herself, to Malaga, Spain, leaving her husband and child in Britain. Her doctor had suggested that she needed a break from her work at a girls' school, and some time away from her husband, owing to strains in the marriage. She was thirty-six years old, and her job often took her away from home for several nights a week. A few years before, she had written in her diary about the pressure she felt to be *a good mother, a reliable worker, a considerate wife*.

Experiment begins with a premise that seems disarming enough – the book is her attempt to *solve certain aspects of the everyday problem of what to do with one's spare time*. To write it, she turned to her experiences of feeling interested and absorbed in something, memories with a *peculiar warm*

quality. She also wanted to test if her feelings were reliable. *I had decided therefore that my experiment with leisure interests might also provide a way for studying certain feelings and might show me under what circumstance they were to be trusted, if at all.* She wrote, at the outset, that this was not a book for everyone. There are people, she said, who know who they are, they have opinions, they never wonder what to do with their spare time. But there are also other people, *who are less certain in their attitudes, who are often more aware of other people's identity than their own, and for them I think the problem is real. For them, and very often they are women, it is so fatally easy to live parasitically upon other people's happiness, to answer the question – 'What shall we do today?' by – 'We'll do whatever you like, my dear.'*

I was unwilling to recognise myself in Milner's description, because it was too close to the bone – but the psychic effort of maintaining the disavowal of my feelings was so great that it made it almost impossible for me to understand what she was saying. As I wasn't getting very far with reading Milner's books, I started visiting her archives. These were held at the British Psychoanalytical Society in Maida Vale, in a building with an eerie level of sound-proofing and multiple security doors. Though my purpose was to understand her influences, to find out which books she was reading, what really interested me were the diary entries in which Milner wrote about her marriage. She had married Dennis Milner at the age of twenty-seven, and not long after had begun to experience doubts about

the marriage – questioning their suitability for each other, the restrictions imposed by monogamy, but feeling herself bound to him, not least because of his ill health.

Reading through her diaries, I was particularly drawn to instances where she described her discontent. *That he should have married me, for anything but the most romantic notions. That I should have to suffer his spite against woman (against his mother for not giving him the love he needed).* She hated him, she felt for him, she was embarrassed by him, she wanted to please him. Leaving the archives, I went for walks by the canal in Little Venice, comparing my relationship to her marriage.

I used the discontent in Milner's marriage to justify the feeling of unease I had in my relationship. Surely all relationships were unfulfilling, and had to be accepted as such? One of my favourite novelistic voices is what I like to think of as the 'first-person evasive', where you can sense that the person telling the story is missing something crucial. Sometimes only you, the reader, can see the significance of what is happening in the margins of their awareness, and at other times this peripheral knowledge jolts the narrator. Because the story is told in the first person, the novelist must convey what escapes in the narrator's own voice, too. The plot may head to a denouement where what has so far been held at arm's length arrives home, dramatising the failure to keep certain facts out of view. In other instances the evasion is sustained from beginning to end, with no final reckoning.

Maybe I enjoy these novels so much because they help

me recognise a drama that is always unfolding in my own mind, a kind of movement between things that are forgotten and resurfacing, thoughts that have been hastily set aside or aggressively pushed down, premonitions of things that are yet to come, memories that surface with all the quality of prophecy. Living in the flat in Stoke Newington, visiting the archives in Maida Vale, scanning Milner's diaries for news about my relationship, I was living in full immersion in the first-person evasive.

I wanted my boyfriend to marry me. Opposed to the institution of marriage, I didn't want to be a wife, but I was intensely aware that my work visa was time-limited, and I wasn't certain if I'd find another job before my immigration permission expired. Being married was a way of staying in the country where I was making a life. Perhaps the only way that felt reliable. This subjected love, desire and the knots in my psyche to the crudest forms of arithmetic. There wasn't enough time left to meet someone else, I *had* to love my boyfriend. I *would* love him. I *did* love him. *Was* I in love? I asked myself this question often. I always wanted the answer to be yes. It helped that I could change what I meant by love to suit how I was feeling. Did I feel *we are young together, immensely young* as Milner did about her husband? (No, I didn't.) *My daydreams are nearly all of country cottages, of little gardens, of 'settling down' with flowers in vases and coloured curtains.* (I had these dreams, too, and now I had the vases, flowers and blue cotton curtains.)

My boyfriend was still deciding about marriage. He wasn't against marriage, like I was; he felt there was merit to the institution. But he wasn't sure if I was the right person. There were things he knew I was good at, like cooking, thinking, and choosing fabric and furniture. And then there were things I was bad at: sex, reining in my anger, being who he wanted me to be. Sometimes it felt like I only had to make a little effort, maybe a little effort more, and all would be OK. Maybe he thought, with his fidelity to the idea of choice, that I wasn't choosing to make the right efforts. What kept me from trying, just a little bit more? Why couldn't I just comply? Maybe, like Milner, *I was faced with the paradox that perhaps what I most wanted to do was not to do what I most wanted to do.*

I had got myself into a fix. Questions about what was wanted of me, and what I ought to be doing, clouded my capacity to think of what I wanted, or needed. Writing *An Experiment in Leisure*, Milner was soon immersed in memories of her childhood and adolescence, and the book quotes from a nature diary she kept when she was about twelve years old. As she tried to *reach an adult standard of independence in thought and action*, she found her mind flooded with images from *apparently infantile ways of thinking*. I couldn't understand the significance of what Milner describes in her book without thinking back to my own childhood and adolescence, and letting my own memories surface. To read Milner, I had to allow for a

free interplay of memories and associations in my mind. I realised that recollections from my past were returning to me as a means of guiding me through the present. *And I was also finding that they did not come shamefacedly, as with a sense of something I should have outgrown, but with a sense of power that beckoned me onward.*

I broke up with my first ever boyfriend after opening a book of Emily Dickinson's poems. I told him he wasn't *deep* enough. A few days earlier, I'd been standing at a book fair in a school hall that, in a total failure of imagination, was called the 'multi-purpose room'. Next to me was my best friend, my soulmate, my most trusted ally, the one who made school and family and small-town life bearable. She always wore the pinstriped shirt of our weekday school uniform closely tucked into the grey skirt. I was always pulling my shirt out in imitation of other, seemingly cooler, girls. *Deep* was our measure of intellectual achievement and profound emotion in writing, film and music. The ending of *Casablanca*, which we watched many times over, was deep. So was the compilation of Simon and Garfunkel songs she had burnt onto a CD for me. We never thought to ask what we meant when we called something deep. Maybe what we were trying to say was that when something was deep, like listening to 'Bridge Over Troubled Water', or talking about it on the phone late at night in the dark, it simply stirred something in us. It touched a part of ourselves that we would later learn to call the unconscious.

At the book fair, there was a small section among the

makeshift shelves marked 'poetry'. I picked up a book and began reading. I thought of my boyfriend, I didn't suppose he would *get* this writing, which was so pleasurable and exciting to me. I thought: I should break up with him. I then conveyed this to my friend, and she said, yes, I know *just* what you mean. In fact, when I opened the book, I mistook the contents page for a poem. I was at the stage of life and experience where I couldn't tell a list from a poem, and assumed it must be usual for lines to be followed by little numbers. I can't say for sure, but that may have been the first book of poetry I had ever opened. Of course, the lines didn't make sense, but understanding was overrated – I *got* it. And he didn't.

Only a few minutes had passed since I picked up that selection of Emily Dickinson's poems. I had already decided to break up with my boyfriend. I'd also realised, to my embarrassment, that the contents page of the book was not a poem. But it is *like* a poem, my friend and I agreed. She gently restored my lost confidence, and soon we were in giggles, lost for words, because we'd found the most *amazing* poem.

> I'm Nobody! Who are you?
> Are you – Nobody – too?
> Then there's a pair of us!
> Don't tell! they'd advertise – you know!
>
> How dreary – to be – Somebody!
> How public – like a Frog –

To tell one's name – the livelong June –
To an admiring Bog!

It was a poem about us! About our walks during break time, during which I ate the contents of my tiffin box and also a portion of hers, about how we felt about the world, our distance from the people around us, our secrets, our privacy, our wish to be separate from everyone setting out to please a teacher or win a medal, like my boyfriend with his impeccable reputation. And in that moment it was clear, perhaps the clearest it's ever been to me, that what mattered was poetry, friendship, gossip and deep thinking. Boyfriends were incidental.

A few years before Emily Dickinson made me break up with my boyfriend, I had read a story about a boy who runs away from home and starts living in a room built on the roof of the house of the people who take him in. The adults are downstairs, and the boy has access to a whole new world of animals and people through his new living quarters. The story set off a chain of fantasies of a rooftop room of my own, where I would find ways of encouraging squirrels, babblers and mynahs to be my friends. I furnished it with a desk and typewriter. The house in Jaipur had just the kind of room I wanted – it was on the roof, with an attached bathroom. To access it you climbed the outdoor stairs to the roof which were shaded by a large, hospitable tree always home to nesting birds, and walked across the flat hot concrete surface to the set of padlocked

double doors. My mother used it as a storeroom; there were metal trunks filled with winter clothes, wedding clothes, old papers, furniture that hadn't found a place in the house downstairs, broken things. Going in always required some courage – the room had a high probability of geckos, spiders and mice, and it smelt of the dark. Over time, my life in the room on the roof became more real to me, and much more elaborate. I was convinced it would cure the unhappiness and bad tempers that were the miasma in which I walked and breathed. Already, in my mind, I had moved into the room upstairs.

So convinced was I of my new living arrangements that when I spoke to my mother about them I had trouble understanding that she was saying that I would *never* live in the room on the roof. But I already lived there! Who was she to refuse? But *why*? My mother looked at me as though I was a creature of infinite stupidity. *Of course not*, she said. For my mother, it was common sense that I couldn't live upstairs, unsupervised and independent. What I didn't know then was that I too would take this idea of common sense inside myself, and that later in my life it would stop me from taking risks that were necessary for living a life that felt like it was my own.

I didn't tell my mother that my wish to live on the roof came from a story I'd read. My parents were always accusing me of 'getting ideas' from books. 'It's given her ideas,' one parent might say to the other. There was something very wrong with getting ideas; my parents spoke of them like

they were lice or scabies, unwelcome things that you weren't supposed to bring home. Some people (like me) were always getting ideas, and other people (my parents) were upset about this. Reading books, watching films, observing people, and later, going to university, living in Delhi – these were all things that had at some point or another given me ideas. I was always a bit afraid that they would somehow be forbidden in some project of idea-disinfection. You can't keep reading, it's just giving you ideas; she can't be your friend, she's giving you ideas; you've come back with all these ideas from university. And yet these were the same people who spoke at length about the virtues of *educated* people, and used *cultured* as a compliment. Being cultured and educated was the same as being from a good family, though it was different from having money and certainly not the same thing as having ideas. I thought it best to exercise some discretion about my ideas – if they escaped me, I could at least try to conceal their origins. I was only partially successful, because I tended to be upset when these ideas were misattributed. Delhi, for example, could hardly be credited as the source of thoughts that had long been fermenting in Jaipur.

Since my parents were the ones who bought me books while I was at school, I tried to pretend that the books I read didn't really change me. I decided that I could *have* ideas, as long as I didn't visibly *get* ideas. It was in the jumble of these adolescent years that I first read Virginia Woolf's *A Room of One's Own*, which helped me understand my longing for

that room on the roof. But it didn't explain why that room had to be on the roof. My brother had left for university, so in practice I now had *two* rooms of my own in my parents' house. They each had two sets of doors – solid wood doors, and then a frame with wire mosquito netting. We rarely closed the wooden doors, so everyone could sort of see what was going on in each room as they walked past it – but it was permissible to draw the curtains, and the frame doors would make a little sound when opened, about three seconds' notice before anyone stepped inside. I knew the doors well – I had learnt all their sounds because I liked to read *Middlemarch* instead of studying for geography exams.

Between the door creaking and a parental gaze directed at me, I usually had enough time to hide the novel I was reading, by wedging it between my knees and the desk, or stuffing it down my clothes. I may not have been able to close the doors to my room, but my mother had let me pick the colour of the curtains, and the cushions on the bed. Punch-drunk on freedom, I had chosen fabrics in bright red and yellow, arranged in an alternating pattern. The overall effect was appalling, an unabating fever dream. It was perhaps an early intimation that finding out what I liked meant I would get things wrong, and that instead of fearing this, I would have to accept these mistakes and failures as part of living my own life.

Growing up in Jaipur, I often had a strange, inexplicable feeling. It was a mix of resentment and contempt for the Aravalli Range. In geography lessons at school, I was taught

that these were *old* fold mountains, once much higher than what the eye could see in the present. Now it was their time in life to sink into the ground and become flat. In contrast, the Himalayas were *young* fold mountains. They're still rising. As a child, all my excitement was for the Himalayas, for the smells of pine and cedar preserved in my memory from the two, maybe three times I had travelled there with my family. Ferns underfoot, fruit on trees, the discovery of lychees, intact pine cones, rivers that were not dry, not even flat and stately, but cascading, tumbling. The Aravallis were home, mountains that were now hills. Dry, bare, scarred by quarrying. Contempt and sadness and regret when I looked at them.

I felt for the Aravallis feelings that more properly belonged to the world around me, which was also an old fold society. Interminable conversations about the past. I had been born into a faded aftermath. The present was reduced, and compromised. In the past, someone had fought a tiger with a sword, and won. Now we were pre-occupied with whether cheese sold in tins was cheaper than cheese in cubes. Adults sitting with their tea. It seemed they could all still hear horses in stables long gone, the fourteen elephants of wartime. None of the families I knew took part in any anti-colonial organising. The past was uninter-rupted, narrated in the tense of decline continuous. Then the first McDonald's opened in Jaipur. The children all gathered for a visit. Who dared to ask for a *Happy Meal*? Helpful to have mountains to hold heretical thoughts.

Even as I write this I hear my mother's voice saying that's not how it was, that's not how it is.

For a long time I had guessed that the difficulties of the 'good' child were just as serious as those of the 'bad' child, perhaps more so. For as a 'good' child, I had never learnt not to mind hurting or displeasing and so had never accepted my own power to hurt or realized that to please everyone is spiritual death. Like Milner, I'd learnt to keep my ideas to myself, I'd put my feelings about the world around me into mountains, and all this was good, because anything else attracted too much attention, felt like too great a risk. Last year I was speaking to my younger cousin and she said her mother had asked her why she was unhappy, since they'd let her paint her room in a colour she liked, and select her own furniture. It struck me then that there was little use in having a room of one's own if you could not have a life of your own. Growing up, I could see that the women of the bourgeoisie had all the rooms they wanted, but, at least to my eyes, they didn't seem to have their own lives. If you were mistress of Pemberley, but it was someone else who decided who you could have coffee with and what time you had to be at home, then surely rooms weren't the only necessity for an independent life? If women could have streets and wild fields and mountains that were theirs to roam and think and write, then maybe they wouldn't even want to stay in their rooms. If I had been offered a choice, even as an adolescent, between a *life* of my own or a room, I know what I would have chosen.

Though I had known all this at various points in my life, I didn't know it any more. Within two months of moving in with my boyfriend, I'd bought at least three vases. I kept making trips to the British Heart Foundation's charity shops to look for furniture. Once the boxes of books were unpacked, and my boyfriend's creaking wardrobe had been carried on the shoulders of two men up into the bedroom, once the laundry basket began to overflow and there were leftovers in the fridge, then I turned to Marie Kondo, folding my clothes into chubby envelopes. The 'common sense' which had been imposed from without in childhood and adolescence now acted from inside of me. In becoming concerned with things like the future and security, I'd forgotten something of what animated me and lost a spontaneity of thought and action.

Like Selin, the protagonist in Elif Batuman's campus novel *The Idiot*, one summer at university in Delhi I cut my jeans into shorts. I also bought myself a T-shirt with Warhol-style pop-art pictures of Amrita Sher-Gil, Bob Dylan, Billie Holiday and Akira Kurosawa. I could have done without Dylan and Kurosawa, but I was delighted with the two women, whom I admired passionately. I felt like something important and true about myself had been made exterior in that T-shirt. My parents played no part in the choosing of it. I was going to wear my T-shirt to class with the cut-off shorts but noticed I hadn't shaved my legs. Unlike many of my university friends, I never got into the habit of regularly

waxing my legs and arms because the procedure left me
with itchy bumps on my skin. My mother had treated the
onset of my adolescence with a degree of dismay. Bras!
Palaver. Hair! Tedium. So my relation to femininity was
more one of deferral than deference.

To the end-of-corridor bathroom it was, razor in hand.
I shaved each calf in turn, then navigated the knees. A
few inches up my thighs, and the boredom was unbear-
able. Why should I be shaving my legs when I could be
sitting with my friends? And why should I be late for my
class because of the hair on my legs? I put the razor down,
washed my legs and pulled on my shorts. Sitting on the
bench next to me, my friend looked at my legs. I followed
her gaze. Below the frayed edge of the shorts there were
three dark inches of hair, then an expanse of smooth skin
till my ankles. I thought the consecutive gradations of
colour and texture were quite pleasing, in their own way.
What have you *done*? my friend said. I looked at her face.
Dismay, horror and concern for my welfare. I got bored, I
said. But you can't *do* that. You can't do it. But there I was,
doing it. My friends didn't stop being my friends. I had
such a good day.

Years later, when this memory came back to me, I was
filled with embarrassment, just as I was when I looked at
pictures of myself when I was twenty-one (the back of my
head shaved off in a barbershop buzz cut that I didn't have
the courage to see through to its conclusion). I was now
my friend. What have you *done*? You can't *do* that. Trying

to push the memories back into the snakepit from which they emerged.

In *A Life of One's Own*, Marion Milner describes a visit to the zoo. Looking at the desert mice, she felt a strong wish to have one as a pet. They were for sale, but it was a Saturday and the official in charge was away. *But I was not to be put off and surprised myself by the urgency of my determination to get that mouse.* She succeeded, and took the mouse home. *I had not minded what other people thought, so strong had been my own urge.* In the past when I read this passage, I pictured Milner as a little girl, carrying a mouse home. Maybe it's because she mentions other childhood pets – dormice, lizards, white rats – while telling the story of the mouse. But reading it now, I see no reason to assume Milner is speaking of herself as a child. So I picture her, a woman in her late twenties or early thirties, perhaps wearing the French students' overalls that she describes buying earlier in the book. She is taking the mouse home. So now, in the image in my mind, Milner the child and Milner the woman walk home together, each carrying a mouse, the mouse's nose twitching.

When did I begin to think that growing up meant sawing off my wishes and wants? What did it even mean, to be an adult? There seemed to be some kind of unspoken law operating – that adulthood meant surrendering the fantasies and hopes that had been so sustaining in childhood and adolescence. I didn't know if everyone felt like this, but I was becoming aware of a voice in my head that

kept saying things were *childish*, as though that were an adjective of condemnation. Once I had begun to successfully sever myself from the wants and passions of childhood, it was unbearable to even think of them, to think of the loss. And what if I'd lost not just my wishes but also my capacity to wish and want?

When I look back and see myself abandoning my legs mid-shave, I see a kind of thinking in action. I can't remember how much feminist writing I had come across at the time. I was eighteen. My boredom posed some fundamental questions: how should a woman spend her time? How does a woman navigate the expectations placed on her body? And there was a way in which my body and mind worked in tandem, making a decision that responded to those questions, however unconscious they were. There was no agony. By the time I lived in Stoke Newington, there was nothing particularly arresting about my appearance. In the summer, I made sure to depilate carefully. My hair was long. None of this was particularly important or worrying. But alongside these adult habits, there had grown a gap between thinking, wanting and acting. I thought I had so successfully civilised myself, but what had I lost? Milner's books hum with descriptions of childhood. Woman, child and mouse walk together. This was not the case for me.

A few months before I moved into the Stoke Newington flat with my boyfriend, I got entangled in what felt like

never-ending paperwork around immigration permissions. I was at the end of my studies and my migration status was about to change. Putting in applications, I was afraid of errors, aware that any slips could change my life. *Hey hey, Theresa May, how many lives did you ruin today?* I couldn't remember the protest where I'd first heard that chant – there were too many occasions to use it – but it looped around my head as I filled out forms, and read stories in the news about officials in the immigration department being given targets of how many applications they had to reject. I didn't want to *go back to where you came from* just because someone in an immigration office was in a rush to meet their quota of refusals.

Then the seemingly inevitable happened, the obvious plot development that I had been trying my best to put off. An application was rejected, a letter arrived in the post threatening deportation. The official routes into getting papers that allow you to live and work in the UK are all designed to keep people out. In addition to this basic purpose, they also function as a class-filtration system. To extend my student visa, for example, I had to demonstrate that I held more than £2,000 in my bank account, consistently, over a period of months. But who has that kind of money on a university teaching assistant salary? I certainly didn't. Each month, I exhausted what I earnt, cooked lentils and walked everywhere the week before payday. Class, however, is generational, and the migration system acknowledges this. I had the option of submitting

my parents' bank statements, and if they had the money, and were willing to write a letter, I could stay.

At university in Delhi, I would go and listen to lectures by feminist activists. They often argued that the state in India functioned as a powerful extension of the patriarchal family, punishing women for sexual or moral transgressions. Women wanting to escape their families, often at risk to their lives, found that they had to contend not just with relatives and communities, but also the far-reaching network of the state. I realised that the UK migration system did something similar. If you were a woman without money in the bank, you had to either turn to your family or find someone to marry you. And the person you married had to show their money to the immigration office. It seemed designed to ensure that people who migrated from the Third World via these official channels would form no relationships of class solidarity with people here who perhaps shared the colour of their skin but not their wealth.

My parents had money, their bank statements were in English, but the immigration departments had targets. I read the decision letter which said I hadn't demonstrated adequate financial provision, looked at my papers and saw that they'd made a mistake. My boyfriend said he would visit me in India if I was deported. Over the years, English boyfriends had always reacted with similar insouciance to the alarm with which I approached each visa application. It had been difficult to find solace in such easy assurance and I set no store by my boyfriend's words. It took a long,

worried time to reverse the decision, and in the meantime I found a three-year research grant that would sponsor my visa. There was a sense of resolution, but I didn't realise till many years later that, long after that period, my mind still remained in the defensive foetal position which it had adopted during that time.

This state of mind made it difficult to move easily between thoughts of the past and present, and it made me anxious for security. When I tried to think of Milner's descriptions of a wide focus of attention while living in Stoke Newington, I noticed something clench inside of me, a revolt against the kind of relaxation Milner describes. In the many untabulated losses resulting from the hostile environment policy, not being able to understand Marion Milner's ideas may perhaps be the most inconsequential. I couldn't read those books because worry had wound me tight. I'd started by defending myself – successfully, as it turned out – against the uncertainties and degradations of migration paperwork. But I'd pushed away the doubts and questions that came from inside me, found them too threatening. I wanted my mind to feel safe, and certain, when the world didn't. There were costs, though, in trying to secure and make predictable what by its nature was a changing, impetuous thing. I was trying to flatten my soul.

One May, the year after I moved to London, I wrote in my diary: 'I want to go on sitting like this in the sun – almost as though I want nothing, want for nothing, body sensual,

ready to receive. But I know that this too is an act – an act of relaxation that could convince even me. I know there is something in me wound tight that stays that way – I am playing at leisure. But even so, there is something to cherish in this expectant languor. This should be a beach. There should be sand between the thighs. Not this cold wind that says London, May, London, England. There should be a man. I want to be an object.' I thought at the time that the presence of someone else through sex or companionship could turn my playing at leisure into something that felt authentic. It could transform the chill air of London into a tropical paradise. The word 'object' conjured a glossy, rounded equanimity. There was a lack in my leisure.

On my twenty-ninth birthday my boyfriend took a photograph of me. I'm standing by the window, my hair comes down to my waist. All morning I'd been washing my hair in the bath cupboard, and my arms hurt from detangling. I'm wearing a new skirt. That evening after work I went to the pub. The feminist historian Sally Alexander was there, we'd been at the same seminar. A film had just been made about her, and about how she had disrupted the Miss World beauty pageant with flour bombs. She wrote about psychoanalysis, and for me and many of my colleagues she was the object of a long-standing crush. For many years, I had observed her hair from the back row of seminars convened by her. It was always pinned in some indecipherable and exceedingly beautiful yet casual arrangement. She said she liked my skirt. It has pockets! I said.

Without pockets, replied Sally, you're only really half alive.

On Valentine's Day, a few weeks before this birthday, I had discovered that my boyfriend had cheated on me. For some time our sexual relationship had been the fraught site of conflict and pressure. Our relationship played out against the backdrop of a widespread social reckoning with the unwelcome sexualisation of women and harassment at the workplace. I was confronted with my own sexual history, and grim and demeaning situations in places I'd worked. This meant that my feelings about sex, and how I had sex with my male partner, were shifting around. For my boyfriend, something about this was illegible, and a source of frustration. He was of the opinion that there was something wrong with me, and for that 'something wrong' to be righted would mean I would want sex with him in the ways he wanted. He gave me a book on tantric sexual technique, and when I refused to read it he was irritable and cross.

The difficulty also was that I was inclined to see my sexual desire not as my own but as somehow secondary to my boyfriend's, because he had a clear and strident idea about what he wanted and where his pleasure lay, and I didn't. My boyfriend explained his decision to have sex with someone else, and to conceal this from me, as arising out of our sexual circumstances. A need that I hadn't satisfied had been met elsewhere, so his argument went. We fought about it, we made up, and a few months later, because he found our sexual relationship unsatisfactory and

lacking, my boyfriend and I decided to *open* ourselves to other partners. Though 'decided' isn't quite the right verb. I thought of the women of whom Milner writes at the beginning of *Experiment*. The ones who answer other people's questions with *whatever you like, my dear*. The ones who found it *fatally easy* to live on other people's happiness. Fatal, easy but also ever so difficult. And yet it still seemed easier than thinking about what I wanted and acting on it.

The terms of our *openness* were skewed. He said something about feeling jealous if I gave to another partner what I *denied* him. And I felt too alienated from my wants and wishes to make any assertions on behalf of my own sexual desire. It was easier in many ways to think that perhaps I didn't have any desire at all. Sex, like leisure, can connect us with a part of ourselves that doesn't easily find expression elsewhere. But as was the case in my relationship, sex is all too often caught in a net of obligation and demand, and thus severed from its promise of release and renewal. My relationship was open, but if I had sex with someone else it was also likely over. He said I'd be like his mother if I stopped him from seeing other people. Time went past, it felt like our new arrangement had been forgotten. Then one day he announced he was going to spend the night with a lover. He wanted to ask me if it was OK, but if I said no, I'd make him feel just like his mother made him feel. So much of my life had been spent disentangling myself from my own mother that I hadn't considered the possibility that I could end up morphing into a white woman in

the English countryside, set against a background of sheep and cows.

I said OK. It was difficult, it was fatally easy. It was his insistence on having breakfast with his lover that tipped me over the edge, though to be fair I think the edge had long since gone missing. Or maybe it was the unreal feeling of being entirely inhabited by the spectre of his mother. I knew too that I was responsible – that in being pliable, in pushing myself to the limits of accommodation, I had put myself in a place where I was interchangeable with another woman who was also resented. That night, I took his books off the shelves and threw them on the floor. I took his shirts out of the wardrobe, took them off the hangers, and left them in a pile. And then I looked at all the surfaces on which I had assembled books, vases, dried flowers, the stones and pebbles inspired by a visit to Kettle's Yard in Cambridge. I picked these up too, but gently. I put them all on the dinner table, where they formed a surrealist collage of domestic life. I realised, in that moment, something that should have been obvious all along. That the house I had made I could also take apart.

Even though I had moments of clarity about my wishes and capacities, I was still inclined to obfuscate what I desired, or to think that the change I wanted in my life would come through someone else, or through a fated event. It was easy for me to occupy a position of waiting. And so months passed, and I stayed with my boyfriend. One day I was lying

on the futon, alone in the flat. My back hurt, my breasts were sore, I felt bloated. My period was late. I loved the flat when it was empty, and I sank into a reverie. Maybe I am pregnant, I thought. I was happy, almost floating. Now my life can change, I thought, now my life will change. The test was negative, the blood came later that night. But my life *was* changing. Something shifted when I took those vases off the shelves, even though I put them back a few days later. I had asserted myself; in my anger and distress I had acted on my desire. I could read more of Milner, it didn't feel as difficult any more. I started reading a lot, in fact. One novel after another, all by women. Reading makes it possible for me to write. I started thinking again about what I wanted. Maybe it *was* childish to want to be a writer, when I had left it this late. But the years stretched before me, and I didn't know what to do, if not what I wanted. I was beginning to realise that it is hard work to live a life estranged from my wants. Fatally easy. Fatally difficult.

In *Experiment*, Milner describes a practice that, for many years, I found terrifying. I think of it as her 'nothingness gesture'. *Whenever I felt the clutch of anxiety, particularly in relation to my work, whenever I felt a flood of inferiority lest I should never be able to reach the good I was aiming at, I tried a ritual sacrifice of all my plans and strivings. Instead of straining harder, as I always felt an impulse to do when things were getting difficult, I said: 'I am nothing, I know nothing, I want nothing,' and with a momentary gesture*

*wiped away all sense of my own existence. The result sur-
prised me so that I could not for the first few times believe it;
for not only would all my anxiety fall away, leaving me serene
and happy, but also, within a short period, sometimes after
only a few minutes, my mind would begin, entirely of itself,
throwing up useful ideas on the very problem which I had
been struggling with.*

How could I wipe out my wants when they were so pre-
carious to begin with, their voices so hesitant? Isn't that
what people seemed to want of women anyway? Gestures of
self-sacrifice and erasure? Wasn't this nothingness precisely
what I confronted every time I thought of my immigration
permission ending? Yes, I was lucky – nothing bad awaited
me were I to leave England. Life there was no worse than
life here. I didn't belong to a persecuted minority. I wasn't
in any danger. But none of these thoughts were consoling
when I was asked to leave. I felt betrayed by Milner. She'd
helped me rediscover my wants, and just as I was beginning
to pay attention to them she'd led me to a precipice and was
asking me to jump. I didn't jump. The gesture of nothing-
ness was not for me, I decided. I didn't know then that in
a few years' time this mental trick would become an indis-
pensable tool in distinguishing my own desires and wants
from the demands of others.

On my thirtieth birthday, my boyfriend and I fought
because I wanted to stay home and get a takeaway, and
he wanted to meet his colleagues after work, at the pub.

A part of me knew I was interesting. After all, I had just finished reading Rebecca West's unfinished *The Fountain Overflows* trilogy. *And* it was my birthday. But once again, I was his mother. Asking him to come home, to be good, to be loyal, when what he really wanted . . . He knew I didn't want to be his mother, so why act like her? The birthday present he got me was expensive. Creams and bath stuff, beautifully packaged. I had shopped from the same store for his mother's Christmas presents. I felt firmly lodged in his mind at the same spot as his mother. I lay on the futon and cried, waiting for him to come back from work. There was no takeaway that night.

But I wanted so little, I thought. I didn't ask for much. Then I was angry, and threw some books on the floor. It was getting repetitive, all this throwing of books to the floor. It was always books, as though I was trying to remind myself that I too could overturn something (the books that represented my boyfriend's views and opinions) with my body and my thoughts. That my thoughts mattered, that they had power, that they could turn into action. And I was beginning to wonder: why *did* I ask for so little? Becoming my boyfriend's mother – this felt both mysterious and like some obvious destiny picked out from the pages of a newspaper advice column. I couldn't see my complicity, my own responsibility. What was I doing to myself to become so easily assimilated to an image in someone's mind? I was a woman, not a blank slate. I could push back. I could refuse. I could use my legs, and walk. Instead I practised the clichés

of coupled-up domesticity, even though they were painful, and tedious, because this felt easier than thinking about my life – because being in a relationship felt grown up, because it felt like common sense.

On my visits to Milner's archives, I would look at the balconies of the Maida Vale mansions, wondering about the people inside. Who lived there? Maybe someone from an Anita Brookner novel. I had recently read *Look at Me*, bought at Waterloo Station while waiting for a train to see my boyfriend's parents. The heroine is lonely at the beginning of the book, and lonely in a different way when it ends. I began seeking out novels that ended with women being by themselves. I began to think of a novel I wanted to write. I wasn't sure what it was about, but I knew it didn't end in marriage. In *Experiment*, Milner writes about discovering *the futility of hoping to find the solution to one's own problems all ready-made in another person, on whose wonderful qualities one could live parasitically forever.* In *A Life of One's Own*, when she is dreaming of country cottages, she also says: *I want to write books, to see them printed and bound.* Something was stirring inside me and gathering shape. I didn't know what it was, but reading Milner I felt like I could trust myself to it.

On her return from Spain, Milner wrote *Experiment*, which was published the following year, in 1937. Milner concluded her book with the importance of understanding *our feelings better, to know what we really want*, and to find a way of being *alert to the changing seasons of inner*

need. The gesture of nothingness, which I hadn't yet learnt to use, became for Milner a way of distinguishing her true desires from imagined pictures and ideals of herself. In 1938, she began going to psychoanalysis, and was herself accepted into the training programme for psychoanalysts. It was a time of great anxiety and worry. War was imminent, and in the agony of those years Milner found that she couldn't always remember her own revelations and insights, recorded so eloquently in her book. When war was declared she embarked upon her next project, the free drawings that would form the basis for her book *On Not Being Able to Paint.*

Looking back on this time in *Bothered by Alligators,* her last book, Milner describes a divorce of great elegance. *Dennis and I had many enriching times during our sixteen years together, but I had come to the conclusion that it could not go on, and that we had both married for the wrong reasons.* A few days after my thirtieth birthday, in the midst of an uneasy peace, my boyfriend and I went to watch a film. The Rio cinema was just a ten-minute walk from where we lived, and that evening it was showing Céline Sciamma's *Portrait of a Lady on Fire.* I didn't know anything about the film, but not long after the screening started I knew it would do something to my life. My boyfriend and I were holding hands. I disentangled mine from his.

At the end of the film the two lovers, Marianne and Héloïse, attend a concert, separately. Héloïse is now married, and for the final minutes of the film we watch

her crying to Vivaldi's 'Storm' – a piece Marianne played her during their brief time together. Watching the film, I kept picturing the face of my girlfriend at university. And I knew I wasn't in love now, because I knew what it was like to love, and I had just been reminded that this was not it. I started crying in the final minutes of the film, and tears kept flowing, past the shops and the Turkish restaurants, all the way home.

The question of what to do with one's spare time can't be answered with an activity – go kayaking, learn to crochet. This is merely to defer the question, which when posed and addressed meaningfully and honestly requires a passage through our wishes and wants, a revisiting of child-hood interests and adolescent passions, it involves exam-ining our systems of morality and attendant ideas about what is good and worthwhile, and it makes us confront the politics of our time, which may have a relationship of uncomfortable proximity to our wishes. Recognising and situating ourselves in all these questions also means acting as though all these things matter.

Quite unawares, I was living in a state of waiting and deferral when I read *Experiment* over the course of two years, as though someone else was going to tell me how to live, and what I wanted. I would have denied it if someone had suggested this to me, because I liked to think of myself as independent and liberated. But reading Milner con-fronted me with the gap between how I liked to see myself (and thought other people saw me) and the deep-rooted

positions of passivity and deference which, unknown to me, guided my decisions. Thus I came to occupy the familiar position of a woman who appears to be confident and capable, but who, often inexplicably, remains in a relationship or milieu where she is unsatisfied and disregarded. It was only by recognising this split in myself that I could embark upon posing the question of what I truly desired. This included how I would live if I accepted that my time belonged to me not to an imagined other, who by virtue of the knowledge, authority and power I had attributed to them (often simply because they were anyone but me) seemed to have more claim or right to my time than I did.

Milner's *Experiment* isn't a book about ease and calm and the absence of worry. I found in it images of volcanoes, devils and witches, ritual sacrifices, a giant centipede. *Fires tearing and rending the earth, upheavals.* Much like the scene in Sciamma's film when women gather in the dark around fires to speak and sing, and Héloïse's dress catches fire. When Milner embarked upon the question of figuring out what to do with her spare time, she didn't find the answer in the leisure of hobbies, making a nice home, the consolation of pleasant distractions. Those things have their merit and place, but at the heart of Milner's *Experiment* is *the titanic force of desire.*

Listening

I have no musical talent. At school, I discovered I couldn't sing. Sometimes, when the music teacher had to make up the numbers to sing devotional and patriotic songs during the school assembly, she would call on me, then ask me to stand at the back and sing quietly, maybe even just mouth the words. I tried playing the flute in the school's marching band, which convened to mark days of nationalist pride. I could barely get my fingers and legs to work in sync with each other. I wanted to be one of the boys, so I tried playing the drum kit in the school's 'Western music' class. The teacher told my mother that though I had no rhythm or natural aptitude, I could perhaps try the guitar instead. Given my record of inexcellence, it felt like too much for my parents to buy me a guitar. I had to accept that when it came to music, I would be a listener – only a listener.

Music has always felt like it belongs to someone else, someone more discerning, knowledgeable, or talented. Writing of her own experience of music, Milner says: *my listening had been too much bothered by the haunting idea that there was far more in it than I was hearing, but occasionally I*

would find that I had slipped through this barrier to a delight that was enough in itself, in which I forgot my own inadequacy. I tried to make more of a claim to music by listening widely, once again guided by what I thought I ought to like. In my diaries, I made lists of what I had been listening to, but the pleasure I found was stilted and effortful. Yes, there were songs and singers I loved passionately, and listened to with abandon, but I didn't feel like that was enough. And because it wasn't enough, I couldn't claim or sustain my pleasure in music.

At a concert by the great multi-percussionist and composer Kahil El'Zabar, I was surrounded by people who were much taller than me, and I felt rigid and self-conscious, intensely aware that I knew so little about the music. Then I overheard a conversation between two of my friends. One of them wrote about music and had his own record label. The other one said that he liked listening to classical music, but he didn't know much about it. It was the kind of thing that I'd said many times in the past, somewhat apologetically. My musical friend said: But listening is *how* you know.

I found this astounding and freeing. Something that I had made out to be complex and fraught was suddenly simple. The awkwardness left me, and I found myself moving to *a delight that was enough in itself.* Milner drew an illustration to capture this feeling of being in the music. She includes it in *A Life of One's Own.* There is a figure seated on a chair or a bench with arms outstretched, and

a vivid sketch of musicians playing violins and what looks like a trombone. Three exuberant lines form an arch from the seated figure towards the musicians. At the concert I felt something of the exuberance of those lines in my body. Afterwards, I bought a record by Kahil El'Zabar, and I play it often. I still don't know much about the music, or the musicians. My pleasure in music is inexpert but now I can say, without shame, that I love music carelessly, badly. Which frees me into loving it more fully. I remind myself that leisure doesn't need the justification of mastery. It is enough that I know I like listening.

4

Who Can Look at a Painting?

At the onset, they felt like ordinary menstrual cramps. I took a painkiller, then another. There was no relief. The blood was excessive. Then the diarrhoea started. I couldn't walk, so I went up and down the stairs on my hands and knees, to the bathroom and back. The cat stationed himself on the landing, a majestic, watchful presence. Something had exploded, and my body was in spasms and contractions, occupied solely with expelling what was inside me. At some point I gave up trying to move between the futon and the bathroom, and sat on the stairs and waited for the night, and the pain, to pass. My usual strategies of distraction – my phone, a television show – were useless. I felt like I had no choice but to fall into the pain, to give myself over to what was happening. The ferrous tang of blood mixed with the warm smells of shit and sweat, everything damp and clammy on a summer night. My body and mind felt like they had been stripped back to some bare essence. And sometime during the early hours of the

morning, a thought emerged, clear and perfectly formed: I can't do this any more.

Soon after my thirtieth birthday, my boyfriend and I decided to end our relationship. He said that he didn't love me like he used to, and I took the statement to what seemed to be its logical conclusion. I had the distinct impression of being handed some kind of administrative role, like one of those firms that are brought in to dissolve corporate entities, to sell off assets and give out redundancy payments. And then a lockdown was announced by the UK government, so I moved – not out of the flat, but from the bedroom to the futon downstairs. A month passed, then another. There was no obvious place for me to go. Letting agents were shut, and people everywhere were stranded in bizarre and difficult situations. My ex and I cohabited well, and I started stalling. The prospect of moving out was daunting, the subject of postponement.

Looking back, I am struck by my capacity for delay. In the days following my menstrual cramps, I felt like my body had staged an intervention on my behalf. It had reminded me of the costs of putting things off. I was grateful that there was something else to me other than my everyday, supposedly rational self, who spoke and bartered and negotiated in a measured way, but whose search for security and equilibrium seemed to be a form of madness in itself. There was a rough, somewhat crude quality to how the other part of me spoke, but that was its strength. Maybe it felt like it had to strike a match and throw it into gunpowder

because that was what it would take to get my notice. I knew I didn't want to experience a night like that again, and so I set about paying attention to my circumstances, and trying to change them. Although in that moment it seemed like what I needed to change was my housing situation, it became clearer later that the conditions I was protesting had deeper roots.

In the months that followed, I would confront my relationship to risk and security, and the ways in which I was haunted by ideas of failure, and I would learn that imagination and dreaming can be needs, not just luxuries. Accompanied by Milner's third memoir, *On Not Being Able to Paint*, I discovered that it is possible and necessary to find pleasure and leisure even when the conditions for these experiences feel contingent and improvised. In this book about her attempts at painting, I found words to describe the fear and stuckness that can accompany creative endeavour, a way to articulate the need for the space and rhythm to pursue such projects, and the courage to ask for what I really wanted. I found that once I began to pose the question of how I wanted to live, everything from looking at paintings to decorating my room and sorting through my wardrobe helped me elaborate this question and bring me closer to a sense of what mattered in my life.

After the end of our relationship, my ex helped me buy a bicycle, and gave me a few riding lessons. As a child, I knew how to ride a bike but gave it up because I had no hope of

matching my brother's skill. I see him before me: riding his bicycle down the steps surrounding the veranda. Whipping up dust as he turns a quick corner. As siblings we divided up the world. He took drawing and painting. I took words. Mathematics, his. English, mine. He made strings of fairy lights for electronics class, melting nickel with his soldering iron. I memorised lines for the school play. He's building empires on his computer, pixelated figures moving across the screen. I borrow books from the school library – I'm given extra library cards. As we grew older I was surprised to discover our interests had converged. Bookstores, films, the internet. And yet something of that primal division remained. He dies, and there is a subterranean sense of betrayal in doing something he was good at, as though I'm taking up space that belonged to him. Why can I stand in his place? Because he's not there. He's not there.

Learning to ride my bicycle, I was surprised by the intensity of my fear. Fears of falling, crashing, injury. Everything seemed unreliable – balance, speed, the weight of my own body. I was terrified. It felt ridiculous, because all around me there were people cycling – children, chic women with grey hair and neon panniers, fathers with toddlers on baby seats. I learnt to balance on the bike, and pedal in a straight line. I thought to myself: but you can stop if you need to. You can just walk, I reassured myself. Then I was faced with a problem both literal and metaphorical – I didn't know how to turn a corner. I was afraid of falling. Somewhere in my mind, I believed that falling could only be catastrophic.

A debilitating injury. Death. I knew my fear was disproportionate. But it felt like it was towing something in its wake, something I couldn't see yet. Maybe falling sounded, looked and felt too much like failing.

I couldn't fully make out the shape of the other fears, but I began to hope that responding to the one most immediately in sight might also allay the lurking ones. I began to feel like if I could learn how to cycle, I might rediscover some faith in myself. Pedalling, I found a rhythm. I loosened my grip on the handlebars. As I cycled a full loop around Hackney Downs park, I found myself repeating to myself: I am cycling away from something, I am cycling towards something. And suddenly the world seemed full of new inspiration. Every time I saw a woman on a bicycle, I felt a rush of possibility.

Then, at work, I was asked to record an interview with a poet I admired. I decided to cycle to meet her, my first solo expedition. I bought her a plant from the florist near my flat, a succulent with orange flowers. There was hardly anyone on the roads. I saw myself as though in a film, cycling with a plant hanging from the handlebars, smiling to myself, my yellow knapsack on my back. There was a loud crunching sound and the bicycle stalled. I looked down to see that the bag with the plant was caught in the spokes of the front wheel, which had also crushed the plastic pot, scattering soil all over the road. I picked up the plant, which was still intact, and put in back into what remained of the pot. I arrived late, and nervous, holding a

broken pot. The poet told me that on her lockdown walks she collected injured and abandoned plants, and had set up a hospital for them in her garden. The flowering succulent was in luck. It was soon sitting in a new pot, its prospects bright in the company of other convalescing foliage.

I think back to the young woman who ran away to be in the films. Maybe she wasn't the star she'd longed to become. Maybe her experiences were disappointing and unnerving. But maybe when she danced as an extra she found pleasure in it, because she had risked something, and arrived somewhere by herself. I didn't know, and everyone laughing at her, with the parrots on their shoulders that only ever said the same two words – *shame, shame* – they didn't know either.

Some days before I left the flat I shared with my ex in Stoke Newington, I made a new friend. She invited me for a bike ride to the Walthamstow Marshes, and when we got there she opened a Tupperware box. Inside were mushroom and sour-cream puff-pastry rolls that she had made earlier that day. We spoke about past relationships, friends we had in common, how we'd both ended up in London. We were there for ages, and at some point she said: Right, I need to pee. And she walked down the bank behind us, sheltered by bushes, and came back. I needed to pee too, but I felt shy. She said: You can do it! I asked her if she would keep watch. Just go, she said, just go.

*

'No one has asked to change the curtains before,' the landlady said. 'They were made especially for the room, and the last tenant loved them.'

Moments earlier, I had agreed to pay her £1,200 a month, for a bedsit on the first floor of her house in Brockley. I felt flattened at the prospect of paying more than half my salary in rent. I knew she was taking advantage of the misery produced by the pandemic, and profiting from desperation. I wanted to assert some autonomy, even if it was purely aesthetic. She agreed to have the curtains taken down. But that was it. The bed, covered in black pleather, was staying, as was the rest of her furniture. The room had pink walls, a fireplace and large windows, and a few days later I was sitting there with boxes around me. My ex had driven the cat over, helped me move some things around, and left. Things hadn't gone to plan – my plan, or anyone else's. There was no baby in sight. I was not married. I was not a writer – not even close. But with hesitation, and trepidation, I could ride a bicycle. I stretched out on the bed, feeling all the space around me.

Nothing is as it was meant to be, and I am excited. I feel grateful for my failures of adjustment. It is a strange sort of reassurance, based on the knowledge that I have failed at what was expected of me, and what I was expecting of myself – but I have not ceased to exist. I sink into this feeling of security, which seems based on nothing more solid than a surrender to a part of myself that doesn't know what is coming next, and perhaps doesn't need to. I don't

know it then, but I am back by the seaside in Ramsgate. The waves are at my feet, asking me to ask questions of myself. I am in my life again.

Brockley is hilly. I push my bike up steep slopes, and grip the brakes while going downhill. I half cycle, half walk to Ladywell, to a bike-repair man who looks it over and calls it a *cruiser*. That's the kind of bike you would ride on the promenade in Miami, he says. I have a vision of my bike by a coconut shack on the beach. It works on my imagination in a strange way – during my time in Brockley I keep feeling like the sea is nearby. I cycle to the large Asda, the Sri Lankan deli and the Tamil grocery store. When I want to buy elephant foot yam, the woman behind the counter cuts me a small single-person portion. I find another bright purple yam in her shop and she tells me how to prepare it. Every day I cook myself meals that that I like, dosai for breakfast, lunch and dinner. Every day I ask myself: what do I want? What would I like? And in asking and answering, the questions become ordinary.

What did I discover about my wants in this time? I wanted to go through my clothes, and sell or donate everything that didn't fit. I wanted to buy second-hand copies of Elizabeth Taylor's novels and wait for them to arrive in the post. I liked ghee. I liked playing chase the laser with my cat. I wanted to take long baths. I wanted to take my book to Hilly Fields and once in the park I wanted to stop reading and watch dogs chasing after balls, chasing after other dogs, chasing after air. I liked lying by my bicycle

on the grass, watching the sky change colour. I decided that I only felt like reading novels by Elizabeth Taylor, one followed by another. I thought for a moment about whether anyone would find that weird, and then I thought, and the thought surprised me, that I didn't have to think about that. It didn't matter.

How do I narrate those days? You are a squirrel, stand on the street and observe. A woman leaves the house, she returns with a tote bag on each shoulder, and still more groceries in a large purple-and-white basket. If you clamber up the tree you'll catch sight of her putting these away. Now she's leaving the house again, so turn into a crow, and follow her. She's on her way on Peckham Rye on her bike. She stops in the middle of an empty road, takes her phone from the back pocket of her jeans and texts her friend to say she is late. Her bicycle has no gears, and she does not know a bicycle can have gears. There is an expanding patch of sweat of her back. You land and hop closer to the two women talking in the park. They don't seem to be talking about anything remarkable, so you turn your attention to the ground where there are crumbs from many picnics. Everyone meets in the park these days.

She's heading back home, and you're tired. You turn into a leaf and hitch a ride back, stuck to one of her shoes. Over the next few days you'll observe her in the room. She opens her diary, tracks her menstrual cycle. Now she's setting up her laptop to do an exercise class on Zoom. She is reading, napping, doodling in her notebook, her camera

turned off during a work meeting. She goes to the hair-dresser and shows him a photograph on her phone. He cuts off her long hair and gives her a fringe. Back in her room, she takes her phone out to take a photograph of herself. Then she cleans the cat's litter tray, and runs a bath. She catches sight of you, still stuck to her shoe, and picks you up and drops you out of the window. Nothing to note, you think to yourself as you float to the ground. Nothing much to observe here.

One day, two friends visited and brought armfuls of flowers – sunflowers, roses in various colours – but I didn't have enough vases, so I emptied jars and improvised containers. It wasn't my birthday, or any other occasion, but I thought they were saying that living by yourself, doing as you like – these are also things to celebrate.

Marion Milner often described herself as someone who thought in images, and she explores her experiences of drawing and painting in *On Not Being Able to Paint*. I first picked up the book when I was twenty-four, living in a student flat share in Crofton Park, about fifteen minutes' walk from the bedsit where I now lived. One half of a small terraced house, this flat had hosted a series of doctoral students, who furnished it thoughtfully and made it a home. After living in student housing and short sublets, this flat offered welcome warmth and stability. My flatmates, strangers to me when I moved in, soon became friends. We bought groceries together, walking to the

market in Lewisham to pick up fruit and vegetables sold in tubs for a pound each. When my flatmate spotted a tub of avocados, she would make guacamole for everyone in the flat, and any visitors who stopped by. We were all busy, and I spent a lot of time by myself, I was independent. I became good at taking care of myself in an everyday way – I went swimming regularly, we ate lots of fruit and vegetables.

Looking back at the diaries I wrote at the time, I was surprised to discover how taken I was with Milner's *On Not Being Able to Paint*. I tried imitating Milner's free-drawing experiments. Someone had given me crayons and a sketchbook for my twenty-fifth birthday. Since I had no experience of painting or drawing, I started by simply trying to draw what I saw in the kitchen. This is what I wrote in my diary: 'I felt a sense of satisfaction looking at a drawing that I don't much like otherwise – I've drawn a pot of aloe, then behind it a chair, behind the chair a jar of tulips on a counter, behind the tulips a jar and a bottle. What satisfies me is the sense of depth and distance . . . it is all because of *On Not Being Able to Paint*.' Some days later, another observation followed, based on the drawing I had made: 'I have known myself almost as a piece of furniture – in relation to the objects around it, on it – by placing oneself in relation to the edges and designated places of others.'

Painting is concerned with the feelings conveyed by space, Milner writes. Space and feelings, thought together, touch upon so much, from *the babyhood problem of reaching for one's mother's arms* to *the problem of being a separate body in*

a world of other bodies. Painting, then, is deeply concerned with having and losing. What I hadn't realised was that these significant feelings could surface, and find expression even in my attempts at drawing, which were lacking in both skill and experience. The drawing I made sitting in the kitchen identified the chief problem I was grappling with at the time, even though I was not aware of it directly. As a twenty-five-year-old, I was trying to figure out how to speak from my own place, in my own voice. This was a fraught endeavour.

If painting was concerned with feelings and space, then so was grief, and the problem of mourning my brother seemed at least in part to be about adjusting to a new ordering of space, which had at its heart something that was missing. Absence meant that there was too much space, but there was also too little, because absence also filled space. No wonder it was consoling to draw objects placed against each other, as though space was something simple and factual. But even if grief could be set aside – and it couldn't – space, and the feelings it produced, was still a problem for me. I hadn't learnt how to separate myself from everyone who wanted to speak for me. I made a break from familial and social expectations, but I didn't understand that these bonds of love and duty were alive inside me in the shape of a feeling of guilt. Deeply embedded and painful, and therefore too difficult to admit, guilt saw my attempts to carve a life for myself as a form of betrayal. My conscious rejection of a life I did not want collided with

my attachment to the people who wanted that life for me. The result of that conflict was that, unconsciously, I experienced my freedom, and my life, as something of a crime, a transgression that demanded explanation and atonement.

My attempts at drawing, and the words in my diary, were trying to communicate something of this impasse to me, but I couldn't grasp their import. I had a tendency to think that other people would be able to give me what I was looking for – they had the answers, not I. My diaries at the time relate conversations with others, worries about my relation to them. I was so oriented towards other people I didn't think I had anything important to offer myself. My experiments with painting didn't last very long. It wasn't till I was learning how to ride a bicycle that I realised that in trying to paint I must have felt like I was stepping into my brother's place, and thus dissolving what was left of him – his absence. Painting was certainly concerned with the feelings conveyed by space – for me, this was the space between my family and me, between my brother and myself; it was the kind of space that merged an internal scene with an external landscape. It feels fitting that I tried, and failed, to read Milner's book in Crofton Park, where I also tried, and failed, at drawing. It was also a time in my life when I tried, and failed, to understand something about myself and my desires.

On Not Being Able to Paint is a book about doing something that you don't know how to do. For Milner, failure is generative and exciting, it is the starting point for curiosity

and discovery. Leisure is important because it allows us the opportunity to be inexpert and incompetent, if we allow ourselves to be – to make a mess, to muddle through things, to feel frustrated and confused. Though concerned with painting, Milner's account of failing – of not being able to – feels pertinent to all creative projects, chief among these life itself.

It was important to me that the bedsit in Brockley look as nice as possible. Since I had no money to spend on any new objects, and I couldn't remove the landlady's furniture, I could only improvise and conceal. I had a poster of a painting by Jamini Roy, of a cat holding a giant prawn in its mouth, bought at the National Gallery of Modern Art in Delhi. I admired the interplay of colours in this painting, the non-realistic depiction of the cat with its large ornamental green and yellow eyes. I rarely *thought* about the painting when I looked at it, but I was always glad when my gaze rested there. Years later, when I read the artist Celia Paul's autobiography, *Self-Portrait*, I was struck by the phrase 'painting is unvoiced language'. What was unvoiced in my affection for this painting?

Before I moved to London I spent nearly a year living in Calcutta, and when I came to London my diary of that time came with me. That notebook records both the last months of living in Calcutta, and my first months in London. As such, it is the record of a transition. In Calcutta, I lived on money my parents sent me, studying German and passing

the days in libraries as I put together applications for doctoral studies. Living didn't cost much there, that was the explanation I offered myself for not finding employment and relying instead on my parents, as I cultivated an ignorance of the links between financial dependence and psychic obligation. The city was accommodating of this kind of itinerant, ragged, but unmistakably bourgeois existence, seemed to encourage it even, as though what people in other cities would call drifting was a worthy end in itself. And so I read, and walked, and watched one film after another in the air-conditioned video library of the German Institute. No one asked me to explain myself.

And yet when I read my diary from this time, I can't help but notice that even in these conditions of near-perfect leisure I was trying to be someone I thought I should be – an image of myself cobbled together from the values and preferences of people around me whom I admired, people with more forceful views than mine. I had time to myself, but I gave that time over to trying to become someone who would be approved of and accepted by others. As I tried to become a scholarly, cultured person I found myself dissatisfied, because what I wanted was some kind of recklessly fulfilling romantic life. That the two appeared to be in some kind of opposition already posed a problem, and the split was not of my making.

I was in a bind. I had too few thoughts of my own to experience my leisure and solitude as nourishing and plentiful. But I also had too many thoughts of my own

to participate, with any hope of success, in the heterosexual relationships that were available to me. Relationships with women offered a respite from this, an opportunity to experience a sexual and intellectual life away from an impossible split between thinking and sexuality which seemed to undergird the choreographies of man and woman, woman with man. But these havens were fragile. I didn't have it in me to assert an identity based on desires that I was still figuring out, and neither did the women I loved. Sexuality felt provisional and contingent, the declarations and assertions of announcing an identity felt out of reach. Of course the prospect of censure and incomprehension from our families also directed us towards a non-declarative discretion, a way of loving and living that was veiled, but that allowed for its own forms of flourishing.

It was in these relationships that I could experience the joining up of mind, body and soul that is sometimes afforded us in our moments of leisure; where I could learn to exist as myself, instead of existing for someone else. Between the ages of nineteen and twenty-two, it was with my girlfriends, out shopping for books and clothes, lying in bed together after dinner, or talking about politics that I found myself learning not just how to think, but also how to ask and discover what I wanted. Around men, this space closed up. I tried to be what was expected of me, what was meant to be desirable. My late adolescence and early twenties felt like an appropriate enough age to be a bit lost and uncertain, to not know what to do. But at thirty,

sitting in my Brockley bedsit, I realised that in my recently ended relationship I had once again not been able to assert what I thought or wanted.

There was a cork noticeboard among the other furniture the landlady had left in the room, and I covered this with a blue cotton curtain, pinning the fabric at the back with thumb tacks. Then I pinned the Jamini Roy print to the centre of the board and placed this in front of the fireplace. I liked it when paintings were not displayed at eye level, instead surprising the eye from unexpected places. Milner describes painting as a way of discovering what the eye likes. It is difficult not to hear a pun here, between eye and I. Rearranging the bedsit in Brockley, I was beginning to discover that what the eye liked – and maybe even what I liked – could be something improvised and contingent.

During this time I bought two cashmere jumpers on eBay. My cat can sniff out a cashmere jumper from a mile off, and he likes to sit on them. I was hopeful he would sit on my lap more if I was wearing cashmere jumpers, but by the time the jumpers arrived he was too busy pursuing a rivalry with the landlady's cat to notice or care. Still, I enjoyed wearing them and I felt doubly cocooned – in my jumpers, and in the room which I had managed to arrange to my satisfaction. Some months back, I'd made a big change in my life. I'd allowed myself to experience the upheaval that is so central to Milner's account of leisure. I had a new appreciation for the necessity of taking risks, I had a feeling of interest in the everyday details of my

life – like the second-hand jumpers and the groceries from the Tamil store, how the room looked. Five years back, I had written in my diary about feeling like a piece of furniture. As I rearranged and decorated the bedsit, I noticed that this feeling was beginning to shift.

Sometime later, visiting a retrospective of the artist Lubaina Himid's work in London, I felt an immediate rapport with the work, as though my life was somehow in conversation with it. There was a sculpture of a woman seemingly made out of white wooden drawers, arranged cake-like in tiers, in a work called *A Fashionable Marriage*. Maybe I wasn't the first woman to have felt like furniture. It was tricky, in particular and shared ways, to be a woman. Clothes were tricky. Other people's expectations were tricky. The ways in which those expectations clung to clothes was another kind of tricky. The work seemed to take this in, and laugh. There was a question written on one of the gallery walls: 'We live in clothes, we live in buildings – do they fit us?' I realised that this was a question that Milner was also asking herself, as was I then, and this felt urgent, especially as I became aware of how, in trying to fit in, I hadn't stopped to ask myself if the circumstances to which I was trying to adjust myself fitted me.

A Life of One's Own was written in the context of interwar modernism, and Milner's work is in dialogue with modernist writers such as Virginia Woolf and Sylvia Townsend Warner. The historian Rosemary Hill identifies interwar modernism as the period in which 'frock consciousness' – a

phrase she borrows from Virginia Woolf – came to be 'a significant aspect of female experience, a colour on the writer's palette, a possible agent in a narrative'. Woolf's *Mrs Dalloway* and *Orlando* are both alive with clothes. 'A silver green mermaid's dress' shimmers through *Mrs Dalloway*; in the course of the novel Clarissa Dalloway repairs, then wears, the dress. And surely part of the mood of *Orlando* are the clothes, the many dramatic dress changes. In her own way, Milner was also part of this literary moment that was so concerned with how interior and exterior are intermeshed, delineating a threshold space between body and world where clothes may come to serve and signify.

The dresses in *A Life of One's Own* do not have the brilliant colours, the vivid textures of Woolf's novels. They are dresses of desire, longing, distraction, moments where something about the mind can only be said through a dress. Early in the book, in an attempt to become familiar with what she wants, Milner makes a two-part list. The first part is titled *Things I hate* and includes *lace curtains* and *unshaded lights*; *fussy dresses* and *being unsuitably dressed* also get a mention. The second part is titled *Things I love*. Here are the last three items on the list:

> *A new idea when it is first grasped.*
> *People singing out of doors.*
> *Clean clothes.*

Struggling to find a purpose in her life, Milner finds that the things she thinks of in moments of leisure may offer

a way and she lists among them the wish to *dress moderately well*. It is perhaps unsurprising that a project of finding one's own life would involve the question of what clothes that life would be lived in. When Milner writes of having *an idea of my life, not as the slow shaping of achievement to fit my preconceived purposes, but as the gradual discovery and growth of a purpose which I did not know*, she may well be describing a wardrobe that doesn't yet exist but must be slowly assembled through trial, error, sensing, alteration and experimentation.

In her book *Dressed: A Philosophy of Clothes*, Shahidha Bari draws our attention to an etymological connection between clothes and communication. The word 'text' is connected to 'textile' deriving from the Latin *texere*, to weave – 'if you love language', Bari writes, 'you might find that you love clothes too'. The aural resonance between a dress as a garment, and address as communication can be traced back to their shared etymology in the Latin *directus*, to direct. In her very first book, Milner composes clothes out of words. Then she discovers that words may be *clothing for outcast thoughts*. In Brockley, when I wanted to find my words, some instinct led me to clothes. I got rid of the dresses I never had occasion to wear, which hung in my cupboard like a reproach. I started wearing an old pair of jeans again. And I wore the cashmere jumpers all the time, because it was nice to feel warm and cocooned as I was reaching after words.

<p style="text-align:center">*</p>

I was being foolish. Wanting to live in the bedsit had the same quality of adolescent excitement that I associated with my fantasy of living in the room on the roof. This time, I had been able to realise that wish, but I was running out of money. A visa application – *another* visa application – wiped out what I had saved. On my income, living alone went against common sense. Till this point in my life, so much had been explained to me, and so much I had explained to myself, through the logic of common sense. The phrase itself is an indictment of those who wanted to raise questions. Who are you, if you don't have common, let alone uncommon, sense?

But I was beginning to recognise that common sense may be a way of not thinking, or not listening. Maybe the function of common sense was to hide my own wishes from me in plain sight. *On Not Being Able to Paint* makes a case for the imagination. For Milner, imagination is not a luxury, or an indulgence. Rather, it is fundamentally connected to truth. And yet, perhaps because the imagination may bring us close to the truth – of what we feel, desire, think – it is something we may find ourselves rejecting. As she experiments with drawing, Milner thinks about lines, how these can *imprison objects rigidly within themselves*, or express *a play of edges*. Rigid outlines, in painting and in living, ward off the world of imagination, where there is an intermixing of *the tangible realities of the outer world* and *imaginative realities*. Our lives are impoverished if we persist in closing the door to the

imagination. And maybe 'common sense' is one way of slamming the door shut.

There were two pieces of furniture in the bedsit to which I formed a loving attachment. The first was a writing bureau. I had seen one some years back at a sale of old furniture in Hackney, and wanted to buy one for myself, only to be dissuaded by the price, and my boyfriend, who associated bureaux with his parents' house, with long legs insufficiently accommodated. Maybe the design of the bureau represented things I wanted in my life: a designated place for writing, privacy, a desk that was also a room of my own. That the bedsit had a bureau augured well. It didn't matter that it was wobbly, with a splintered leg. In addition to the bureau, there was a chaise longue, upholstered in faded green fabric. I moved it to the centre of the room, and from that place it issued me an invitation, to my own experiment in leisure. The bureau represented writing, the chaise stood for dreaming.

Lying on the chaise reading, I would fall asleep, wake up and let my eyes rest on the pink walls. Taking in the colour, I lost sense of time, of myself. Sometimes it was the green of the leaves outside which so absorbed me. For the colour to work on me, I had to let go of something inside myself, forget myself even. My most powerful experiences of looking at paintings had been when the colours had felt like they were coming out of the canvas and washing over me, and simultaneously drawing me into the frame of the painting. Being open, or closed off, to colour made all the

difference. When I thought of visits to the Turner paintings at Tate Britain, or an exhibition of Agnes Martin's work, I remembered the feeling of colour so vividly that my memory of the paintings was close to the experience of entering a flowing, living stream. Milner describes colour *as something moving and alive in its own right.* And the verb she associated with colour?

Plunging.

Colour offers an invitation to surrender to an imaginative relation to the world, an experience of not knowing where I am or even where I start and end. This experience is the opposite of being fixed, in identity or an opinion. And yet it was clear that this experience was threatening, because I resisted it. To Milner, colour represented movement, and the possibility of change. Like her, I too felt that safety was something to be found in fixity, and the experiencing of a loosening of boundaries was associated with fear, even madness. Why then did I want it so? Why did I reach for it when I was tired or inattentive, my gaze seeking out the leaves, my feet walking me to a painting? Imagination, colour, madness – I longed for these, I needed them.

On Not Being Able to Paint presents a concept that is central to how Milner imagines the possibilities of leisure, and it helped me understand a particular state of mind that I had been searching for but did not know how to describe or name. This is the idea of a *primary madness* – where inner dream and outer perception are the same. As infants,

we begin by imagining the world. We think we've brought it into being. Even though we learn to recognise this as an illusion, the experience forms the basis of our ability to endow the world with significance. This primary madness, this feeling of being one with the world, is a state to which we may want, and need, to return. In other words, we may need what Milner calls *the dream*. This is an experience that Milner compares to the magical quality that being in love brings. Or when, in looking at a painting, *the eye was lost in a secret germination and a coloured state of grace*. For Milner, this state of dream, illusion or primary madness may be *the essential root of a high morale and vital enthusiasm for living*. These are moments of *transfiguration*. It is through these moments *that one comes to know what one loves, comes to hammer out over the years the knowledge of what is worth striving for.*

For this reason, Milner writes, it is important to reach for whatever it is in the world that brings this experience of love and significance into our lives, because to do so is to nourish the dream, to allow it to grow and be altered. It doesn't matter so much what this activity is, or where it leads – it is the giving over of oneself to it that is the point. Deciding to learn a language, figuring out how to change the inner tubing of a bicycle wheel, texting someone to ask them out for a drink – all of these can be ways of enriching the dream, but what it will be for each of us is something that can only be discovered, not received by instruction.

Some months into writing this book, I was feeling

completely crushed by my work at a university. I would wake up early and go to bed late trying to complete tasks which seemed meaningless. Almost everything that made my life feel significant was out of reach and, most painfully, I could not find even a few uninterrupted hours in which to write. During this time, I found myself drawn towards the cut flowers that are sold in supermarkets and florists. Arranging these flowers, and drying them, was a real pleasure. I felt ashamed, too, because the form of my pleasure felt too easy, too commercial, too unthinking. One day I bought myself a bunch of Scottish thistles, with long stems and spiky purple heads. For weeks, then months, I watched them slowly dry out, retaining their shape as their colour faded. In between answering emails, I would draw the thistles in the margins of my notebook. I could never quite capture their shape, the way in which their lines interacted with each other in the vase. Later, when I returned to writing, I realised that the thistles had been holding my dream for me. And then I wondered what would have happened if I had given in to my feeling of shame, and denied myself flowers.

So often I've stopped myself from pursuing something that feels like it has the transfigured quality that Milner describes so eloquently. I've done this, not for lack of opportunity or means – though these often pose real and excruciating barriers – but through some kind of dreadful, defeating common sense, which scoffs at experimentation and risk. At the basis of Milner's account of the dream is

the assertion that something about our lives is important. We can be so beaten down by the obscenity of our political systems, the cruelty of our workplaces, the misery of the daily injustices we witness, that it can feel like a risk to think that our lives matter, to allow them to matter, even to ourselves. Her work urges us to hold on to the significance of a life imaginatively lived. *On Not Being Able to Paint* doesn't promise its reader any results, it doesn't offer a product, and it would be difficult even to find in it a generalisable method. What it extends can perhaps be described as a process. For me this is a process of hope, a kind of hope that has risk at its heart.

Looking back at my diaries as I wrote this book, I was surprised by how long I had been preoccupied with the question of how to write, and how intensely it had absorbed me. Painful, desperate, insistent anxieties about writing trouble the diaries, all the way back to the oldest notebook I have with me. In my parents' house somewhere there is a plastic bag filled with diaries that are even older, most of them written in grey school notebooks. If I was to open them, I would find the questions and worries there, too. The diaries witness a failure, they are a record of not being able to write. Page after page of stories begun, scenes described, lines of verse. Each time, some kind of hope in beginning. But the attempts are all abandoned. If I wanted it so much, I find myself asking, then why did I not set aside time for it?

Maybe, as in other aspects of my life, I expected the answer to come from elsewhere. Someone else would teach me how to write. Someone else would unlock this ability in me. Someone else would make me a writer. Maybe it was difficult to make a claim for myself, because I was young, lonely, a woman. But looking through my diaries, I found something else: 'I seem to block myself from writing. Some sort of rage there, in tearing up one's own work, thwarting one's own plans.' Another day I had written: 'If I could be less angry at myself maybe I could work. Sometimes it feels like a subterranean vicious hatred running inside – also a kind of contempt that directs itself at myself.'

Looking back, I feel like I was asking the writing to cure or soothe something inside me, but writing was not equal to the task, the fabric of words would tear under the intensity of my need. I wanted my writing to be perfect, I found it revolting. When I wrote in my diary about how the inability to write was bound up with feelings of anger and hate, I was perhaps beginning to glimpse that the high expectations I brought to my writing, and the vicious scrutiny to which I subjected it, were the product of unresolved and unadmitted feelings. Writing about her difficulties in painting, Milner says that she *had to realise too that the denied hate can then work itself out internally, making one feel, in extreme conditions, that one's inner world is wrecked and everything is hopeless; even though the external environment, objectively seen, may be full of promise.*

I had always thought that the ability to write was

something to do with putting words on a page. It wasn't till years passed that it slowly began to dawn on me that in addition to putting words on the page I needed to be able to return to them, to stay in close proximity to something that could feel like an excrescence. The more I could do this in writing, the easier it would be to do this with my emotions, and the other way round too. I had to learn to stay with painful thoughts and feelings in order to write, but writing has also expanded my capacity to tolerate what I find difficult and unlikeable about myself, and those parts of the past that are a source of hurt and regret. Towards the end of her book on painting, Milner writes: *I no longer expected a painting to be a magical solution to every problem of life, and so no longer made the half-admitted demand that every picture should be a masterpiece or it was not worth doing.* Making something is also a process of being altered and reshaped by that making. In writing this book, so many times I have stopped, noticing, once again, that as I write this book, it also rewrites me.

The Covid pandemic was a time of death, separation and uncertainty. It was also the first time during my life in England that I did not have to be somewhere, to meet someone. In one of the intervals where some pandemic regulations were suspended, as he cut my hair short the hairdresser said he had planted a garden for the first time in his life. It was something he'd always wanted to do, but never had the time. Later, when I met my friend in the park, he

told me about the three reading groups he attended, all online. One read the work of Italian feminist-Marxists. Another read Spinoza. I cannot remember what the third group was reading, but my friend seemed really well, like he was in his element.

Repetition, Milner writes, often becomes associated with the impositions of work. And when this happens, variety becomes important as an antidote to the repetitive workday. It is only in the experience of variety that we feel like we are able to express our will. But there is another kind of repetition, one connected to rhythm, that we need for creative work, and yet turn away from because repetition itself is so associated with impositions from outside. Maybe we're not able to write, paint or play the violin because the repetition associated with becoming adept at any kind of creative practice is too much like going to work, or being at school. We can't find pleasure in it, because pleasure has had to retreat into the things that offer interruption and escape.

Milner makes a distinction between *imposed* and *inherent* order, finding that *control by rhythm and control by self-conscious willed endeavour are mutually exclusive processes.* But I had found it difficult to trust myself to develop *control by rhythm.* I'd thought that in order to do anything I had to put myself to work. I didn't know then that when I allowed myself to be led by rhythm I would *want* to write every day, I would look forward to it, I would miss it when I couldn't and long to go back to it. It wouldn't become easy, but it would be interesting. As long as I thought I

should be writing – every day, or more, or better – my interest took flight from writing, landing instead on my phone, because I wasn't following my interest, I was corralling it. I was *kettling* it, like the London police *kettled* protesters during student demonstrations when I'd first moved to the city. In *A Life of One's Own*, Milner writes about how the role of the will is not to police the crowd of one's thoughts, but to stand aside and clear the ground. *On Not Being Able to Paint* offers another version of what the will can do – its role is to *plan the gap* into which things emerge, to *provide the frame*. The will must facilitate and foster, it must not bully and force.

Should I paint on Sundays? Milner asked herself this question and didn't know how to answer. All around her people were *all busy with their daily lives*. To paint was to suggest that dreams were somehow more significant than real life. That imagination was at least as significant as common sense. Maybe there was something a bit audacious about this suggestion. Maybe it would offend people. In the end Milner's answer doesn't rely on her evaluation of her talent, or the quality of her work. She decides to paint, coming simply to the conclusion that *it is perhaps ourselves that the artist in us is trying to create*.

For Milner, creativity is not about achieving goals, or achieving a standard of perfection. There is no right way to be creative, there is no secret. When the creative work is motivated by an intrinsic impulse, and not by ideas of where it should end up, then it is possible to be guided by

that inner impulse, and to learn from the creative process itself what forms of routine and rhythm are best suited to it. Everyone can find for themselves the rhythm of their creative lives, and this is something that changes as the circumstances of life change, with illness, responsibilities and forms of political urgency. In her own life, Milner took lessons in drawing, sketched on holiday, and went to summer schools, and continued to paint and make mixed-media collages till the very end of her life.

In my life in the bedsit, the light was fading sooner each evening, the days were getting colder. Chill draughts rose up through gaps in the floorboards. The trees outside the windows lost their leaves. There was a near-constant film of condensation on the windowpanes. The landlady controlled the heating, and the radiators in my room stayed cold. It was proving increasingly difficult to find money for the rent. I gave my notice and left. In the month that followed, she refused to return my deposit to me – a foolish strategy, as the deposit was protected by law, and held by a third party. As I sought advice from charities and legal helplines, I found myself wondering if she thought she could cheat me because I was a migrant and perhaps unfamiliar with my rights as a tenant. When I think back on that time, I always picture myself shivering, standing on the landing next to my bedsit. I have cystitis and the toilet is broken. She appears wearing a glittering purple gown, and as I try to tell her about the toilet she waves at me and says: I'm off to see Handel's *Messiah*!

When I left the bedsit I didn't know that the next six months would bring housing problems that would make me long for the cold room with the impossible rent. In Brockley, for half a year I had been granted both a room and a life of my own. As I spent the next six months moving between sublets and friends' spare rooms, I longed for a place that I could make into a home. But despite being unsettled, this time I had something to hold on to. I had my writing, and though it stalled when I was worrying myself sick about where I was going to live, it also kept me going. When I was writing I could build myself a place to live that was mine.

Walking

I looked at the Isle of Arran from Scalpsie beach. There was cloud and rain over the island, and perhaps for that reason the outlines of all the shapes seemed softer, not easily discernible. The water nearest me was blue, with a touch of turquoise. The far water was grey. The hills of Arran were a colour I had never seen before. I stood looking at them, trying to find a name for their colour. Months later, I found it in a story by Alice Munro, set in Scotland's Ettrick Valley. *Lilac brown.* I was experiencing the landscape as colour. The hills didn't have a colour, they *were* colour. And I felt the lilac brown wash over me.

I had come to the beach in sadness. Watching seals perched on rocks I felt something tugging at me, a downward pull, as though there was a stone suspended from my heart. Later, turning my back to Arran, I walked to the car, and noticed that my sorrow had dissolved. I had been absorbed into something that was separate from me, and indifferent to me. Or I could say I had renewed an intimacy with something of which I had always been a part.

That lilac brown bequeathed to me a simultaneous experience of otherness and belonging.

Earlier that day, after missing a ferry at Ardrossan, I visited a small bookstore in the marina, and bought a copy of Nan Shepherd's *The Living Mountain*. Reading the book in the days that followed, I found another vocabulary of colour: 'brownish pink', 'opalescent milky-white', 'opulently blue'. Like Milner's *On Not Being Able to Paint*, Shepherd's *The Living Mountain* was written during the Second World War. She writes about her intimate, sustained relationship with the Cairngorm Mountains. Shepherd notes facts about the mountains, in the register of 'so many square miles of area, so many lochs, so many summits of over 4000 feet', but she finds that these are only 'a pallid simulacrum of their reality, which, like every reality that matters ultimately to human beings, is a reality of the mind'. Here are two women, Milner and Shepherd, holding on to what they love in the world, insisting upon the imagination, at a time in history when everything is at risk of being lost.

Reading Shepherd's descriptions of walking in the Cairngorms, I feel like I am once again in the world of Milner's book on painting. Shepherd, like Milner, bears witness to the mystery and unknowability of the psyche. Describing her walks to the sources of the Highland rivers, she writes: 'One walks among elementals, and elementals are not governable. There are awakened also in oneself by the contact elementals that are as unpredictable as wind or snow.' She is describing a radical openness to the world,

where inner and outer interpenetrate, a simultaneity of separation and merging. This relation to the world is both risky and enlivening, and it is also where Milner locates the experience of creativity. Here is Milner, on colour: *some of the foreboded dangers of this plunge into colour experience were to do with fears of embracing, becoming one with, something infinitely suffering, fears of plunging into a sea of pain.*

Doing something without a purpose, without an expectation of reward or achievement – I hadn't realised how much this went against the grain of my education, of how I had learnt to be in the world. And yet this suspension of purpose is what I have been seeking when I reach for leisure. Pleasures so easily turn into obligations. Unawares, I become hooked to purposes. Leisure is letting myself off the hook. 'Yet often the mountain gives itself most completely when I have no destination,' Shepherd writes, 'when I reach nowhere in particular, but have gone out merely to be with the mountain as one visits a friend with no intention but to be with him.'

In Milner's archives, there is a folder of clippings and brochures related to dance and posture. It is a record of her sustained interest in how we inhabit our bodies. She was never a professional or successful dancer, but she danced all her life. No doubt this enriched her ability to think about bodies in a psychoanalytic exchange. But I don't think she danced in order to develop her psychoanalytic practice. I think she danced for the pleasure and challenge of it. Pleasure has far-reaching and unexpected effects, but to

start with the effects and try to wring them out of activity feels like an assured way of hollowing out the experience of leisure. Sometimes, when my mind is tired, and running along the same well-worn tracks, I remember to go for a walk. Most days, my wandering legs will lead my mind to wonder.

5

Mad Thoughts

A Cadbury's eclair is wrapped in gold-silver foil, with purple lettering. Inside the lockjaw caramel of the shell, there is something more yielding, something like chocolate. I'm holding a single Cadbury's eclair in my hand. Where did I get it? In school. Some unexpected reward or treat. My father sits in a chair on the lawn. The lawn is vast. I am very small. I offer the eclair to my father, holding it out in the palm of my hand. He says thank you. I watch him unwrap the eclair and place it in his mouth. A few moments later, I'm crying and inconsolable. He *ate* it. Now it's gone and I'll never see it again. I'm bereft. Someone leaves the house and returns with a thin blue polythene bag, filled with Cadbury's eclairs. I can have as many as I want. But they're not the same as the one that's gone. It's not the same, I say through my tears, my nose streaming. I am made entirely of regret and loss. What makes anyone think they are equal to the task of being a parent?

The house in Jodhpur had a fireplace and chimney. We never lit a fire there. It was cold in winter, but we could

move to rooms warm with winter sunshine, on the other side of the house. I think of that house being built around a longing for England, arranged around the totemic comfort of a fireplace. But it is difficult to ignore the desert. A lumbering two-blade fan in the vast dining room, verandas full of shade. Once a storm blew sand inside the house. Do things appear large in memory because I see with the eyes of a three-year-old? Or are these just the dimensions of colonial audacity? Schools named after John, and Paul, and Mary. Lined up for assembly, being taught to blow my nose, what to do with the handkerchief after. Mine, small and scalloped. My father's: large, white, folded, ironed. When I have a cold I ask for my father's handkerchiefs and complain when they are starched. My mother has placed a pot, red with a pattern of flowers, in the fireplace. It is an endless source of wonder that a pebble dropped through the chimney will fall into the red pot.

Chimneys, roofs, adults. These are mysterious. It is wrong to run naked into the living room when guests are visiting, to ask your mother's help with washing. Shame is coupled with skin. I will lose my plush monkey with his long tail. Everyone recognises that the monkey is important, everyone looks for him. I am loved. My brother learns to ride his bicycle down the stairs. I catch flu. I am loved, day after day. My mother is at work, and I miss the stories she reads to me, so I start to read to myself. The words and their sense arrive all at once. Later, I will use these words to betray my family. Their values, their love, their secrets.

Even now, I think of my plush monkey, and I want to cry. Even now, I wonder if I can find him again.

Milner first had a brief psychoanalysis in America, when she was there on a Rockefeller fellowship. Psychoanalysis was popular in her milieu of intellectuals and psychologists. It represented a new and exciting set of ideas during a time when Sigmund Freud was still living and practising in Vienna. A few years later, when she had returned to London, she attended a lecture by the paediatrician and psychoanalyst Donald Winnicott, one of the best-known British psychoanalysts, who was highly regarded for his writing on play and infant–mother relationships. Milner decided to start analysis again, this time with Sylvia Payne, a doctor and psychoanalyst who served as the president of the British Psychoanalytical Society during wartime years. Milner's diaries from the late 1930s are witnesses to her psychoanalysis – they record observations by her analyst, the movement of her thoughts, dreams and memories. Psychoanalysis would always remain a part of Milner's life. Later, she had periods of analysis with Donald Winnicott and the Canadian analyst Clifford Scott, as well as practising as an analyst and supervisor herself.

I first saw my psychoanalyst when I was twenty-three; I still go for analysis three times a week. I can see that my analysis will end, but psychoanalysis will stay a part of my life – it has become internal to me now. My ten years of psychoanalysis and my reading of Milner are intertwined.

When something Milner had written struck me as an insight, it was sometimes because months of psychoanalysis had quietly prepared the ground for the idea to come into thought. And it was with Milner's help that I could reach for the words and images to represent the subtle and sometimes shattering movements in myself that were initiated by sitting in a chair, or lying on a couch, and talking – week after week, year after year. I have relied on Milner and psychoanalysis as supports and allies in allowing myself the full complexity of my mind. And in writing this book I realised that when I was searching for a way of describing what leisure meant to Milner, and what it has come to mean for me, in trying to capture both its potential for upheaval and disruption, and its gentle and nurturing qualities, I was actually trying to describe what I have also experienced in psychoanalysis.

Reading and rereading Milner's books, I noticed that the same thing seems to happen in each of them. She discovers something about herself, she is surprised by her mind. Sometimes, across the books, she is surprised by the same thing – the discovery of the same fear, or same reason for anger, for example. And in the writing it is clear that she arrived at her discovery after the same painstaking search. It is as though the something intransigent about living and being alive has to be learnt over and over again. To me, this circuitous quality of her oeuvre is akin to psychoanalysis. Is this a failing? In her book about painting, Milner notes that beauty or happiness can be destroyed by a too direct

striving towards them. If psychoanalysis has an indirect or accidental relation to happiness, then surely it would be fair to ask who has the time, or money, to speak to a psychoanalyst – one, two, five times a week over ten years, or more – in order to achieve that happiness.

We live in conditions of stark economic and political injustice and such speaking is indeed a luxury. But when I hear people dismiss psychoanalysis as an indulgence for those who lead a life of leisure, or when I hear leisure itself described as something that is only relevant to those who have yachts and trust funds, I feel like we are missing the point. In reading Milner, and in psychoanalysis – which I can only afford and sustain because I am fortunate to have an analyst who asks for a fee that is commensurate with my means – I have found that, alongside all the things that are worth fighting for, surely it is also worth including the leisure to reckon with what is difficult and inadmissible, in our lives and minds. We are accustomed to thinking of leisure as free time, and in that capacity it is crucial – but leisure can also be time to make free.

The first time I saw my analyst, I sat in the chair opposite, not knowing what to say. I'm listening, he said. Those were the first words he said to me, not hello, not welcome, not tell me about yourself or what brings you here today. I'm listening. At least that's how I remember it.

When I was twenty-five, I had a brief relationship with a man about sixteen years older than me. He had many

preferences, and underneath each preference there was something hard and prickly. Rules, really, presented as preferences. I wasn't to text or call some days of the week, when he wanted to be absorbed in his work. If I did, it meant I didn't respect him, I was too young to understand the importance of what he was doing. I couldn't be late to meet him. He was always about to call things off, so it was imperative I didn't give him further cause. One evening, meeting at the Barbican, I realised I was three minutes late. I texted to say I was already there, in the toilet. Then I sprinted the remaining distance between the Tube stop and the building. He noted I was late. I offered him the box of couscous I'd made for our dinner, because I couldn't afford to eat out, and he was particular about splitting bills.

The relentless contingency of the relationship felt like passion. I was in love. He wanted to talk to me about his ideas, his past. I felt chosen. But I was never the right listener. I asked too many questions, or too few. I was too quiet, or nodded too much; once I suggested he read something and that led to an hours-long argument walking in the far reaches of south London, roundabout after roundabout of summer flowers. I wasn't *listening*. In those months I was often very late for my psychoanalysis. After some weeks my psychoanalyst asked if I could try to come ten minutes earlier. I was about to reply that I couldn't, because I was always entangled in interminable arguments with my boyfriend, but just before the words came out of my mouth I became conscious of the absurdity of my

excuse. The awareness didn't last long. When my boyfriend broke up with me in the middle of a lunch date – because it was so obvious to him that I wasn't listening – I was as involved, as keen and as desperate for things to carry on.

I'd all but forgotten about him when, eight years later, I saw him across a crowded room. In that moment, my twenty-five-year-old self came back to me, and I was appalled. How quick I was then to sacrifice my wishes at the altar of his preferences. Where had I acquired such hunger for self-immolation? Why did I act like my time or my thoughts didn't matter, like I didn't have a life of my own? I was carrying a copy of Sheila Heti's *Motherhood* in my bag that day, along with a green notebook and a fountain pen I'd bought to celebrate signing the contract for this book. Later, taking the train home, I read: 'The most womanly problem is not giving oneself enough space or time, or not being allowed it. We squeeze ourselves into the moments we allow, or the moments that have been allowed us.'

It is clear to me now that the problem Heti describes – of not giving oneself enough time – is akin to what Milner diagnosed when she was writing *An Experiment in Leisure* – the problem of the person who responds to questions about what to do with *whatever you like, my dear*. During that relationship, it was probably clear to my psychoanalyst that I was living in my boyfriend's time. In asking me to come to my sessions earlier, he was gently nudging me towards inhabiting my own time. I couldn't make use of his help then, at least not in this particular matter of

claiming my own time and space. I was too determined, to borrow Heti's words again, to occupy 'the smallest spaces in the hopes of being loved'. *Motherhood* hadn't yet been published when I was twenty-five, and I had not read *An Experiment in Leisure*. Would I have recognised myself in those lines? Would I have been able to ask myself why women are expected to give something up in exchange for love? If the book existed then, would I have picked it up?

A few days after we ran into each other this former boyfriend emailed me, *to break the ice*. I wanted to be concise in my reply, hope you're well, let's catch up when we see each other next. His reply was swift. Catching up was presumptuous. A step too far. I was welcome to say hello, and he'd say hello back. It came back to me, the feeling of always putting a foot in the wrong place. How had I not noticed how bizarre his demands were? I felt rage, anger that perhaps belonged eight years in the past. I asked my psychoanalyst if he remembered this boyfriend, the one who broke up with me because I didn't listen. Yes, he said. My session that day was on the phone. Who is he, I said, standing under the arches of St Pancras Station, to tell me what I can and cannot do?

For a long time I thought I couldn't offer the kind of listening that men needed, something like the finely attuned ear of a psychoanalyst. I tried, and I couldn't understand why I failed. Now I wonder if any sign of life from me compromised the listening. Perhaps *not listening* meant not just *not hearing*, but also *not obeying*. Now, sometimes when I

am writing by myself, or having a long soak in the bath, doing nothing, dreaming, drifting, dozing, having refused an obligation or demand, I marvel at this, because it would have been so easy to have never allowed myself such time, to have thought it unjustifiable, to have thought myself inadequate or undeserving. And then I think, all this really was born out of not obeying, of not listening to others, of learning to listen to something in myself.

I was on a Thameslink train to King's Cross to see a friend when my mother called to say that her brother had killed himself. In the months that followed I told my analyst that my brother's death had opened up a kind of black hole, because his death felt out of time. Someone in my family had died every year in the years after my brother died. Now it was my uncle. Death seemed to attract more death. I felt afraid for my family, knowledge of their mortality was immediate and regular, like my pulse. It was difficult to live with this knowledge so close to the surface. And if they lived, would the tar of sorrow set solid around them? I spoke of this week after week in analysis, how I didn't know what to do, how what I tried to do didn't help. One day he asked: Do you think you can rescue them?

I was shocked out of something, *into* something, by the question. Maybe all this time I had presumed that I *could* rescue them – even that they needed rescuing. I had presumed for myself some kind of quasi-divine power. Greater than grief, greater than their responsibility for their

own lives. Nothing in my life suggested that I was omniscient in this way. My ability to change things was small, at best. My influence was faint. To extend my influence, to intervene more effectively, these seemed like projects that would consume me, with little to show for it. I knew well the examples of women who had turned their care into sacrifice. I knew they were admired above any other kind of woman. I also knew they were mocked, when frayed from their exertions they became too angry, too religious, too frightened.

Can you rescue them? The question touched upon a raw nerve ⊢ the *wish* to rescue them, which was really a wish to undo something about the weight of the past, to deny its consequence. The question made me aware of the wish, and of the impossibility of its realisation. And yet, even now, ten years later, I don't know if I can entirely give it up. I don't know if I am permitted to give it up, because it is a strange kind of wish, both imposed from the outside and internal to my soul. But I feel it now as a faint, occasional whisper. A wish among others. *Can you rescue them?* What am I to do then? Stand at a distance and witness the loss, the mistakes, the hurt, the missed opportunities? Exchange one form of difficulty for another? People go to psychoanalysis to exchange an impossibility for a difficulty. I had gone with grief and grieving, but if you stay long enough psychoanalysis becomes a question about living. Turning an impossibility into a difficulty, exchanging an impasse for a problem – these are ways of living, they are forms of

freedom created by the recognition of limits. Witnessing my family's sorrow, their inability to speak, and learning to accept that I couldn't rescue them, this was a form of painful freedom. Not like stepping into an open field, grass underneath my feet, birds singing in the trees. But freedom nonetheless.

Once, in a newspaper column compiling advice to aspiring writers, I came across a mention of a book by the writer Anne Lamott, titled *Bird by Bird*. I didn't read the book, but the phrase 'bird by bird', in its absurd and unobvious quality, must have evoked something in me, because I returned to it when I was stuck with writing. I understood it to mean writing sentence by sentence, step by step, image by image. I fell in love with that phrase, because bird by bird made much more sense than word by word. Perhaps analysis proceeds knot by knot. The speed of boats moving through water is measured in knots, as is the speed of ocean currents. Because the mind is vast and unknown, and because analysis does not quite lend itself to representation, let alone measurement, maybe it can be accounted for in knots.

Knots per session.

Knots per year.

Knots unravelled.

Knots tied.

My mother once told me that if I wanted to remember something, I should put a knot in my handkerchief. Later, when I found the handkerchief, found the knot, the

memory would come back to me. Knots also sound like nots; perhaps that can be another measure of psychoanalysis? I am not. I will not. All the refusals learnt so slowly. No, no, *no*. Each one a knife in my hand, carving something, myself, into existence.

I had only been in London a few months. My desire to speak was choking me – too many words, and they all wanted out at the same time. Inside my newly acquired down jacket was the wish to know, and be known by people. Such need was embarrassing. London's *cool* was a social temperature. Did I wear stigmata – is that why no one spoke to me? I used to hate walking into the pub to meet people, would brace myself as though I was about to pour iced water down my spine. Hours passed watching pints drained and refilled before my eyes. Why doesn't anyone *say* anything? Where do they go to be intimate? Do I have to drink my bodyweight in alcohol before I catch a glimpse of sex, or truth? I wish I'd read Natalia Ginzburg then, describing a typically English conversation, 'in which everyone is careful to keep to superficialities and never touch on anything essential'. I kept wondering if I was doing something wrong.

I went to the counselling service at the university where I was studying, filled out a form, was offered an assessment. The woman I saw said I was entitled to five sessions with her. And then she stepped out of her role, and said: This won't really help you. Try and find someone you can speak to long-term. So I took this acute, excruciating feeling to

a low-fee psychoanalytic clinic. Then to my analyst. After most sessions I would think: it doesn't help, it *never* helps. But without my noticing, over the years, the words must have thinned out, because they no longer all gather in my throat, leaving me without voice. Who would have thought I needed fewer words in order to speak, not more? It is difficult to speak when you want to say a hundred things all at the same time, and are convinced no one will listen. If someone does listen, like my psychoanalyst, then it may become possible to take the expectation of being heard into the wider world. In psychoanalysis, I've spoken about so much that feels inconsequential, irrelevant, mistaken. But how could I have learnt to recognise what was important if I hadn't been given a chance to say everything?

I'm at an event, my friend has invited me. *Everyone* is there, even though it is a small room. I've been living in London for nine years. I'm with a friend. We keep seeing people who are friends in other contexts – or so we'd thought. There is some elaborate choreography at work, like one of those dances from television adaptations of Jane Austen. Who you can be seen talking to, who extends an acknowledgement first, who must survey the room with carefully glazed-over eyes. Later, when we step out into the spring evening, my friend and I say that was so *London*. I think of Marion Milner writing in her diary: *At the Club I was cross because I talked to no one. R. sat beside me on the sofa and giggled at* Punch. *From embarrassment I asked for a match, went to get my cigarettes and when I came*

back someone had taken my place. Another gift from psychoanalysis: the possibility of thinking I'm not uniquely affected, or singularly at fault. That some things precede me, and are not my problems to solve.

In the paper that marked her membership of the British Psychoanalytical Society, Milner describes her work with a three-year-old child called Rachel. This is one of their interactions: *she burst into a fury of real tears and gripped my arm in a frenzy of anxiety when I did not understand exactly what she wanted me to do although she had not told me.* Rachel is so very upset because she thinks that Milner is inside her, and if she's inside her she should understand, without being told, just what Rachel wants of her. When I read this exchange between analyst and patient I felt such empathy with Rachel. There is something relentlessly frustrating about someone not being able to understand you from the inside out, rather than the outside in. Even in the most attuned friendships, there comes a moment when there is a gap, where one person has to step out from inside themselves and explain what they want.

One of the phrases my psychoanalyst uses most often is 'Can you say a bit more about that?' The spider inside me has to spin some more, and I pull the threads out of my mouth, more words. And so I keep learning how to use the words to make the inside of myself external. It is tiring! And unsuccessful! Like Rachel, I wish he could just look inside me, and know what I want, what I need, what ails

me. But there he is, in his chair, stubborn in his refusal of symbiotic understanding. What can I do? I have to learn to make myself understood. To him, to myself. I'll say something, and then I'll ask, 'Does that make sense?' And then he'll reply, 'Does it make sense to you?'

When I first started speaking to my psychoanalyst, I thought of his work with a feeling akin to horror. This man sits in a chair for seven hours a day, while people cry in front of him. I cried a lot, I thought everyone did. Imagine sitting in a chair and not offering any consolation, not even tea, no reassuring embrace. It seemed to me that he lived an unbearable life. Still, I was glad he was there. And afterwards, when I walked to Golders Hill Park to look at the flightless rhea in its enclosure, I was glad for having spoken to him. To my delight, I discovered in the diaries Milner kept during her analysis an account of a visit to Golders Hill Park. *This feeling of the encroachment of other personalities, even people wandering around the garden disturb me, I feel I must get away . . . but just now I stood and looked at the autumn crocuses, at their pale freshness – in contrast with the brown and heavy green and trees and grass.* It was a relief to remember that everyone, at some point in their lives, found the problem of what to do around other people insoluble, and was able to find comfort in a public park.

I smiled, in relief and recognition and amusement, when I first saw a painting by the artist and designer Moki Cherry at an exhibition of her work in London. It was titled *Communicate, How?* The painting shows a figure

in a yellow shirt – for some reason I thought of her as a woman, though there was no reason to assume this about the painting, except perhaps my identification with it. The shirt has what looks like a lace collar, the kind I'd associate with a certain variety of demure fashion. The figure has a face, but I'm not sure if it is a human face. It looks a bit like a bird, or some kind of alien. At least three parts of the face look like eyes to me, and I wonder if the alien figure has some kind of bird coming out of the side of its face. The face appears to have large, red swollen lips, but maybe I am wrong to think of it as a face – it could very well be some kind of botanical cross section. And yet however strange and multiple the possibilities of interpretation, the drawing to me looks like a woman wearing a yellow shirt, her head quizzically tilted to one side. Yes, she appears to have a bird coming out of the side of her head. And yes, on the other side of her head are some wavy lines, which may be the bird's tail, but which make me think of something entering or coming out of her ear. In a gentle arch over the figure's head, Moki Cherry wrote the words 'Communicate, How?'

The painting captures everything I find so weird, wonderful, fantastical and impossible about communicating. (In a diary entry titled 'On communication' Milner wrote: *Is it that I want something impossible from it?*) How will the woman in the yellow shirt translate this avian fruit jellyfish inside her head into words, into something that someone else will understand? She seems like she has so much to

say (so much that some of it has taken the form of a bird pushing itself out of the side of her head), but how will she say it? With what? From where? Then I wonder if she can't speak because everyone around her already sees her as a lost cause, as someone who is strange, with eyebrows that look like sections of grapefruit and no nose to speak of – maybe she has for so long been considered outside of speech that she's lost hope in making herself understood. Or maybe her face has become so bizarre and unrecognisable because no one has listened to her in a long time. I look at the painting again and I'm no longer sure if the woman is trying to speak. It seems to me like the figure is sending waves out of her ear, wavy communicative signals as if to say, I'm listening, I'm trying to understand. Maybe she's keeping the faith.

At the same exhibition where I saw the painting, I also watched a film that showed Moki Cherry with her husband Don and their son Eagle-Eye, at their house in Tågarp, Sweden. A young Eagle-Eye was playing the drums, and after he had played, Don Cherry would return the tune to him on a flute. To my ears, what Don played sounded both like a repetition of Eagle-Eye's playing, but also as though it had somehow been structured. They carry on like that for a while, in the film, while Moki paints a drum. I was struck by how the way in which Don listened to Eagle-Eye had created a conversation in their playing. A child banging away on the drums, his father playing the flute, his mother painting a drum. These are images of leisure. Is it in this

kind of unhurried time, where there is pleasure in following a wish or an impulse, where there are no goals to be met or targets to achieve, that we learn to communicate?

Maybe psychoanalysis is worthwhile not in spite of the time it takes, but precisely for all the time it seemingly wastes. Playing, free association, complaining, being stuck, going on and on about something, not knowing what to do – these are the daily bread of psychoanalysis, and intrinsic to an experience of leisure, which like psychoanalysis is not meant to be efficient. You can have efficiency only when you know where you're headed. But for any real discovery or surprise, for something unexpected to come into language, surely all this needs plenty of time when nothing recognisably important happens – a meandering, wandering kind of time.

I have a session of psychoanalysis one afternoon at work, over the phone. I'm sitting on a bench outside, there wasn't time to walk the distance to my office. I've just come out of a meeting where a man patronised me. We were about the same age, and I'd never met him before. We had both been invited to speak about our work. When he finished, I asked him questions and complimented him. He accepted the compliments as though they were his due, though his response to my questions was somewhat contemptuous. He did not listen when it was my turn to speak about my work, and in that small gathering it was impossible not to be aware of this. I was left with the feeling that my mouth had

been producing sounds untethered to meaning, rather than words that conveyed an argument. I felt dispirited, like I didn't have a place at the university, something I also felt when security guards questioned me when I tried accessing my office, or when colleagues mistook me for a student – their disbelief often persisting even after I'd produced my identity card. Speaking to most men at university, I told my psychoanalyst, I had the impression that I would only be heard if I was offering praise. But I can't always fake it, I said.

And there were other problems. I tried to inhabit this position of deference as though it was camp. But men took my irony for praise. It is women who taught me how to write, how to think. So why do I keep meeting men who act as though these things belong to them? Even as I write this, I don't fully believe it, or don't want to. But have you ever gone to a dinner party? Have you ever gone to work? As men talk over me, I think, but surely the loss is theirs? Surely they must realise that, if they carry on like this, I'll know much more about them than they know about me, than they know about themselves?

Tactics and manoeuvres, I say to my psychoanalyst on the phone, I am waist-deep in them, trying to cope with the masculinity of straight men at work. I really want to win, I say, but I don't want to win at their game. To recognise the rules and rewards as set by them feels like a form of entrapment. I just want to write my stories, and not be noticed very much. I don't want respect or recognition

from these men, but I also don't want to face the consequences of injured masculinity. I'm afraid I'll go too far, I say. Too far? he asks. Yes, I'm afraid that I'll have a full-blown attack of the giggles when I'm talking to an important man with a big desk.

When the session ends, I turn round and notice that there is another bench behind mine, separated by a bush. Two men are sitting there. Their clothes and posture are professorial. I crouch behind the bush. Are these the same men I've been talking about? Will they turn round and look at me? I stay crouched, then walk away. I shouldn't worry. For reasons I don't understand, man after man I meet will think he is an exception to the critique.

Sometimes when I am reading a book by someone who is trans, or queer, or a woman, a book that has taught me how to think, and how to write, I'm struck by everything that book has contested to just be there, and it is as though that pressure has brought something into being, something sharp and new and revelatory, something that expands the possibilities of living. These books sustain me and I'll often speak of them during psychoanalysis, and often I feel that my psychoanalyst lets me have my revelations from books, as he quietly listens. For ten years he's been listening to me, and he hasn't told me what to think, how to be, what to do. And why should he? Aren't there enough men who are willing to take that place, who think they know, who think they know better?

*

What happens when a listener is unkind? Or there is no listener?

Housing trouble, immigration woes, workplace animosities, discrimination. In all of these, I have received truly essential and life-changing help from unions, activists, legal volunteers, among others. Psychoanalysis cannot act on the sources of these troubles. My psychoanalysis, however long, or intensive, won't change the immigration policies in this country, it will not act on prejudice in the workplace. Sometimes, while speaking in analysis, I'm struck by how the situation I'm so troubled by would be different if an employer or politician took the time to interrogate themselves. *They* should be in analysis, I think. But that won't happen. Maybe music or films or writing can encourage self-questioning, but no one can be forced into a psychoanalysis. When I was twenty-four, I asked my psychoanalyst: Can someone be a psychoanalyst and a nationalist? Psychoanalysis saves no one from stupidity, he replied.

I tell my psychoanalyst how something felt unfair, racialised, rude. Did you say something? he asks. *Did you say something?* After years of being asked that question I think, maybe I *can* say something. One day I tell him about how I feel, and sense, and think that expectations at work are structured by racialised assumptions. I tell him how I think these thoughts, and then push them away, because I have to carry on working.

So you repress yourself, he says.

That has a sting. I don't want to be on the side of

repression. But I notice the part I'm playing towards myself. That recognition is uneasy. It is more bearable when I can think that all the difficulty comes from somewhere outside. What would it mean to exchange repression for speech in these circumstances? I can't find out without trying.

The results aren't magical. *Did you say something?* Yes, and it was a disaster. I'm trying to replace repression with speech, but all too often that speech is taken as confrontation. When you're expected to be silent, speaking has a cost. 'Collegiality is a promotion criterion', I'm reminded in a work meeting. Being hated, disparaged, mocked, insulted – none of this is easy, or pleasurable. Is it really worth it? I'll ask myself, and ask again. Seeming mad to others, and at times to myself. Surely the road to success – or even just a peaceable life – is paved with repression? But there are costs there too. Less visible perhaps, paid privately. Distraction, aches and pains, drowsiness, not being able to write, not being able to sustain a dialogue with myself. A mind coming apart at the seams.

Writing *A Life of One's Own*, Milner discovered how an unadmitted thought could produce an array of symptoms – *worry, depression, headache, feelings of rush and over-busyness* – and she found out that she was relieved when she could finally put the thought into words and say it to herself. The only way of finding out what was going on was to *stop all attempts at being reasonable and give the thoughts free rein*. This sounds like a description of psychoanalysis, but in it I've also found a prescription for refusing

the repression that is concealed in the demand to be reasonable, a demand that is disproportionately directed at young women, workers demanding better conditions, protesters outside an arms factory – at anyone who is asking for a different, more humane world.

My psychoanalysis is making me unpopular. I joke to my friends that I go to psychoanalysis so that I can be more of a bitch. It is a joke, but it's true; how much and how long will women suffer from their accommodations? *Did you say something?* Yes I did. I was angry and I said what I was thinking.

I was walking in Peckham Rye with a friend, and we were talking about our lives, and our psychoanalyses. This was when I lived in the bedsit in Brockley, when we could only meet friends in parks. I told her that I felt much angrier than I'd been when I first started my psychoanalysis. She said she felt like she was testing what it was like to be angry too. After I left, on the long walk alone to my flat, I wondered if what I had said was true. Was it really the case that I wasn't angry in my twenties? I couldn't remember being angry, but I could remember being sad.

It was around the time of that conversation that I felt, in a session of analysis, an expanding sense of anger, like a slow explosion. I started feeling it when I was talking about a video my mother had sent me, a contextless short clip circulated on the internet. A baby in an elaborate and pretty white dress is placed in front of a photographer. And then

she does a massive poo. My mother had said something about how much that video reminded her of me as a baby. I'd shit over all her efforts to make me look nice. But I was a baby, I said to my analyst. Babies poo, and 'mothers were those who told you how hard it was to have you', writes Carolyn Steedman in her memoir about her working-class childhood. It doesn't make sense to compare my life to hers, but I read that line with a jolt, my mother saying she never got her body back after having me, never lost the weight that came with the pregnancy, I didn't eat, I spat out my food, I did a poo. It continues, I said to my analyst. My mother's upset when I visit her – you're not getting married, I don't have a reason to buy nice clothes or colour my hair.

I was angry for three entire days without respite. All alone in my bedsit, I was so angry, I felt like my thought breached all taboos. My body could barely contain the rage or hatred I felt towards my mother. I wished her dead. For three days the anger burned, and then I realised that I was no longer angry, and something was loose, and free, in my body and my mind. After surrendering to the most violent emotions, I felt released from the need to blame – my mother, my parents, anyone at all. And yet, nothing had changed in my circumstances. I don't fully understand what happened, but I wonder if all through my twenties I converted my anger into sadness, and the greater the force of my anger, the more despondent I was. And because I was scared of my anger, I couldn't allow myself to notice

it, and I couldn't be angry, except in a slow tearing down of myself.

Especially when the world is at war, as it always is, there will be people who criticise men for their violence, and praise women for their peace. As though the world would somehow be more harmonious if it were run by women. I want to believe in this vision, but I can't, because I've been living in Britain for the last ten years, and it is women in charge who have deported refugees to places where they face a threat to their lives and denied migrant mothers a £3 a week allowance to feed their children healthy food while trapped in hotels. But even of the peaceful women invoked by this fantasy, I wonder – what have they done with their anger?

I find myself wishing that instead of striving for harmony, pleasantness, order, maybe women can strive for a fuller experience of the mind, and experience their own nastiness, including the force of their anger. And then I think of what anger has done to the social fabric – in India, in Britain, in other places I don't know well – and wonder if I was right to fear my anger. My rage brings me so close to what I deplore. Over and over again, in her autobiographical writing, Milner comes up against the problem of the disturbing emotions – anger and hate and envy. They show up when she least expects them. *It seemed very odd that thoughts of fire and tempest could be, without one's knowing it, so close beneath the surface in what appeared to be moments of greatest peace.* I don't think she ever finds a

resolution to these emotions. She seems instead to find, over and over again, ways of accepting them.

To fully experience one's mind, to not make it someone else's problem, to be able to protest loudly and publicly without that protest being read solely as a psychic symptom (or being criminalised), this is what I want for myself, for other people. Milner's writing issues a complex invitation: to allow oneself to feel the most unsettling emotions, without settling into them, or taking them as the basis of a fixed psychic position. Feelings need to be allowed in their intensity, and then they can also be allowed to change into something else. This can happen in psychoanalysis, but it takes time. And it can also happen in the time we call leisure. If I can kill my mother without wanting her to die, if hating her frees me to love her, then maybe I have to find a way to inhabit my rage and hate without fully believing in their truth, and to do it with the knowledge that I share more with those I hate than I would like to admit.

The experience of leisure can often feel oblique – like a dream, where it is not always possible to say what is significant. We don't always understand what leisure does for us, for our minds and bodies. Just because understanding is elusive, or the experience doesn't lend itself to justification in terms of utility, should be no reason to deny such time to ourselves. I have been trying to narrate something about my psychoanalysis but I know I have left out so much of what was essential – because I don't remember it, because

I didn't notice, because I don't have the right words. Often
when I think of my psychoanalysis, I remember a particular
conversation. I still don't know what significance to attri-
bute to this exchange, which seems in many ways acciden-
tal. If I have to attribute some meaning to it, I could say
that, like leisure, psychoanalysis leaves one open to the gift
of surprise, of the unexpected.

One day, I was telling my psychoanalyst about a stray
cat that had started living with me. I didn't know if he was a
stray cat, or a greedy neighbourhood cat. In any case, he was
getting sachets of Whiskas wet food from me, and sleeping
on my bed.

I wonder if I'm stealing him from someone, I said. I
wonder if he already has a home.

Like Six Dinner Sid, my psychoanalyst said.

Six Dinner Sid? I asked.

Don't you know *Six Dinner Sid*? he said.

Inga Moore's book tells the story of a cat called Sid, who
lives on Aristotle Street. Sid lives in six different houses,
has six names, and eats six dinners every night. When he
gets a cough, he is taken to the vet six times, by six dif-
ferent people. This is his undoing. He is found out, and
his dinners are rationed. So, Sid then moves to Pythag-
oras Place, where his six-house and six-dinner ways are
welcomed by the residents. I could say that this conver-
sation is significant because my cat gave me a feeling of
belonging – I may have offered him a place to live, but he
helped me feel at home. Or that my analyst and Six Dinner

Sid both understood that home could be multiple, contingent and various. I could even say that *Six Dinner Sid* is a story about finding a life of one's own, even if it means also finding a new habitat in which to live. But I really think that this conversation was a fortuitous accident, an unexpected gift. Although I've been speaking to my psychoanalyst for ten years, I know very little about him. Now I like to imagine him reading *Six Dinner Sid* in his leisure, surely that is what he does when all the patients are gone at the end of the day . . . and in the meantime my cat, to the best of my knowledge, has given up his six-dinner ways to live with me. He pads in and out of my psychoanalysis, sometimes using a fat, fluffy paw to knock something off a shelf.

When we finished school, my brother and I left our parents' home, and went to university in different cities. My adoring relation to my brother never changed, I wanted him as a witness to my life, I wanted to know him and be known by him. My brother was laconic and elusive, and I never stopped feeling like a younger sister trying to catch up, but he was also present to recognise significant moments in my life. After he got his first job, when I was at university, he bought me a laptop, because he knew I liked watching films and writing. Another time, when my girlfriend and I were on holiday with my parents and brother, he made a joking remark suggesting that my girlfriend and I should marry, much to my mother's alarm. Like his humour, which was pithy and dry, the recognition my brother offered me was

through remarks and gestures that were both succinct and entirely on point.

From childhood, he had a questioning relationship to the values and morals of our parents' world. As we grew older this developed into a form of tacit allyship – we were both trying to make a break from a milieu we found constricting and oppressive. We each wanted a life of our own. We had different interests growing up, but from his adolescence my brother questioned religion, nationalist history as we were taught it at school, and he was uncompromising in his beliefs and commitments. For this reason I was also always concerned for him, because it often felt to me that the people around us could be cruel – albeit unintentionally – in their narrow-mindedness, could act frustrated and disappointed in relation to someone who did not think or live in the way they did.

As someone who had lived with a painful chronic illness since he was a child, my brother had always been at the receiving end of well-intentioned efforts to cure and change him. In a culture that prized able-bodied masculinity, all too often he was offered pity instead of understanding. I don't think anyone ever said to him that he was fine and loved just as he was, that he did not owe anyone health or compliance. I felt connected to him as if by a living pulsating organ, and though dazzled by his brilliance and eager for his insights, I also felt an aching worry about him, so constant that it felt like an organic part of my being.

When my brother died, my father kept the manner

of his death – suicide by a careful combination of pre-scription pills – from my mother and me. For my part, I believed the explanation I was given – he had asphyxi-ated in his sleep. I must have wanted, very much, to believe this, because I don't remember asking any questions and I remember repeating the explanation to friends and rela-tions who had come to our house to mourn. But a part of me, entirely silent and yet capable of acting on intuition, must have known. Some days after his death I walked over to his desktop computer, turned it on, and found the note he had left. I didn't know what prompted me to open the computer, or what I was looking for, till I read his note. I read it a few times, and it was as though what I was reading was a confirmation of something I had already known, of the worry I'd always had inside me. The note did not offer an explanation for my brother's decision, only some instruc-tions and an apology to his friends. He left no message for me; the note didn't mention me at all.

I told my father about the note, and it was then I learnt that he already knew. He asked me to remove the note from the computer. I did, and I still regret my obedience, because it meant I lost my brother's last words. I hold the impression of those words in my mind, but they have long been subject to the distortions and erasures of memory. My father said I mustn't speak of what I had discovered. I must not tell my mother how her son had died. In this instance it was harder to obey. I was nineteen, but even then it felt obvious that to lie to someone on the basis that the lie was

in their interest (my mother would suffer too much, she wouldn't be able to take it) was to subject them to a form of personal disrespect and political disenfranchisement.

Despite this, my obedience clung tight to me, and sealed my lips. A few weeks after my brother's death I was back at university, working on an essay on the *Prison Notebooks* of the Italian Marxist Antonio Gramsci, written over the course of his eleven years of imprisonment under emergency laws in Mussolini's Fascist Italy. I did with the essay what I would go on to do with my doctoral studies – I poured my anguish into thinking and writing. The essay was successful; it was praised as an exemplary piece of writing by the lecturer, who asked me to read it to the entire class of students. She was a beloved teacher of mine, and one of the first people to whom I relayed the circumstances of my brother's death. I told her I wanted to tell my mother but the words would not pass my lips. She suggested that if I could not speak I should write, and send my mother a letter. But while my lips were sealed my hands too felt paralysed, and I could neither speak nor write.

Stuck between speech and silence, the weeks then months passed in anguish, inarticulate and unsparing. At Christmas I went to see my girlfriend and her family in Colombo. I remember the visit from a photograph: at church in a cotton sari, beside me my girlfriend and a visiting Canadian who was a former Cirque du Soleil gymnast. All of us are wearing red, the gymnast is glowing from a holiday tan, the clothes hang loose on my body. My

parents had agreed to visit me there. My mother felt like I was keeping something from her, and I said we could speak when we met in Sri Lanka over the holidays. My girlfriend and I had conversations about how I would tell my mother, she gave me courage and her family looked after me. About three months before my brother died, the Liberation Tigers of the Tamil Eelam had conceded defeat to the Sri Lankan armed forces, after a long war accompanied by the relentless persecution of Sri Lanka's Tamil minority. I was visiting a country in the immediate aftermath of a war, and my girlfriend's family welcomed me among them when they were grieving the loss of a political future and the dream of a homeland.

Some days before New Year's Eve, my parents, my girlfriend, and her aunts and cousins all went to a seaside resort. My parents made it clear to everyone that they didn't want to be there. I was fearful in their presence, afraid of the terrible emotions enveloping them. I had a bed in their room. One morning, as I left to go to the beach, my mother stopped me. Anticipating that I would tell my mother about my brother's suicide, my father had told her himself. My mother was angry. I was wrong, she said, to have forced him into such a position. I had caused them both pain. Then she said I was living a reckless life with the wrong people – I would drink too much, I would take drugs, I would have sex and ruin myself, I would kill myself. My mother was foretelling my future. I must have protested what she said; I can't remember a single word I said. I just

remember the feeling of shock, and I remember that I was wearing my favourite blue T-shirt, the one printed with pictures of Amrita Sher-Gil and Billie Holiday.

Later, I lay on the beach, and read my paperback copy of *The History of Sexuality* by the French historian Michel Foucault, making notes in the margins. Since writing my essay on Gramsci, I had discovered that reading something dense and challenging could dislodge the pain and incomprehension that were otherwise a constant. This was for the most part an efficient and largely effective strategy, and one that was more easily available to me than alcohol or drugs. It was a way to manage the pain that also left the pain as it was, cauterised from thought and language. Years later, speaking in analysis was a means of re-irrigating parts of my history with language, a process that was also bound up with reading Milner, which required me to dissolve the system of dams and flood walls I had built inside myself. And then to allow myself to write in a style I associated with Milner, drawing more on memory and experience than a period of research – this also meant returning to that time immediately after my brother's death, when I had first begun to rely on forms of academic striving as a way of keeping pain at arm's length.

For a long time my father's prohibition on speech and my mother's words to me in the seaside resort lived inside me. When I turned twenty-four, I thought what my mother said would come to pass. I thought I too must die at the same age as my brother. But a month or so before my

twenty-fourth birthday, which felt more like an appoint-
ment with death or nothingness than any kind of joyful
occasion, I had made my first visit to my psychoanalyst. I
had told him I had a feeling of death inside me. And in
speaking to him, even in those initial first weeks, I was able
to access another meridian, different to the one where I was
on a timeline of ruin and death. I had entered another time,
one where he was present every week, where he was there
to listen to me. So it came to pass that on my twenty-fourth
birthday, when I had thought I would and must die – not
by any act of my own but by some kind of fate or destiny –
well, by then I had been granted another time, that of my
own life.

I will never understand why my brother decided to end
his life. There is something about the decision that will
forever escape me, even though in the years that followed
I tried and tried to imagine myself into his mind. How
someone dies inevitably shapes the grief that follows.
Suicide extinguished the explanations that may soothe
mourning. Its message is incontestable. Life was unbear-
able. When I went to psychoanalysis, I wanted to ask ques-
tions about my brother's death. I wanted to understand
what or who was to blame, myself included, and how.
These are questions I've lived with every single day since my
brother died. I wanted to ask them in someone's presence.
No one could answer these questions, but psychoanalysis
could help me live with them. I could accept the question-
ing. I wanted to examine every failure – of understanding,

communication, courage. In so many ways, my brother was failed by his education, his family, his society. This was painful, still is. But even as I know that my understanding fails, I know I owe him understanding, and curiosity.

Writing about my brother and my uncle, I have felt a sense of betrayal, an enveloping feeling of shame. The betrayal is connected with speaking itself, and with writing that comes out of wanting to speak. Intimate with silence, with things that must not be spoken, in my family speech must make itself weightless, lest something detonates. I could even say that silence is all too familiar, especially as the etymological root of 'familiar' lies in *familia*, family. Silence is seen as the substance of loyalty, and the foundation of honour. And in silence, shame flourishes. It is still difficult for me to judge whether speaking is better than silence. I fear that speaking will bring its own harm, its own forms of heartbreak.

For years after my brother died, I dreamt of him. The dreams followed a pattern. He was in danger, or he was about to die, and I was trying to find a way to keep him alive. In one of these dreams I say to him: 'I want to claim you for life.' For life, from death. Then, over time, these dreams became less frequent, and when my brother appeared in my dreams it felt like a lucky visit. Recently, when these feelings of shame and betrayal connected to writing were particularly acute, I dreamt of my brother. In the dream I ask him how he feels about me writing about him, sharing details of his life. I ask him what he thinks of

that, whether he will assent to it, but I don't receive a reply. The dream was consoling. I realised that no one could answer these questions for me. I had to decide for myself.

Maybe it is possible to live as though the mind isn't complex and the will is obedient. After all, this intricacy is troubling, and perhaps it is possible to live a full life without ever having to reckon with it. But I feel like I know far too intimately the consequences of not being able to see, or speak, the complexity of the mind, to inhabit it. It can be so easy to want things to be simple, and so devastating. My family loved my brother, of that I have no doubt. They loved my uncle too. But love isn't the same as understanding, or acceptance. Love can leave questions unasked, love can claim to know what's right, love can care too much about what other people and society will think, and still be felt as love. Does grief beget thought, or stunt it? I don't know, but I needed a place to ask the question. And in that place, someone sat, and said, I'm listening.

After my brother died, and then my uncle, my family could arrive at no shared understanding of what had happened. If you spend most of your life not speaking about things that matter, it is difficult to learn all of a sudden how to talk. Though the costs of not speaking were stark, speaking still felt too close to shame. Milner's project of writing and living by experiment begins with a refusal of inner censorship. For me, psychoanalysis has been an experiment in speaking, and I told myself that writing too could be a similar endeavour. I'll put the words on the

page, and then decide. So I wrote, and I put the writing aside. In writing about my brother and uncle, I thought I was describing something in the past. This was a false form of reassurance. Just as I was halfway through writing this book, I received the news that my uncle's grandson, my young cousin, had taken his life. He had jumped from the roof of the building where most of my maternal family lives. My mother called and told me he had an *accident*. But in that difference between accident and intention lies the question of memory. Do we owe memory truth, or lies? And what will memory accept?

The stakes of speaking and not speaking shouldn't feel so high. But all through these years the deaths have placed such a burden on my psychoanalysis, the burden of urgency, understanding, finding a way to live and mourn all at the same time. This urgency, which makes speaking so necessary, can also make words freeze. When I received news of my cousin's death, I found myself grieving not just a bright young boy fascinated by the world, but my whole family, their tragic destiny. At first, my mind could only absorb the news at some cognitive level. It wasn't until I fainted, weeks later, that something became real about the death. To understand, I too had needed to fall.

Almost two months had passed since my cousin died – during this time, I moved to Glasgow. It was late evening and I was preparing a seminar for the next day's teaching at university. I picked up Charlotte Salomon's *Life? or Theatre?* from my bookshelf. Made when she was in

hiding from Nazi authorities in France, Salomon's work is an extraordinary record of her life – entirely unique in its form, it brings together her paintings, writing, and is accompanied by notes about what music accompanies the words and paintings. I had meant to look at a few pages, but I sat down and read the entire book. When I stopped, it was half past one, and the streets and houses had gone very quiet. The window in my third-floor flat was very big, and opened like a door. I thought of someone, myself, jumping out. On the ground below were large vegetable beds, run as a community allotment.

Every suicide opens a door. Those remaining may look at that door and wonder: can I also walk through to the other side, to death? Charlotte Salomon made her work after learning of the suicides in her maternal family, which included her mother, aunt and great-grandmother. The manner of their death had been concealed from her, and her family history was only revealed to her by her grandfather after her grandmother also killed herself after war was declared in 1939, news of the war playing a decisive part in her suicide. Salomon made nearly a thousand paintings for the book. Though it addresses suicide and political devastation, the work is Salomon's affirmation of life. At one point, deliberating over whether to live or to join her family in death, she writes: 'I shall live for them all!'

I thought I had started psychoanalysis to learn to grieve – but it has turned out to be about living. When I started writing this book, I thought Milner's work was

important to me in finding a life *of my own*. That was what I was searching for, a way of living that felt honest to myself. But then I thought, maybe I am so drawn to her work, so in need of it, simply because it is about *life* – it is a work that has the joys and tribulations of living as its beating heart. Death, especially suicide, puts life into question. Confronted with death, that's what I wanted to find. An affirmation of life. *I was as sure as that I was alive, that happiness not only needs no justification, but that it is also the only final test of whether what I am doing is right for me. Only of course happiness is not the same as pleasure, it includes the pain of losing as well as the pleasure of finding.*

Sewing

The low-fee clinic through which I found my analyst was run by a psychoanalytic organisation that was influenced by the work of the French psychoanalyst Jacques Lacan. I went for the referral meeting to an unfamiliar part of London, which I would later learn was New Cross. And still later, after many years had passed, I listened to a recording of Linton Kwesi Johnson reading 'New Craas Massakah'. But that afternoon I didn't know where I was, and I was guided only by a map I had drawn myself, and a list of street names and directions copied out from the internet. For all my interest in psychoanalysis, I had no idea what to say to an actual flesh and blood psychoanalyst. I found myself telling the psychoanalyst I was seeing for the assessment about my sadness, how I had lost the wish to do anything. All I could do was a form of embroidery known as cross-stitch, and she must have asked me something about this because I found myself explaining the movements of the needle through fabric that were needed to arrive at a cross made from thread. She said, 'It sounds like you are literally stitching your life together,' and I remembered that I had

first learnt to embroider in the weeks after my brother had died. At the end of our meeting she printed out the name and contact details of the man who would become my psychoanalyst, saying that I was clearly very interested in literature and culture, and he was too.

I speak to my analyst about my family (again). As I'm speaking, I see an image before my eyes: large baskets, full of yarn. What am I to do? I open one of the old diaries and see a poem I composed years earlier:

> Oh Mother I'm old now as you
> When you had your first child
> And a little older now
> Than your son when he died
> And I'm learning to cook
> And I'm learning to sew
> Myself into a woman-not-you
> But I find in my bag
> With needles and thread and fabric glue
> So many patches and ribbons and swatches of you, you, you.

My mother has often expressed the regret that I have chosen a life that cannot accommodate her vast collection of saris. In doing so, I have deprived her of the opportunity to collect even more saris for me to inherit. I keep depriving my mother of reasons. By not getting married, I steal from her a reason to colour her hair. By living in a cold country I steal her pleasure in buying soft, fine-spun cotton. By not having children . . . and so it goes. Last

year, I bought myself a sewing machine, and cut up some of my mother's saris to make curtains. All that yarn can't be wished away. I've always wanted to get away from my mother and now I'm surrounded by her. I laugh when I think that a curtain is a separation, a barrier, an instrument of privacy. I am sewing separation out of the material of identification. The next time someone asks me what I've got from my psychoanalysis – as people sometimes do at parties, especially clever men – I will tell them that I have learnt to make curtains.

6

Coats and Cocoons

Before I stepped into the room, I stopped in the toilet to look at my hair, and smoothed down the frizz. I reapplied some lipstick and blinked my contact lenses into place. I was intensely aware of having a body, and it wasn't at all obvious what I was supposed to do with a corporeality which felt so distant from any consciousness I had of myself. I wasn't in my body. I was hovering above it, or walking a few steps ahead of it, and once I had sat down in the chair by the window I was convinced that my thoughts and memories and attention were all inside a little chirruping bird which was hopping on one leg on the tree outside. I unstrapped my wristwatch and put it on the windowsill. I wanted to bring myself back into my body. Looking at the tree, I tried to become aware of the centre of my body, as though I was building a nest where my bird-self might come to rest. The room was a clinic for students, in the attic of an art school building, and I was sitting in the analyst's chair.

I was about to see a patient in the context of an analytic training. Many years into my own psychoanalysis, the work

that my analyst did no longer felt unbearable to me – in fact, it had become interesting, and I wondered if I might be able to do it too. My own analyst never used the word 'training', instead saying 'formation', which was closer to the French of the divisive psychoanalyst Jacques Lacan. The distinction made intuitive sense. What kind of training could be adequate to something as ordinary, and as terrifying, as listening to another person? The word 'training' suggested something restrictive, or prescriptive. Something had to shift in me to accommodate being a psychoanalyst, and the unconscious as I knew it was not inclined to respect a set of imperatives in the name of training. Something more fundamental had to take place, something *formative*.

All this was no consolation as I sat waiting for my patient. There had been no rehearsal for this, there were no guidelines – there was a code of ethics, yes, and the experience of my own analysis, but these felt thin in that moment. Later, when I told my clinical supervisor that I had felt anxious, he asked me what it would mean not to feel any anxiety when encountering someone for the first time. In refusing to allay my anxiety, or telling me what to do, I felt like my supervisor was reminding me that I was alone in the room with my patient, and the responsibility was mine, I would have to think for myself.

Around this time, I read Milner's *The Hands of the Living God* for the first time. I have returned to it many times

since, and the questions it has raised on each reading have become intrinsic to how I think about the practice of psychoanalysis, and so much else besides, and as with everything Milner wrote I discover something new in it every time. *The Hands of the Living God* describes Milner's analytic work over the course of more than twenty years with a patient she called Susan, who first came to Milner's consulting room in 1943, after a period in a psychiatric ward. At the hospital she had been given electroconvulsive therapy, which involves administering an electric current to the head, resulting in a controlled seizure. On meeting Milner she said *three things: that she had lost her soul; that the world was no longer outside her; and that all this had happened since she had received E.C.T. in hospital.*

After nearly sixteen years of five times a week analysis, Susan saw Milner less often, stopping by for a session once or twice a week. In as much as *The Hands of the Living God* is a 'case study', an account of work with a patient, it is also a book that can be included, I think, within Milner's autobiographical writing. As it leads us through twenty years of Susan's life, the book also offers an account of how Milner herself changed, despaired and grew as an analyst. If Milner's other books are autobiographical explorations of things that intrigue her – painting, leisure, travel – this one can also be read as the history of her engagement with psychoanalysis, no less an experiment because it is presented as a case study.

Towards the end of the book, Milner mentions a curious

detail about a coat. *I had kept a spare coat of mine for Susan to borrow on occasions, since she was so little in touch with what the weather was likely to do that she would often turn up quite inadequately clothed.* When I first read the book, I had never come across any instance of an analyst lending clothes to their patient. My surprise was perhaps as much to do with the keeping as with the lending. That Milner had made over not just her time, and attention, but a part of her wardrobe to her patient, not just once but over the years – I didn't know what to make of this. *The Hands of the Living God* is a book with all the paratexts of authority – glossary, bibliography, index, a foreword by Donald Winnicott. But within the pages of the book I found Milner refusing the position of one who enacts a cure, or solves a mystery.

Instead I found a coat, curved like a question. Traversing, and sometimes creating, composites of analyst–mother–patient–daughter, the coat passes between analyst and patient, a shared space, perhaps a shared body. What is being passed on with the coat? Feeling imprisoned in grief for my brother, and unable to translate this to those around me, I had found comfort in a fantasy. I would turn into a little mouse, and live in my analyst's coat pocket. Sometimes, I came out for conversations. Milner lent her patient an actual coat; I borrowed an imagined jacket pocket from my analyst. In both instances, the experience of being in a cocoon was significant, and, among other things, what Milner discovered in her work with Susan was the importance of cocoons to experiences of leisure and creativity.

Reading *The Hands of the Living God* and embarking upon an analytic practice myself also brought into view for me the connections between care and security, and how these shape our experience of leisure and creativity.

Susan was twenty-three years old when she started psycho-analysis with Milner. Meeting Susan at the hospital, Alice Winnicott, the first wife of Donald Winnicott, was struck by her beauty – *like the Botticelli Venus rising from the waves.* A sculptor and painter as well as a skilled ceramicist, Alice Winnicott was then offering occupational therapy at the hospital. She persuaded Susan to leave the hospital and live with the Winnicotts at their house. In addition to providing Susan with a home, referring her to Milner for analysis, for which he paid, Donald Winnicott also became Milner's analyst – an analysis that was carried out at Milner's consulting room. He had previously been her former husband Dennis's analyst.

This was incredibly messy, as Milner and Winnicott were also close colleagues, confidants, and had expressed intense feelings for each other. Her relationship with Winnicott left Milner troubled, and was never resolved. The relations between Alice Winnicott and her husband, and Milner and her analyst, were complicated enough, but Susan's appearance, her beauty and the way she shuttled between them drew them into a tighter knot. There is something about all this that leaves me feeling squeamish. All these people trying to do good things, did they ever

stop to ask themselves what all this helping was doing? It worries me that Susan was just available to them, and they could have so much of a say over her life – an authority conferred on them as much by their class position as by the status of psychoanalysis.

In the history that Milner writes for Susan, deprivation stands out as much as beauty. We are told that Susan's maternal grandmother died of malnutrition, holding her six-month-old baby, Susan's mother, in her arms. Of her own childhood, Susan *remembered always being hungry.* Her mother worked in a laundry, and the family received food from the parish relief. They lived with a man called Jack, a former soldier. It was only after beginning analysis with Milner that Susan discovered that Jack was her father, having been told by her mother that her father was 'Pop', her mother's husband who had left them to live with another woman in London. For Susan, deprivation went hand in hand with sexual exploitation. When Susan was about four years old, a neighbour, an *old man,* would *give her bread and jam and sweets to bribe her to let him masturbate against her.* At the age of sixteen, Susan joined a dancing troupe. She was staying with Pop, and one morning when Susan was in bed *he came and tried to make love to her.* Milner's phrasing is ambiguous, but the breach isn't – whether the attempts to make love were physical or verbal, they took place between a girl of sixteen and the man she thought to be her father.

Poverty, sexual violence, neglect – Susan's childhood

was marked by all these. What Milner leaves out of her book, but mentions in a paper she presented to the British Psychoanalytical Society, was that Susan's real but unacknowledged father, the lodger in their house, had served with the colonial army in India. Invalided from the army, he became an alcoholic, and Susan witnessed violent quarrels between her parents – both Susan and her mother were terrified of him. To the already devastating forms of violence Susan was subject to as a child, we can also add the brutality of a recursive colonial violence, brought home by one of its agents.

When the Second World War started, Susan left the troupe to work at a friend's farm, where she found herself *breaking down into reality*, an experience that was accompanied by heart pains and vomiting. A nervous breakdown followed, in response to which Susan was moved to a hospital and given ECT. After the ECT, Susan lost this sense of outside space and being in the world: she was both the entire world and felt that she did not exist. Milner describes how, at the beginning of the analysis, Susan *continued to maintain that neither she nor I was there*. One of the consequences of this, as Milner discovered after Susan started coming to see her, was that during the air raids on London, Susan was particularly terrified. Having lost the distinction between herself and the world, *there was nowhere else for the bomb to fall except on her, since everything was her*.

During her analysis, Susan, who had been compared

to Botticelli's *Birth of Venus*, positioning her as the object rather than the subject of artistic and aesthetic experience, herself started drawing and painting. Over the course of her analysis, she brought more than 4,000 drawings to Milner, many of them recasting both the water and the birth that are such a striking part of Botticelli's painting. Reproduced in black and white in *The Hands of the Living God*, Susan's drawings convey both power and urgency. Many remain imprinted in my mind – striking images that are now part of my psychic vocabulary. Looking at paintings made by Susan, some of which are held in Milner's archives, I was struck by her use of colour, her felicity in capturing the eye and imagination. My own analysis was instructive in the necessity of leisure and creativity as ways of bearing and sustaining the difficulty of psychic life. Susan's drawings and paintings, and Milner's record of the analysis, make even clearer that having time for creative expression is a matter of urgency, the very thing that makes a life possible.

Susan drew, and Milner paid attention to her drawings. Milner's interpretations, like Susan's drawings, are prolific. The drawings became one of the chief ways in which Susan articulated and communicated her needs, both rejecting and responding to Milner's attempts to read the drawings in the context of their analytic relationship. I started making a list of the many interpretations Milner offers of Susan's drawings: the drawings were a substitute for an

ideal mother (the paper and pen are available and respon-
sive); they were a bridge between Milner and Susan; they
were a defence against acting out destructive urges; com-
munication with the medium (pen and paper) was laying
the foundations for communicating with knowledge of
herself; Milner stood for an all-consuming mother, and
instead of giving herself Susan offered drawings instead;
the drawings functioned as a bridge to the acceptance of
the otherness of the external world.

I was speaking about Milner with some therapists and
academics and one of them said, 'Wasn't Milner unsuccess-
ful as a painter?' It is a difficult assertion to dispute about
someone who wrote a book called *On Not Being Able to
Paint*. By what measure? I wanted to ask, but didn't. It goes
against the spirit of Milner's work to evaluate a creative
pursuit against ideas of doing well or its usefulness. I can't
help but think that all her time spent painting must have
allowed her to pay attention to the drawings and paintings
that Susan brought her. Does that make her a successful or
unsuccessful painter? Or does that just expose the limits of
thinking about creative endeavour in the narrow terms of
individual achievement, based on a contingent set of con-
ventions of taste?

Through most of her life, people exerted the most
brutal claims on Susan's body and mind – some with inten-
tion, others perhaps inadvertently. Mother, father, neigh-
bour, the Winnicotts and, later in her life, the man she
married. Milner's book bears witness equally to Susan's

troubles and her ability to create, her prolific activity in painting and drawing. Milner didn't claim that Susan's suffering had been lessened through her analysis. But what is apparent in the letters that Susan wrote Milner after the end of her analysis is that she had developed a belief that she had important things to communicate, a belief that she mattered. In a letter written in 1980, she says she wanted to write her autobiography, but she struggled with it ('the writing isn't going at all'). Fourteen years later, she was still trying to write the book, aware of both its importance ('I think it would help people understand so much more about this dreadful illness of the soul') and her difficulties in writing it ('I just tear up what I write, not in a feeling of anger, but because I feel it is so badly written, bad grammar, inadequate, unable to put down what I mean. Unlike you, I am not educated.'). That Susan's autobiography did not take its place in the world is unfortunate, and we have only Milner's words to tell Susan's story.

Milner's autobiographies, written in her thirties, helped me articulate my own claims to leisure. This involved being able to see myself and my needs as distinct, even in opposition to those of the people around me. Taking up this position could arouse feelings of guilt and disloyalty, and be met with dismay or pressure. Susan, however, had to face the truly devastating consequences of the ways in which women's time, bodies and lives are seen as available for use through expectation, obligation or force. Milner writes that Susan's mother struggled to see her as a separate person,

confusing her daughter with herself in ways that had far-reaching consequences for Susan's life. The difficulties between Susan and her mother are framed in the context of the extremely difficult lives of both women, marked by poverty and loss. However, men in Susan's life also saw her as a convenient object for appropriation, a form of entitlement enforced through violence.

Leisure, in these circumstances, can easily be dismissed as a frivolity, as there are more immediate concerns at hand. But thinking like this misses the urgency and need in Susan's drawings. What Milner's work with Susan shows is that, in as much as a claim to leisure requires a degree of freedom, it can also be a place to claim this freedom. We are far too accustomed to thinking of rest and creativity as a surplus, but what if we treated them instead as basic rights? In her work with Susan, Milner paid attention to the richness and complexity of Susan's paintings, and to her living circumstances. She often wrote to people to secure appropriate housing for Susan, and at the end of the book she makes a powerful case for social change in terms of the provision available for independent living for people experiencing the kinds of difficulties that were part of Susan's life. Milner shows that both provision of suitable material conditions of living, in the sense of housing, income and safety from violence, as well as the space and time for creative endeavour, such as psychoanalysis and painting, were crucial to making life bearable for Susan.

*

Minds and lives are complex, sometimes uncomfortably so. Reading about Milner's analytic work, I came to accept that this complexity is not something that needs to be resolved, or cured. Instead, the work of the analyst may be to find a way, with the person who has come to speak to them, for that complexity to be something that can be accommodated, sustained and transformed. I began to realise that I may never arrive at the end of my analytic formation – that the only end that made sense would be an acceptance that I would never have answers, I would never be prepared, that each time someone walked through the door for an analysis we would, in each instance, be inventing what psychoanalysis would mean for us. I hadn't anticipated how much being an analyst would be a risk, a risk of messing up, finding myself changed, challenged, taken into places I was not prepared to go. I do not find this easy, and *The Hands of the Living God* suggests Milner didn't either.

One of Susan's drawings in particular has left a powerful impression on me – I do not have a strong visual memory in general (unlike Milner, who said that she thought in pictures), but I can always summon this picture in my mind. But it was only when I was writing this book that I came to wonder why this image had significance for me. Titled 'Baby Seal in Coiled Serpent Nest' by Milner, Susan's drawing shows a little seal-like creature, ensconced in a cosy nest. When I first looked at it, I thought there was something very restful about the drawing of the baby seal. But then I looked again. The nest is made of serpent-like

forms. 'It might even be a boa constrictor,' Milner remarks.
The fear and claustrophobia is palpable. Many of Susan's
drawings and paintings reproduced in Milner's book
depict jugs, frames and houses – containers of various
kinds. Milner read these drawings as depicting a conflict
between Susan's wishes and her fears – her wish to be con-
tained, her fear that she may be annihilated if she allowed
herself to be.

In addition to the personal significance the drawing
had for Susan it also conveys, with great clarity and pre-
cision, a conflict that is more general. The drawing signi-
fies for me an ambivalence around the wish for security.
Many of my decisions were motivated by a wish to ensure
a stable, reliable environment for myself, whether through
work or relationships. But there was something about this
wish which could be hallucinatory, in that even when I
was feeling overworked, disrespected, compromised in my
dignity, I would still associate my dire circumstances with a
feeling of security. Susan's drawing gave me a way of under-
standing why I had stayed so long with my ex-boyfriend
in the flat in Stoke Newington. I had associated being in
a relationship with a feeling of security, so when things
felt bad or wrong I would shush my feelings by saying
to myself that such difficulty was in the service of safety.
The drawing of the baby seal showed me that the wish for
security could turn in on itself, protection morphing into
destruction.

When you make a secure serpent nest for yourself, as I

had a tendency to do, then what is outside the nest begins to feel especially frightening. The serpent nest feels like it is part of one's body, and that everything would collapse without it. Even if it feels deathly inside, well, at least it is an intimate and familiar morbidity. In these circumstances, leisure feels frightening, because it contains the possibility of making an opening into the sealed serpent container. And it is at such times that analysis extends an invitation to an enlivening form of risk-taking, in contrast to the serpent nest which feels secure but is in fact stifling.

The analyst too can have her own version of the serpent's nest in her practice. She may be too certain about what is happening, or too attached to her theories and clinical experience to be genuinely open to what her patient is saying to her. I've read many psychoanalytic case studies full of clever, transformative interpretations on the part of the analyst, which then have profound, life-altering effects on patients. But the analysis that Milner depicts in *The Hands of the Living God* is full of stumbling and missteps. By her own account, Milner keeps getting it wrong. Susan improves only to feel worse. When I first read the book this wasn't exactly reassuring, though I did admire Milner's candour.

It is only many years into my analytic formation that I've realised psychoanalysis is made out of the material of failure – trying to say something, not quite managing. And while the person speaking to the psychoanalyst is flailing, the analyst is failing too. She is inept and has no answers.

Her words are clumsy. All she can offer, perhaps, is her ability to sustain that feeling of failure, of not knowing what is happening or why things are the way they are. In this, too, she will fail, overcome by her wish to comfort, offer resolution, find meaning. And then she must hope that her patient will be able to ignore her, set her words aside, and continue to use her as a background for their own experiments in living.

Reading about Milner's work with Susan I came across a curious paradox: the capacity to experience leisure is connected to being cared for, but leisure itself can provide an experience of being looked after. Growing up, Susan was unable to rely on either parent – or indeed anything else. Milner set herself the task of a waiting and holding work in the analysis: *establishing some sort of belief in an environment that would hold her securely whatever she did.* This meant, in the face of Susan's anger or distress, sitting *quietly 'holding' her warmly, in my attention.* It was only through this *warm 'holding' mood* that Milner felt she could sometimes reach Susan: *If I sat quietly, relaxed and unhurt, and feeling that something of that mood was communicating through my eyes, she would suddenly begin to laugh at herself, and after that would say 'goodbye' naturally, instead of stalking out in an angry silence.*

One of Milner's concerns in the analysis was to find for Susan *a setting in which she would feel it would be safe to be born into separate existence.* There is nothing obvious about

being born and what follows. Being contained in a womb with the *on-going background of darkness and rhythmic beating of the mother's heart and breathing*, exiting into a form of care that can continue to offer containment, and then, because of being so attentively surrounded, *fashioning a kind of psychic sphere or new womb out of one's own body image*. Milner sees that Susan may need from her signs that Milner did *ponder about her* and *see her as a person in her own right* – while also providing an environment where Susan *did not have to keep an eye on the outside world*. Thinking about the coat she lent Susan, Milner writes: *I had accepted this need as part of the process by which she lent to me certain aspects of her ego capacities*. It is not clear what this need is, or indeed if it is one need or many. Is it a need to let someone else watch the weather, take care of the environment?

One way of thinking about leisure is that it is a time of gestation, of making and bringing something new into the world – whether an object or a different way of relating to the world and people around us. In leisure, we may also be trying to create ourselves – we may find the time and freedom to do this. In Milner's writing, especially *A Life of One's Own* and *An Experiment in Leisure*, there is such an emphasis on learning to distinguish one's own desires and values from those handed ready-made to us, and leisure is presented as an opportunity for such an encounter with the self. Milner's work with Susan and my experience as a patient in psychoanalysis are both a reminder of something

else: just how much other people can do for us, by listening, loving and caring about us.

Living in Delhi after my brother's death, I would often find myself travelling from the north of the city, where I lived, to the south – a journey of over an hour and a half – to take naps in a friend's room. I had a room of my own, and I didn't even have trouble sleeping alone, but there was a particularly restorative quality to sleep knowing that my friend was present – not particularly concerned with me, we were both students and she was usually working on an essay, but there if needed. I did not need my friend to offer me consolation, but I needed her breathing body present. Maybe our capacity for rest is not some fixed measure, but a shrinking, expanding thing responsive to our circumstances, and as such requiring tending and renewal all through our lives.

Milner brings together her thinking about leisure, rest and creativity in her descriptions of a state of body and mind that she calls *reverie*. The circumstances of Susan's childhood had meant that she had a *constant need to keep a watchful eye on the world, which thus starved her of that very state of reverie, of absent-mindedness, in which the distinction between fantasy and actuality can be temporarily suspended*. Reverie is the word that Milner uses to describe a state of mind and body which inside and outside are not clearly differentiated – it is a state of suspension, when boundaries between the self and others, the self and world, between dream and waking are not watchfully policed. She

considered such a state as *necessary for all creative work, whether the work is within the psyche or in the outer world.*

Reverie relies on being able to create a cocoon around oneself, and Milner thought that this state could be traced back to being in the care of another person and feeling a oneness with them. In this cared-for state, one's own capacities would not need to be differentiated from theirs, allowing for an experience of safety and relaxation. The infant experience, if all goes well, is something that we can reach towards later in life, even when we are alone, to make a cocoon around ourselves. This kind of cocoon has an internal correlate in being able to create *a kind of inner space* essential for thinking or creative endeavour, and Milner suggests that *one of the earliest roots of such a capacity might be the experience of being held in one's mother's arms.* This suggests a linear movement from infancy to adulthood, but Milner's writing and her work with Susan also allow us to turn this on its head. If we haven't had these early experiences – after all, they assume a caregiver who is not distraught, an environment that is relatively stable – we might need later experiences of reverie all the more, to treat our deprivation. The relationship between infant experiences and later life is bound to be complex, non-linear, and to some extent obscure.

Leisure allows us to experience a state of reverie, to create a cocoon around ourselves where we can allow ourselves to suspend the need to know where we are headed, or, even more radically, our sense of who we are. This

letting go of the boundaries of oneself, this self-forgetting, is in Milner's account an intrinsic aspect of creative experience. Sometimes in order to make something we have to forget ourselves, forget all the distinctive qualities of the 'I' that is doing the making. To discover something about ourselves we have to forget what we think we know about ourselves. We have to enter what, in her book on painting, Milner called *primary madness* or *the dream*, and that, in her work with Susan, she came to think of as *reverie*.

I find in Milner's writing on creativity an important corrective to the myth of the individual genius that can undergird conversations on creativity. Her work alerts us to how creativity relies on care. Individual care, certainly, but also the ability of a society to make sure that doctors have enough time to listen to their patients, that women who are being harassed by their partners have a safe place to stay, that people can receive a universal income without the shame and anxiety of a punitive benefits system. Of course, people find a way to be creative among even the most agonising circumstances. Sometimes, they are even recognised and rewarded for this. But to use this creativity as an argument against the need to build a caring, responsible society is at the very least a form of obtuseness, if not cruelty.

Reading *The Hands of the Living God*, I have wondered if, in the naps I took in my friend's room in Delhi in the years immediately after my brother's death, I was

recreating for myself something of the experience that Milner describes as so key to reverie – being alone in the presence of another. Perhaps this is one of the ways in which a psychoanalyst may be put to use, but it may also be something that people do for each other, without the presence of a psychoanalyst. Our capacity for reverie is something that may need renewing through mutual care, especially when the world begins to feel like, or reveals itself as, an unreliable, unsafe place – which is nearly all the time. Sometimes we may visit people trusting that they will lend us a coat if the weather takes a turn, or, even when we have one of our own, we may want the comforts of something borrowed.

Plunging

Some months after my cousin's death, I travelled to Spain for a wedding. I lay on a crowded beach, delighted by the sun and the presence of relaxed bodies around me. Warmed through, I went to the water. It had been many years since I'd been on a sunny beach. The sea I stepped into was warm, unlike the bracing waters that surround Britain. I was alone, and though the sea was full of swimmers I was scared. My parents' fear and suspicion of water had, belatedly, arrived in my body. Once in the water, I found myself struggling. I felt like I wasn't a strong enough swimmer. And then something clicked. I understood, or rather my body understood, that I had to swim with the sea, not against it – if I tried fighting the sea I would collapse exhausted, but if I let the sea hold me then I could swim, relaxed, working with the movement of the waves to go further into the sea, and return to the beach. I remembered that if I wanted to swim, I couldn't always stay above water.

Plunging is one of Milner's favourite verbs. It is everywhere in her writing. With her, we plunge into colour, into awareness, into our own bodies. In the sea by Barcelona

I realised it was my sense of fear that made swimming difficult. It was my anxious caution that put me at risk. I was reminded of cycling on London roads, my friend saying: Take up space! You're safer in the middle of the road! When I had my first bike accident, it was because I had become intimidated while cycling on Seven Sisters Road, a large, loud, busy thoroughfare. I had edged over to the side of the road to let cars pass, then crashed into the pavement and fallen off. There are forms of leisure that allow for a testing of capacity, an extension of the range of living within which we are comfortable. The sea reminded me that caution, all on its own, could be a danger in itself. Some things, Milner's writing suggests, can only be achieved by plunging.

I spent my remaining few days in Spain finding opportunities to swim, this time in the much wilder waters of the Costa Brava. I've since found it difficult to hold on to what felt so obvious in the water, and I will keep going to the sea to remind myself, because it is only in leisure that some forms of knowing and feeling can be renewed, and our capacities extended.

7

Holidays

Growing up in Jaipur, I hated the romance that the chalky-pink colour of the old city walls held for the multitudes of tourists who walked around enchanted, canvas backpacks on their sunburnt shoulders. In total adolescent solipsism, I resented them because they didn't know how dull my life was, how conservative the milieu, how impossible it was to be thirteen. They didn't know how unhappy I could feel, how nothing in the city offered escape, simmering crushes on strong-shouldered girls at the swimming pool could never be aired, remained confined to an inarticulate substrate of hope and frustration.

Travel and holidays are inevitably what many people think of at the mention of leisure, to the extent that these can seem interchangeable. But holidays are also what leave people stressed, out of pocket and, all too often, tired and cranky. Then there is the question of who actually gets to go on holiday. This is at the outset a question of money, but it is also a matter of visas and borders, who does the childcare while on holiday, and whether the colour of your

skin makes you unwelcome at a countryside pub. In their environmental impact and changes to local economies – for example, when year-long residents are priced out by holiday rentals – holidays also have a dark underside.

Consigning leisure to holidays can be a way to put it off (*I'll do that when I go on holiday*). It can also subject the experience of leisure to a series of expectations about the right way to go on holiday, a labyrinth that, come summer, can leave people feeling miserable, desultorily scrolling airline websites and package holidays. Nice weather and a break from work then just becomes a reminder of money that you don't have, the absence of a romantic partner, and a body that fails to live up to the latest version of whatever body is deemed deserving to be on holiday – thin, muscular, exfoliated, without injury or disability.

Milner's writing on leisure had appealed to me because it situated leisure in the everyday and ordinary, rather than presenting it as an exceptional experience. So when I came across *Eternity's Sunrise*, which reflects on her many travels over the course of two decades, I was suspicious. As a continuation of her project in *A Life of One's Own* and *An Experiment in Leisure*, Milner had written a book about going on holiday. Faced with her choice of topic, I was afraid of being disappointed by her, because as an adult I didn't really know how to go on holiday. I travelled to see family, or with family, which never felt quite like a holiday. I had gone to some conferences and tagged a few days to the end of my visits, but there were few experiences of the

kinds of leisurely travel that Milner describes in her book. I was primed to be distrustful. Reading *Eternity's Sunrise*, I found some suspicions confirmed, but fragments of my own memories of being away came back to me, and I began to consider how going away can offer both respite and insight not always accessible in one's immediate context. Wasn't my own walk from Margate to Ramsgate, where Milner became a companion to my thoughts and life, just such an occasion? I realised I had a lot of learn about, and from, holidays.

The diaries with which Milner began her autobiographical project, now stored in her archives, are for the most part slim and compact. Small enough to fit into a pocket or handbag, discreet, some designed specifically for women, many of these diaries contain pages of printed information before the blank or lined pages. In addition to conversion tables and calendars, there is information about cooking (sample French menus) and the British Empire – the diary from 1921 came with sections about 'Areas and Populations of Empires and Countries' and 'Colonial and Foreign Time Differences'. She used more than one brand of diary, and this seems like standard front matter, included in diaries made by different manufacturers at the time. Milner's autobiographical project, at its beginning, is framed by empire and conventions of femininity. If I needed reminding of the differences between us, then it was here.

Writing about Milner has been a way of thinking about the ways in which I've found my questions and

preoccupations reflected in her writing. Many a time, I've been able to substitute her words for mine, and found them fitting. But there are places where our paths diverge. These are moments when something about history emerges in the writing, and poses a question. This happens in all of her works, but was most stark while reading *Eternity's Sunrise*, a book about diary-keeping on holidays, for which Milner drew upon her diaries written over nearly twenty years. The 'Areas and Populations of Empires' noted in her oldest diaries were altered by the time Milner went on holiday in Greece (1959), as well as subsequent visits to Kashmir (1971) and Palestine/Israel (1975), but the legacies of empire were very much alive in these places.

The lasting effects of enslavement and racial segregation in the American South, the rise of fascism in Europe, military dictatorship in Greece – all these left traces in Milner's writing. Reading her work, sometimes I want her to notice more of the history around her, especially when she is in Palestine and Kashmir; I want her to think and say more, and I feel troubled when I find in her writing a flight into images of oriental timelessness. All the same, her writing also makes clear that the mind, or psychic life, cannot exist in a space unaffected by the political. Leisure, as I have understood it, through Milner's writing and in my own life, has felt profoundly connected to ideas of freedom. Leisure, freedom, care, creativity – these necessarily draw the political and social in their wake. In *Eternity's Sunrise*, being on holiday, an activity that could appear

to be apolitical and escapist, is also a way of crafting a response to the history Milner lived through, in particular the two world wars and their psychic costs. And as I read the book, I started to understand for myself what holidays could offer and what I might need from being away.

On a Hellenic cruise in 1959, Marion Milner found herself sad. She was fifty-nine years old. Neither the Parthenon nor the Daphni mosaics had *spoken* to her. She was following in a psychoanalytic tradition. In 1904, Freud had also found himself unsettled in Greece. Standing on the Acropolis and looking at the landscape, he found himself thinking: 'So all this really *does* exist, just as we learnt at school!' In the essay he wrote years later about the experience he attributes the strangeness of the statement to a feeling of 'derealisation' brought about by guilt at 'the satisfaction in having gone such a long way'. It was easier, he suggests, to think that he had never quite believed in the Acropolis at all than to believe his own good fortune, which so exceeded that of his father. Milner's reservations were, at least on the face of it, more prosaic. In an experience familiar to anyone who has been on a school trip, work away day or group tour, she attributed her inability to connect with her surroundings to *the totally unfamiliar experience (since the days of my boarding school) of doing everything in a crowd*.

By the time the cruise reached the island of Chios, Milner had *come to suspect that moments of solitude were essential*. Eschewing the group trip to the monastery of Nea

Moni – Milner describes herself as *surfeited with sights* – she instead found silence: *And there, beyond a wide stretch of sea, misty forms of land.* 'Turkey', said our driver. *But, in front and to the left, mountains, the mountain hinterlands of Chios. A lovely view, yes. But the momentous thing about it – silence.* The silence is liquid, Milner is *flooded, enveloped, permeated, soaking.* She drinks it in, *taking great gulps of it.* We're left with the impression of an urgent physical need being satisfied. Without silence, something doesn't *speak*.

To be silenced is awful, but maybe there is something to be claimed about silence – not the silence of other people, or silence in response to a question, but the kind of silence that can accompany solitary leisure. I know that sense of restorative peace that can fall upon an apartment when all the other occupants have left, leaving me alone. Some thoughts only emerge when there is silence, just as a problem that feels messy and conflicted will resolve itself if I take myself alone to a quiet place. And yet silence can be frightening, like an abyss opening up before me.

Having offered a powerful account of our need to be cared for by others in *The Hands of the Living God*, in *Eternity's Sunrise* Milner turns to evocative and associative memories that she calls *beads*, and discovers in solitude a scene of encounter between oneself and oneself. On a second visit to Greece the following year, once again on a Hellenic cruise with the added commitment of attending a congress on 'aesthetics', Milner noted her excitement at leaving the cruise ship early to travel alone to the

conference. A band plays and Milner writes that she *felt it played for me, it celebrated my first steps alone onto Greek soil, responsible for myself, my passport no longer kept in a box with two hundred others but in my own handbag.* As she moves further away from the ship, travelling by coach through the dark night, she feels a *deep, quite unreasoning joy, something coming from far down inside.* On a day trip to Delphi with a busload of philosophers from the aesthetics congress, her hat flies off. She persuades the bus to stop and chases after the errant hat. These holidays become an occasion for her to experience herself as capable of relying on her own resources in unfamiliar circumstances. By now sixty years of age, and established in her psychoanalytic work, Milner's writing in this book suggests that travel offers her an opportunity to feel surprised and challenged.

Visiting the Parthenon again on this second trip to Greece, Milner found that when she was accompanied by her colleagues from the congress, it did not 'speak' – a repetition of her experience when she visited the first time with a tour group. Again she went back, unaccompanied. Alone, she found the experience that had so far eluded her: *I did feel as well as see.* What she experiences is *a different form of knowing* where she can experience *the joy in the plain Doric capitals* and feel *the steady rhythm of the pillars.* The gap between object and observer was closed, Milner was not just *at* the Parthenon, but *in* it. Writing about holidays, Milner is evoking a particular quality of attention and absorption, one that feels most available

in leisurely moments alone. This is a space where *one can recurrently let go of preoccupations with one's social image, what people think of one and sink down into the private sea of being.* Without such interludes, without holidays, *there will be no new beginnings, no freeing from the old prisoning rigidities, no spring-time renewal.*

Time spent on holiday is one of the places where something forgotten or estranged about oneself may reappear. I find that it is often when I am on holiday, when I have given up on achieving anything, on trying to please others, that it becomes possible to remember what is important to me – and I start to recall, in images not unlike Milner's beads, the stories I wanted to write and then forgot, and the wish to write, make and think returns to me. But it can be frightening to be alone, and the prospect of being on holiday alone can be especially dispiriting. For Milner, though, there is something else waiting on the other side of the awkwardness of being alone. When she does indeed sink into this private sea of being, she finds that she is not alone. Inside herself is a presence *nearer than breathing* – there is an active *something* that is both *I* and *not I*. Milner tries out various names for this presence, calling it the *answering activity* or *inner other.*

Sometimes this internal presence – Milner also refers to it as an *other mind* – is not easy to accept. There can be a resistance to experiencing a contact with this inner other, *a fight against allowing that there is any 'other' within at all, a wanting one's conscious thought and endeavour to be*

all there is. Being alone can mean being in the presence of something that remains radically unknown. Milner allows herself to wonder whether there is even such a presence: *trouble is that so often what one has to have faith in seems like nothingness, emptiness, a void, when one tries to turn inward.* But she finds that there is something: *there's always the sea of one's breathing. And the feeling of one's weight.*

Recently I went to visit some friends who were staying in a house by a loch in Scotland for their holiday. I arrived on Saturday afternoon, and left Sunday evening. When I was leaving, I felt convinced that I had been away longer – surely I had spent at least a few nights there? Something had happened to time when I was away. It stretched out, and became wider, more capacious. I felt rested and renewed. And then I thought: Ah! This is what going away on holiday can do! It can allow us to rest more deeply, it can reinvigorate the tired rhythm of our days, and by presenting us with a new context it can allow us to look at our usual circumstances with new eyes.

A Life of One's Own, An Experiment in Leisure and *On Not Being Able to Paint* were all shaped by the prospect of war, or its actual experience. But *Eternity's Sunrise* was published in 1987. Why is war still so present in the text? Perhaps because Milner went on holiday abroad to places where conflict stemming from British imperialism and the aftermath of the two world wars was still active. Her last

visit to Greece was the same year that the Colonels' regime took over, and a monastery that Milner had visited became a place where dissidents and communists were imprisoned and tortured. War is present because it didn't really end, and because Milner, in writing about dictators and torture, was aware that peace was something of a cover-up.

But reading Milner's accounts of visiting Kashmir and Palestine, it is difficult not to feel like I am in the presence of yet another white tourist, using an orient stripped of history for their self-realisations. As she travels further from Europe in *Eternity's Sunrise*, it is as though her ability to take note of and respond to political conflict in her writing shrinks. The brief account of her visit to Kashmir, in 1971, is imbued with Milner's sense that she is unable to see something – *there seemed to be not many beads* – and there is an absence of *haunting presences forcing their way into my memory, trying to tell me something as the Greek beads had seemed to be doing*. She concludes by saying that the *real bead* may have been not seeing the mountains that were always there, though not visible. Travelling to Kashmir in 1971, Milner was visiting an occupied territory, where there would be war before the year was out. Any sense that this registered with her is missing in the text. Instead we find an image of oriental timelessness, as she listens to Kashmiri musicians: *the feeling of slipping into another world altogether, a timeless one, but a bit dangerous, one might come back, like Rip van Winkle, to find centuries had passed and nobody knew one any more*. If Milner *had* come

back, even after just a few months, she would have found war, a difficult history being lived out in the present.

Some years later, Milner travelled to Jerusalem, a visit made to explore what she described as her *cultural roots*. She does not specify which roots she is thinking of, but I assume her reference was to Christianity. Staying with friends, Milner visited sites significant in the history of Christianity, travelled to the Dead Sea and spent the night at a kibbutz near the Sea of Galilee. Like her account of her visit to Kashmir, there is nothing to suggest that she was once again visiting an occupied territory, no notice of the Six Day War which saw Israel annex East Jerusalem and the West Bank, and no mention of the Palestinian people. Searching for 'beads' collected during her time in Jerusalem, Milner finds one in a memory of a Bedouin tent that she saw. The tent comes to signify for her the feeling of being cocooned that was so central to her theorisations of creativity, and much as I love Milner's writing, and the emphasis she places on creative life, in that moment I felt like she was really missing the point.

The year I was born, the Indian government granted special powers to armed forces in Kashmir, allowing them legal impunity against charges of rape and extra-judicial killing. This was the latest in a series of moves, both military and governmental, that consolidated India's colonial occupation in Kashmir. When I was nine, lessons were interrupted for us to be told that the school was col-lecting money for the Indian army, which was fighting a

war in Kashmir. Patriotism was an easily accessible drug, and Kashmir the ultimate proof of loyalty. One's very Indianness was posited through a claim to Kashmir, but no one had to know anything of Kashmir, its history, what was happening there, all that mattered was that it was ours. Three years later, when Muslims were killed in Gujarat when Narendra Modi was the minister in charge of the state, it was obvious even to me, even as a twelve-year-old, that what was taking place was state-sanctioned mass murder. But I wasn't in a position to join the dots between the Hindu supremacist vision of the nation that was at the root of so much bloodshed in Gujarat, and the supposedly secular forms of Indian nationalism, which concentrated their violence in colonial zones or in sites of resource extraction.

My best friend from school, with whom I had read Emily Dickinson and dissected every crush, to whom it was possible to say anything, about family or queerness or desire because she was so independently minded, went to university in the same city as me. Some months after we'd settled into our dorm rooms, during one of our evening phone calls, she said: Do you know what India does in Kashmir? I didn't. So she told me, about people disappeared, the terrifying powers of the army, the suppression of the national aspirations of people who had been promised a say in their own destiny. Surely that can't be true, I said. Her roommate, a woman from Kashmir, had been telling her about her life. I had no good reason to disbelieve my friend, or her

lovely room-mate. I read more about the topic, I went to film screenings. Over many shared meals, in late-night conversations during sleepovers, on walks to find chai, and in between the exchange of gossip I realised I had been wrong.

In the years that have passed since, I often return to my initial disbelief with a feeling of shame. In that moment, I was not thinking, I was simply embodying an ideology. There was something I didn't want to see, that I didn't want to know about. I wonder what would have happened if my friend had not been paired with her room-mate in university housing, or if she had stopped talking to me about what her room-mate told her, because of my initial disbelief. Unsurprisingly, I was not immune to the not-seeing that marks Milner's writings about Kashmir and Palestine. In her book on painting, Milner had diagnosed the reluctance people can have to look at things anew, the ways in which they can be *afraid of not seeing the world as they have always seen it.* I was party to this, as was Milner. Sometimes I can despair, wondering if I will always remain stuck in some form of ideological avoidance of the facts of the world. Then I remember that even when she is in Kashmir and Palestine, at her most unobservant, there is something that surfaces in Milner's writing, a form of knowledge that unsettles the equanimity of her travels, an intense awareness that she is missing something.

Leisure can be a way of opening out to the histories that are alive in us, even if they feel distant or removed. It can be a way of remaining alive to forms of unfreedom and

injustice, rather than a way of closing ourselves off to what is difficult to witness. The places we go on holiday are not blank slates, they have their own histories, their possibilities of leisure and freedom for the people who live there. To treat them as somehow empty of history and complexity is to enter a way of relating to the world that is at worst colonial and at best inconsiderate. It reinforces the already unequal access to leisure in our world. Until it is a gift that is fairly shared, none of us will truly be at leisure.

Cooking

My grandmother was married to my grandfather when she was fifteen, and had seven children with him, one of whom died when he was very young. Less than five foot tall, with the softest skin, my grandmother had an idiosyncratic code of good behaviour which she impressed upon her grandchildren. You always peed before leaving the house, because it was rude to visit someone and ask to use the toilet, especially if you were paying a short call. She claimed to know my bladder better than me, even when I was an adolescent and keen to assert bodily autonomy. Sleeveless tops were a risk, they could be considered bad manners (walking around with bare arms!), the colour black was forbidden, my grandmother believing that dull, dark, muddy shades were all an insult to the life within us, which was best reflected in bright colours. My mother and aunts would sometimes run to change into something suitable before they went to see her, and family gatherings at my grandmother's often looked like a Pantone shade card with variations of pink, her favourite colour. But more important

than colour, or going to the toilet, were the preparation, serving and consumption of food.

Softening chickpeas with baking soda was cheating. Buying prepared food from the market and serving it at home was unconscionable. She was herself an excellent cook, and when anyone visited she always offered food. Then she watched everyone's plates – was everyone eating, did they have their kheer, was I eating too much of the things that would give me an upset stomach? When I visited my parents from England, she would send food over in a tiffin box, then call the next day to ask my mother about my bowel movements.

As my grandmother grew older, she found it increasingly difficult to stand in the kitchen and cook. In these years it was unclear whether cooking brought more pleasure or pain. She would exhaust herself in the kitchen, her legs and arms hurting. Unable to cook, she would suffer in the knowledge that her recipes were not being made to her usual high standards. For some time, she had a chair in the kitchen, but that became difficult too, and she eventually had to rely on other people to do the cooking – her daughters, her daughters-in-law, but most of all the woman who worked for her, doing the cooking, cleaning and care work.

Without the ability to cook, my grandmother seemed disconnected from her purposes and motivations. She had taken so much pride in feeding other people, in daily acts of skill in her kitchen, but now she seemed lost. As I spent more time away, I began to think that, for my family,

eating together was a way of resolving the difficulties of not knowing how to speak to each other. Eating, rather than speaking, was the thing we did as a family with our mouths. Everyone was associated with the food they liked – not so much with what was happening in their lives, or what they thought. It was a primary, immediate form of love, and one that, over the years, had begun to feel inadequate to me.

My grandmother often told me that while my middle aunt had learnt how to cook and run a household, my mother preferred to sit in the drawing room on a chair, one leg crossed over the other, reading books. My mother envisaged a certain kind of bourgeois married life for me, so she taught me how to lay a table, how to fold napkins and how to bake cakes. She didn't teach me how to cook, and it was somehow assumed that in the life that lay ahead of me, daily cooking would not be one of my responsibilities. She was unusual in her choices, and unlike many of the girls I grew up with I took my school leaving exams with no idea how to make roti, rice or sabzi. But I could make a layered apple cake, and a lemon cake, from recipes photocopied from a book my mother borrowed from my geography teacher. Maybe she had seen how my grandmother's life had been defined by cooking, and wanted something else for me. Maybe she wanted to protect me from that destiny. Still, it is impossible to think about those cakes without being intensely conscious of the snobbery and aspiration that was poured into me.

All this meant that I relied on friends and lovers to

teach me how to cook, and I was freed from the resentment
of learning how to cook *because* I was a girl while the boys
were out playing. When people began welcoming me into
their houses, after protests or reading groups, I saw a differ-
ent way of eating, people all sitting together, no tables laid,
no women or staff serving. Over the years, I fell in love with
cooking, for myself, for friends, for large picnics. Cooking
offers a material, tangible counterpoint to working with
words. I can go into the kitchen and be soothed or excited,
depending on what I am looking for. I have often timed
my work to the boiling of lentils, or the time it takes for
vegetables to roast in the oven. Knowing that something
is cooking in the background can make tedious tasks more
bearable (I'll reply to emails till the potatoes boil), and it
can offer me a feeling of comfort when I try to write or
think about something difficult.

My cooking was, and still is, based around improvisa-
tion, and I love the alchemy that can transform back-of-
the-drawer ingredients into a sustaining meal. I didn't
discover cookbooks till my late twenties, when I came
across Elizabeth David's books in a charity shop. I didn't
expect to cook from them, but I enjoyed reading them.
Now, when something makes me worried or anxious, I will
take a cookbook to bed, reading through recipes before I
fall asleep. There are cookbooks, like Meera Sodha's *East*,
which connect me to entire groups of friends, and feel like
they are a character themselves in the group, so frequently
are they invoked. Other books feel like I'm learning a

new language, like cooking with Hannah Che's book of vegan Chinese cooking, which has not just opened up new flavours for me, but also parts of the city where I now go searching for ingredients.

When I was trying to finish this book, I stopped cooking. My boyfriend managed the kitchen, bringing plates of food to the desk or bed where I was writing. It was then that I realised my pleasure in cooking is based on a double freedom – being able to cook is not an obligation, and if I don't want to cook, I needn't. These are freedoms I wish for everyone, because there is nothing intrinsic about a task that makes it leisurely. It is the conditions of freedom that make the activity possible in the first place, or the feeling of freedom that the activity brings with it that make for leisure.

8

Cabbages in My Mind

Towards the end of my time in the Brockley bedsit I went on some dates with an old acquaintance who had been my library crush between the ages of twenty-three and twenty-six. I spent enough time at the library to eventually be introduced to him, but he was in a relationship, and our social worlds seemed too far apart for a friendship to develop. I lost touch with him, until he messaged me, and trying to abide by the various clauses of pandemic regulations we started going on long walks, sitting in icy parks with a Thermos of tea and a bottle of whisky. After many painful separations during lockdowns, and some time living with his mother, we found a flat we could rent together, and during the months of settling in, when we were figuring out where the bookcase would be placed and if the cat was allowed outdoors, we signed up for a vegetable bag that was delivered to the local church every week, and had to be collected from a wooden shed with a combination lock.

The vegetables were local, organic and seasonal – and unfamiliar to me. I did not know what to do with a swede,

or celeriac, and as winter approached and the bag was bulky with parsnips I found myself scouring cookbooks and the internet in the hope of transforming these offerings of the earth into something edible, because to me they looked more like ammonites than vegetables. After a friend recommended Meera Sodha's laksa recipe, the swede became an unexpected ally, and with some effort parsnips could be turned into gnocchi or soup. Celeriac remained a puzzle, though, and my stomach always revolted when I ate some, as if my gut was drawing some kind of line in the sand. In any case, the shed of vegetable bags had a 'swap box', and more often than not I was able to exchange the dreaded celeriac for a gleaming, jewel-like aubergine.

While I could claim a cultural disconnect with the celeriacs of the world, the vegetable bag included, nearly every week, a fat and weighty cabbage, a familiar vegetable I had never learnt to like. Living in my new flat, I found myself busier than ever. Work had picked up pace again after the lockdowns, and I needed to be places, then there were friends to meet, exhibitions and films to catch up on. I was moving further and further from the leisurely days of living in the Brockley bedsit, my week such a whirl that at the end of it I could not even say what I had done, just that I had been busy. If I'd been paying attention, I would have noticed that there was a part of my mind that was weighed down and preoccupied with a question.

What was I going to do with the cabbage that was sitting at the back of the fridge?

Sometimes there wasn't just one cabbage, but three. My friend dealt with the cabbages in her vegetable bag by making a Japanese-style omelette, but I was allergic to eggs and my boyfriend was vegan. The cabbages weren't just taking up space in my head, they were also sprouting up in conversation. Numerous people suggested sauerkraut, but I had only recently started making jam and didn't quite feel prepared for another form of food preservation. Talking to an artist friend about cooking, I relayed the problem of the weekly cabbages. Instead of offering any practical help, she told me about the artist Moyra Davey, and her writing about refrigerators. I mentioned this to my boyfriend, and a few weeks later he presented me with a copy of *Index Cards*, which collects Davey's writings. 'I think of a fridge as something to be managed,' she writes, describing the 'atavistic, metabolic anxiety' she feels when the fridge is full.

There are certain arguments that you do not want to have with your boyfriend if you are thirty-one years of age, a feminist, indeed a woman who cares very much about the world. Here is a list, certainly not exhaustive, of some of these arguments:

– Arguments about who does the cleaning, cooking, clothes washing. You might find yourself saying: 'But I need time to write my book!' and he might say: 'But I took out the bins and I always do the washing-up!'

– Arguments about who remembers what, for example

the birthdays of friends or family, the preferences and allergies of your dinner guests. You might find yourself saying: 'I'm *always* the one to think ahead about what your sister wants for her birthday, I'm *always* making lists of Christmas presents, I'm *always* reminding you to message your friends.' And he might say: 'I'm so sorry, it's true, I can't deny it, you are so much better at these things than I am, I never managed to do this before I met you, and I want you to know how much I appreciate it, I really do.' And the next morning you might find a cute drawing and flower on your desk.

– Arguments about who does the planning for holidays, dates, and that dreaded thing, 'the future'. You could find yourself saying, one day: 'I have spent twenty-one hours this week comparing flight tickets, hotels and travel insurance, and I feel like my eyes are dry and my soul is dead.'

You don't want to have these arguments because they make you feel like you're reading from an old, outdated and much-thumbed script, as though you'd walked into the theatre looking for a new part but were cast, once again, in a role that you know all too well but are done with. The costume doesn't fit any more and no one – not you, not the audience, not your fellow players – can disguise your boredom. I felt like I had travelled some distance from the position of *whatever you like, my dear* which Milner describes in *An Experiment in Leisure*. My wants and wishes were less obscure to me and I wanted to act on them. But I found myself coming up against a different kind

of problem – I found myself performing an organisational function in my new relationship, what in old-fashioned terms might have been called 'running the household' but which included things like making plans to spend time with our mutual friends, booking tickets to the cinema, and remembering when the bills were due. Even shared moments of leisure with my boyfriend could still feel like work because I was taking care of the arrangements. Milner writes in one of her diaries, at the age of thirty-two, before she published her first book: *Pleased with myself at getting on so well with my book then dashed because D criticised the way I'd cooked his bacon.* In this regard, I didn't want to be like Milner! And yet these were the arguments I found myself having with my boyfriend. How had two people, who liked going for walks together and discussing the novels they'd read, turned into squabbling, screaming bundles of resentment? Who had I become, and why did I care so much about dust, cabbages and unmade beds?

Looking back, it seems so clear to me that I was replaying many of the choices I had made when I lived with my ex in Stoke Newington. I had thrown myself, once again, into making a beautiful home. This activity was, of course, a defence against the precarious nature of renting, of not knowing where I'd live next, which furniture I would be able to take with me, whether I would be living alone, with my partner or in a house share. But why did this house-keeping turn into such a source of rancour? I had no answers.

I'd learnt so much from Milner about leisure, about wanting and wishing, but now I was realising that leisure and desire have to be constantly claimed back from circumstances that stand in their way. This is perhaps why Milner keeps returning to the same themes in her books, even though their subjects are so varied. It is through her writing that Milner holds on to what she discovers about leisure and creativity, and everything she explores retains a sense of wonder and enchantment. Her discoveries were not a form of static knowledge that could be filed away and consulted as needed, they were a practice that needed to be ongoing and alive. If I was to follow Milner's invitation to leisure, then this would be a lifelong practice for me too.

In between work, seeing friends and housework, I felt like I had little time for anything else. In addition, my contract at work was soon coming to an end, and my ability to stay in the country was contingent on finding employment here. I had enough on my plate, and I was often stressed out and angry, not least when I found myself emptying the fridge of mouldy cabbages. I was annoyed at my boyfriend for not planning things, for not remembering what needed to be done when. My own life was meticulously entered into a diary in small handwriting, the tasks and appointments spilling out of the box that designated each day of the week. Once in the middle of an argument my boyfriend tore up his diary, overwhelmed by my demand that he learn to schedule his days. In response,

I tore up mine too, tired of my responsibilities. Then we repaired our diaries with washi tape, as neither of us felt like buying a new one.

I had the vague sense that my life was slipping away from me again. I felt like I was waiting for someone to do something, for my boyfriend to change his way of being in the world, for my work to change, for the economy and immigration system to be completely transformed. I postponed writing, because so much felt contingent and inconvenient in my life. Around this time, I started reading *A Life of One's Own* again. I read, again, the sentence that had first drawn me to Milner's book: *my life was not as I liked it and I thought it might be in my power to change it.* But I felt like I had lost sight again of what I wanted, let alone knowing how to get there.

I was aware that I was drowning both in other people's demands and in my internalisation of outside expectation. There was no space for anything else to breathe. So I decided I would start with something easy, like making lists. I made many lists every day: things to do, shopping, emails that needed replying to. I started dividing my lists of tasks into two columns, and resolved that for everything I had to do, I would write something that I wanted to do. And when I ticked off a task on the to-do list, I would do something on my want-to-do list. When I first started making these lists, it felt difficult to separate out what I wanted to do from what I had to do. There was something weird and artificial about making a list of wants, and at

times I found myself straining to think of things to write. This was reason enough to persevere.

To try and dispel the fog that had settled on my wanting, I decided that when I woke up in the morning I would start my day doing something that I wanted to do. Not work, not something that was good for me, just something that I wanted, that brought pleasure. I was so accustomed to waking up and going to my computer, in a futile attempt to clear my emails in the hope that I would have time free from them later in the day. Or I would be rushing to fit in some exercise, cycling to a class or rolling out a yoga mat in the living room. I found myself resistant to an easy start to the morning, so I designated a comfortable brown chair as my morning chair. I remembered Milner's description of the person who is trying to be selfless, who is always half rising from the comfortable chair to offer it to another person. I wanted to be the person who could learn to sit in that chair.

My boyfriend and I had found the chair at the flea market in Walthamstow. It was a large chair, and sitting on it felt like being enveloped but also supported, as though someone had turned an embrace into a chair. We almost didn't buy it – I think we were worried it was *too* comfortable, as though comfort was something that had to be carefully rationed out. Once in the flat, we placed the chair so it faced the plane trees in the park outside. In the morning I sat in the chair drinking cups of warm water. I realised that I wanted to do nothing, so I would sit there looking at the

trees, listening to the sounds of the fitness group that met in the park, their instructor yelling, every few minutes, Go! Go! Go! Sometimes I had less than ten minutes sitting in the chair, on other days my time stretched out, and looking at the trees turned into picking a book off the shelf and reading. I began to look forward to the start of the day. Later in the day, while working, I felt buoyed by the private morning hours, which felt like a buffer between myself and the demands of work and other people.

Encouraged by mornings in the comfortable chair, and my want-to-do lists, I started imitating the experiments in free writing that Milner tries in *A Life of One's Own*. Milner wrote down whatever was on her mind, without stopping to reflect or censor, and then considered what had appeared on the page before her. Since moving out of the bedsit I had been writing less and less. To my relief I found that quiet mornings in the chair made for an easy transition into writing.

The question of housework, though, still remained unresolved. It must have been around this time that I remembered the Greek play *Lysistrata*, which I had read as an undergraduate. I hadn't read the play since, but I recalled it told the story of women who collectively agreed to stop having sex with men in the hope of ending a devastating and futile war. I did not remember the details of the play, its historical context, but its memory was accompanied by a thought about housework: I could just stop.

And so I did. There was no one relying on me, I had

no children, no older people to care for, my boyfriend and I had similar forms of employment and were roughly the same age. There was no reason that I should be the one responsible for the cabbages, and all that they had come to stand for. I let things slip, and watched the flat get messier, watched plans get cancelled when it became apparent, all too late, that a person couldn't be in two places at the same time. There were strikes in my workplace at this time, as well as in the public sector. The spirit was catching – I couldn't help but bring it home. My impulse, always, was to go back to tidying and organising. But as I let these things slip I found that I had more time to write, swim and take baths. And I noticed that something about the disarray in the flat had become real to my boyfriend, who began to remark upon it, as though the objects of the house only really became visible when they were out of place.

I was teaching myself that the state of my home was not a reflection of my moral character. I don't think it is a lesson I'll ever learn fully, but I'd rather learn it badly than not at all. I realised that accompanying my resentment towards my boyfriend was a feeling of envy. My responsibilities in the relationship had cut me off from leisure. My boyfriend was not similarly burdened, and did not make the same demands on himself either. I wanted to be careless too, and chaotic. This felt essential to accessing the forms of reverie that Milner describes, and which I found were important to my own writing. There was freedom and pleasure in that: I saw that something about creative work required

me to give up on having a sense of order, whether in my mind or in the house. While I was figuring these things out, my boyfriend was learning how to look after the house, and putting things in his diary. There was nothing harmonious about these shifts. They were fractious and slow, but if this was the price of writing again, I was glad to pay it.

After some time making want-to-do lists, and not starting my day with work, I felt like I was in my life again, reading and writing, and spending time with friends. Some months after I turned thirty-two, I was offered a job at a university in Glasgow. The news brought relief – I had been putting in one job application after another, and getting nowhere. After a period of living in a friend's flat in Glasgow, and unsuccessfully trying to find a place to rent in a city where irresponsible student recruitment by universities had led to a brutal housing crisis, I returned to London, commuting each week to teach my seminars, and staying with friends, in a dormitory at a youth hostel, or in the cheapest budget hotels I could find. It didn't matter so much where I stayed, because for the most part I was in my university office, marking papers late into the night and making myself dinner in the microwave.

Weeks during term time felt very full, and I deferred things like writing and socialising till the holiday periods. When the holidays did come around, though, I realised that work wasn't quite over, that I still had assessments to grade and upload, and a seemingly endless number of forms to fill. Any free time during the holidays was spent

recovering from the previous term, by which time the next one had rolled around. The only respite was during periods of industrial action, which to me were times of urgent rest and decompression as much as battles for better working conditions. A strike, after all, is a powerful political act that aims, among other things, to right the balance of work and leisure. So it feels fitting that it was being on strike that allowed me to think about leisure, to experience it in a profession that was notorious for the claims it made on people's time, while suggesting that work was its own reward.

I started writing the beginnings of this book in the mornings – my exercises in not doing anything after waking up had allowed me to carve out the first part of the day as something that belonged to me. To extend this time, I woke up earlier, then earlier still. I felt like without making time to think and write, I would lose touch with myself. A colleague told me to persevere, reminding me that the summer term was approaching, and this period without the duties of teaching would make up for the intensity of term time.

On my thirty-third birthday, my boyfriend got me a first edition of *A Life of One's Own*, and I was delighted to see colour plates of Milner's drawings and doodles for the first time. I propped the book up on the desk in our living room, so that it was in view every time I walked into the room. A few days after receiving this present, I also found a publisher for my book. There was a feeling of satisfaction in

having wrested from my working week, from all my other circumstances, the time to do something of my own. Very early on in my analysis I had told my analyst how I found it easier to write on scraps of paper, or the backs of envelopes, as though to put something in a notebook was to give it importance to which the writing, or I, was somehow not entitled. Maybe it was also a way of keeping a part of my mind, and my desire, distant from myself, in a place where they remained only half acknowledged. Reading Milner's writing has been a long, meandering and often barely conscious process of getting to know myself better, even if that has meant accepting that parts of my mind will always remain obscure. It is a process of giving myself my own life, and it has also allowed me to fill notebook after notebook with my words in the course of writing this book.

I moved to Glasgow for my job, but the demands of work were gruelling, and I was faced with further visa complications. In trying to keep up with work, I was living in a way that required me to hold things separate – writing, living, the unconscious. Over the Christmas break, I began to return to a different rhythm of living – slowly stretching on the carpet next to my bed every day, going for walks in the sharp winter air. One weekend, my boyfriend and I drove to the Cairngorms, which is Nan Shepherd territory, to stay in a cabin by a forest. It was there, sitting in the cabin looking at the shapes the frost made on the windowpanes, that I became conscious of something I had lost during the past months, something I lost every time I was

entangled in worries about migration or the relentless bur-
eaucracy of university work.

I had lost the ability to see the world around me in its
detail and texture, the ways in which grass silvered in the
cold, the russet-orange-red-brown melange of feathers on
chickens, the butterscotch- and honey-coloured stone of
tenements in Glasgow, which had made me fall in love with
the city. All this disappeared from view. I could not register
the elation in the swoop of a crow's flight, or the cosy way
in which pigeons fluffed their feathers on windowsills.
The smell of fresh bread from the bakery downstairs didn't
evoke anything, and just as the surface and textures of the
world felt eroded, so too did language, reduced as it was to
some joyless arithmetic of means and ends.

Just as I was beginning to admit these thoughts to
myself, I had to return to work, marking volumes of
student essays before the start of teaching in the new year.
I cursed myself, I should have started earlier, now I was
staying up past midnight trying to finish things in time,
fending off emails, making mistakes. I could imagine what
my colleagues would say if I told them how it had been –
I should have managed my time better, it was like this for
them too, they had worked through winter sicknesses to
get things done. Within the confines of my job, the weeks
I had taken for myself to write, the weekend with my boy-
friend by the forest, the Christmas Day spent at a friend's
house eating and watching television – these could only
have the shape of guilt.

I was teaching a seminar on Mary Shelley's *Frankenstein*. It had been one of my favourite novels to study as an undergraduate student when we had spent an entire term discussing the novel, over many lectures, seminars, and evening walks outside of teaching hours. I'd found myself immersed in the world of the novel, and it had led me to writings about the French Revolution, Rousseau's theories of education, Mary Wollstonecraft's *Vindication of the Rights of Woman*, theories of orientalism and eighteenth-century science. The experience was one of absorption. Reading *Frankenstein*, in the months following my brother's death, I had found that novel could take me, and my grief, into itself, its strange alpine and polar landscapes.

That afternoon, I was completely unprepared for the seminar, as I often was, and relying on a set of memories from many years ago to guide my teaching. The feeling of betrayal cascaded. I thought of the students I would be meeting. They would be *fine*, but I knew I was offering them the dregs of myself. I thought of myself just a week ago, the writing that I had so abruptly stopped, the feeling of language, alive and shimmering, that was so quick to drain out of me. I thought also of myself as a nineteen-year-old, looking at the sky striped with colour, how I had felt like I could look at bands of pink and orange all evening, how I had spent hours in the library, how it had been easy and effortless to simply be interested.

As I stepped into the seminar room, I found I was losing my vision and could only make out blurred outlines. I

should have cancelled my seminar and taken a taxi home; instead, I made a calculation. If I cancelled I would be expected to make up for the missed seminar, but the next week was already packed with commitments. Within the arithmetic of work, it was easier to teach now rather than later, even though I had lost most of my vision. I could not see my students' faces, but I sensed some alarm in their voices. I offered some reassurance, I guided them through a discussion of *Frankenstein*. I had planned to see two friends for dinner, at my favourite restaurant. I messaged them to cancel. Back at my flat, I couldn't stop throwing up, eventually falling asleep with a sick bowl next to my bed.

Over the Easter break the previous year, my boyfriend and I had been travelling in the Himalayas. I'd settled into my holiday, and was reading Olga Tokarczuk's novel *Drive Your Plow Over the Bones of the Dead*. A spate of work emails made me feel queasy and soon I was throwing up. At the time I put it down to travel sickness, though a part of me knew it was connected to my feelings about my workplace. When my GP signed me off work the day after the *Frankenstein* seminar, the visceral reaction I'd had to my emails while in India acquired a different meaning, as though my body had known early on something that would take me much longer to become aware of in my mind.

Reading Milner, following her thinking and experiments, had brought me into a more direct relationship to what mattered to me: writing and psychoanalysis. It felt increasingly clear that academic work obstructed my

practice of both. By writing, Milner maintained a living connection to practices of leisure, creativity and a commitment to the complexity of the mind, and to living this complexity with honesty. The irony of being signed off for overwork while writing a book on leisure was not wasted on me. I was confronted with a decision: to bury the messages I was receiving from my body and mind, or to act on what I had learnt from Milner and take the risk of leaving work.

A few days before I had been signed off work, I gave a copy of *Drive Your Plow Over the Bones of the Dead* to a new friend in Glasgow. Weeks later, they texted me a line from the novel: 'The tygers of wrath are wiser than the horses of instruction.' It is taken from William Blake's 'Proverbs of Hell'. I turned the phrase over in my thoughts; it seemed to contain everything I needed to know. Any time, however, that I tried to think directly about the line from Blake, and to derive from it a course of action, my thoughts stalled. Instead I remembered images from Milner's *An Experiment in Leisure*, of volcanic movement under the surface of the earth, and lying in bed I began to picture glowing lava piercing through the ground. In that moment, I decide to try out Milner's gesture of nothingness. I build a fire in my mind. I throw things onto it. Wanting to succeed. Wanting to be a writer. Wanting a home. All the clothes I covet. I can't throw my beloved cat on the fire, even in my imagination. I don't even try. The flames get bigger, then die out. Nothing. No clarity. I take a nap. When I wake up,

I know I don't want the gold dust. I don't want that kind of success. And I know that I still want to write. The cat is at my feet, unsinged.

I was soon to turn thirty-four. Following Milner, I had learnt that there was no abstract, general advice by which life could be lived. I would have to determine what to do on the basis of my experience, and alone. As I waited for the cloud in my mind to clear, for some shape to emerge in the swirling waters of my thoughts, I found myself well looked after. In the time that had passed since our arguments about cabbages and dusting, my boyfriend made himself responsible for much of the work of sustaining a home so that I could write. I started receiving letters in the post from friends, regular invitations to meet for a coffee or film, even when I forgot to reply. I realised that I was suspended in a cocoon, the kind that Milner described in such detail in *The Hands of the Living God*. My cocoon was made of the provision of sick pay, a doctor who was intent on preserving the heart of an underfunded national health system, and the care of friends old and new.

My job at the university had, for the longest time, been the place I turned to for a feeling of security. The cocoon woven around me was a reminder that I could try looking elsewhere, an invitation that I experiment with not sacrificing leisure to security. As my birthday approached, I found myself, once again, longing for the sea. My boyfriend was working in another city. There was nowhere I needed to be. I considered retracing my steps from Ramsgate to Margate,

repeating the walk I had taken seven years before. But that didn't feel quite right. I couldn't go back to the old place because I was somewhere else in my life now.

I took an afternoon train to Troon, a seaside town in easy reach of Glasgow. I checked into a hotel. It was dark by the time I went down for dinner, sitting by myself in the bar-restaurant. Packing for my two days by the seaside, I had stopped by the bookshelf, reaching for my copy of *A Life of One's Own*. Instead, I picked up a draft of this book, with comments made in the margins by my editor. I ate linguine with Scottish mushrooms, trying not to drop food on my clothes or papers, pausing between mouthfuls to write in my notebook. For a long while, I did not dare to look up from my plate or notebook, afraid that I had become an object of curiosity for the other diners. When I did lift my gaze, I was relieved to see that no one cared, I was in a room of people absorbed in their evenings.

I woke early and lay absorbing the morning silence of my birthday. The beach was near, and the sky a brilliant, bright blue. This felt like a rare gift in March. Too happy for thinking, I walked on the sand, following the curve of Troon beach. There was seaweed at my feet, shells and sponges deposited by the shoreline. Dogs chased tennis balls into the sea, shaking themselves free of water once they were back on the sand. I walked further than I had realised, the blissful colours of the sea and sand had altered my sense of distance, and kept tiredness at bay. Back at the hotel I ate, then went for a swim in the hotel pool, then

read some stories by Elizabeth Taylor, dividing my time between the sauna and deckchair.

Since my brother's death, perhaps even before, academic work had offered what felt like a safe way to move towards what I wanted and wished for, but in the course of reading Milner's writing over many years I realised that I did not need such safety any more, that it was time to establish a more direct relation to what I desired, to acknowledge what I wanted and to risk living this knowledge. Milner's writing guided me through grief and romantic relationships, and her account of leisure invited me to learn to accept my mind and life in all their complexity. I learnt that trying to make something is also an opportunity to remake one's own self, but above all it has taught me how to wish and want with my whole heart and being. Looking at Milner's own life – her long and illustrious career as a psychoanalyst, her many books – it strikes me that her chief creative project was living itself, and that she was someone who knew how to give herself over to life.

When I went to the beach again the next morning in Troon, on another bright, clear day, I knew that I was leaving my position at the university. In the end, the decision did not feel like it had emerged from effort, conscious thought, or the balancing of arguments for and against. Those were the horses of instruction, and much as I relied on them, they could not be my guides in this matter. Moreover, I did not feel prepared any more to be a horse, or mare, of instruction myself, ranking the thinking

of young people into an eighteen-band grading system. It was time to do something else with thoughts and words. I picked up a shell on the beach, and a rounded stone. *My life was not to my liking and I realised it was in my power to make it different.* I realised I was finally keeping a promise I had made to myself seven years before, somewhere by the sea between Ramsgate and Margate.

Having, Buying and Making

I had just seen a friend for coffee near the university. It was a weekday morning during term time in November, and I would have been in my office, but I'd taken some days off work for doctors' appointments. I wandered the streets, going into shops to look at second-hand books and kitchenware. Next to the restaurant where I was meeting my boyfriend for lunch was a small, elegant shop. I walked in and looked at the displays, which had been arranged and labelled with the precision usually reserved for precious objects in a museum. Cashmere and lambswool socks, evenly spaced, were laid out on a chest of drawers. The air was perfumed, and I went to the back of the store to look at the artisanal candles and Japanese incense. I wanted so many of the things on display. But more than everything else, I wanted an orange flask with a grey canvas strap, suitable for hot and cold drinks. Together, the flask and its grey strap cost £53. I was paralysed by indecision.

I stood there, unable to leave, or to make a purchase. Other customers came and went. It was raining outside, as it often is in Glasgow. I was there for so long I was afraid

I'd have to start paying rent to the shop owner. The candles and incense, so heady and attractive at first, had turned into a headache. I longed to step out into the rain, to fill my lungs with air and feel the cold water on my face, but I couldn't move. It felt like the store had been placed there by some cosmic force to make something clear to me about the relationship between unhappy work and compensatory consumption. I felt terrible about myself. Was the guiding value of my life the ability to buy a very expensive flask? Was this what my mind was full of, wanting things, wondering if I'd be judged or envied for having them? Was this what I thought of on my day of liberty? It was, but then didn't Milner write that anyone embarking on her project should be *prepared to find themselves a fool*?

I bought the flask. It works very well, I am glad to have it, and it is also simply a flask – many others could serve its function. That day, the flask was victim of an intense condensation of my questions and feelings about the life I was living. During my time working at the university, I had been full of wishes for things – clothes, bed linen, stationery, furniture. Other times in my life too, when I was occupied in work that made me feel invisible or degraded, I bought things. There was a logic of substitution at work – a new pair of shoes would somehow compensate for a loss of dignity or creativity.

Unlike certain moralists – more often than not they're men – I do not think that the pleasures things bring are 'empty' or 'vulgar' or 'wrong', as though it is somehow

intellectually inferior to enjoy shopping. But I have found, in my own life, that the pleasures of purchasing can occlude other, less obvious or immediate pleasures. I found that when I was working all the time, and therefore unhappy and tired, the only pleasure that felt available to me was that of buying something. I'm glad of that, because to lose entirely the feeling of pleasure, of wanting, would have been completely devastating. But this pleasure was accompanied by a worry – how would I find pleasure if I left my work, and no longer had the same kind of disposable income?

Could I make things instead of buying them? I could, but this didn't offer any financial savings. Try making some jam, a cushion, or a clay bowl. Unless you are very talented and resourceful, you may find that the handmade product can never compete with the supermarket commodity, which reflects in its price an entire world system of cheapened labour and stolen resources. There is no possibility of separating, as a single individual, from this upside-down logic. Making things at home may offer other things, like time for contemplation, a reconnection with smells and textures otherwise forgotten, but it also carries within it the threat of householding femininity, and of another kind of laborious, invisible existence.

Later, when I had time off work and returned to writing, I realised I needn't have worried so much about wanting to buy things, and trying to make them. I was involved in a different kind of making, trying to give shape to my words. This was nestled within another form of making – the

process of trying to give shape to my life in a way that kept my desires intact, against the pressures of economics, other people's opinions, my own fears. Thus engaged, I found that I didn't feel the same urge to buy things. This was a different kind of pleasure, slower and more complex, absorbing in ways that things I had bought just couldn't be. There would always be room in my leisure for a visit to the shops, for a stroll down aisles of beautiful garments. But to live a life where this was all there was to leisure, that made no sense, and was the essence of a false bargain.

9

A Manifesto for Leisure

Very late into writing this book, I realised that I had been so absorbed in reading Milner and thinking about her account of leisure that I had completely ignored how it had been imagined by other writers and philosophers. Too late now, I thought, but decided to look up the etymology of the word. I found myself burrowing back to Latin, where the verb *licere* indicates permission, being at liberty to do something. Over the centuries, the word gathered associations with pleasure, freedom, opportunity, deliberation and the absence of obligations. In reading Milner, in living with her writing, and in my own experiments with leisure, it is the associations with freedom and pleasure that have felt most significant. If leisure feels like transgression, if it feels unfamiliar or out of reach, then something may be amiss with our lives and the world in which we live.

Immersed as I have been in thinking about leisure, it has not always been available; that is why this book is a *defence* of leisure. To be at leisure today involves a contestation, with ourselves, and with the world around us. The

following 'Manifesto for Leisure' was written from my sickbed, a hot-water bottle held to my chest and another behind my back. When you read it, picture my cat on the bed next to me. His head, back and tail are tawny, and his legs and stomach are a soft creamy white. Around his neck is an impressive white ruff, the envy of any Elizabethan gentleman, and from his two pointed ears sprout further exuberances of fur. In writing this manifesto, I drew upon notes I had written to myself, scraps of papers that would fall out of a diary, or a few words scribbled on my phone. It is a manifesto for one, because if I have learnt anything, it is that leisure must be a risk, an experiment that each person embarks on for themselves. I also know that my burdens and privileges are not the same as yours, and I do hope that as you read my manifesto for leisure, you may find yourself writing your own.

A Manifesto for Leisure!

Leisure! Now! For everyone!

Organise!

The raindrops on my window on a stormy day in Glasgow are beautiful, and their movement down the glass is absorbing. But only when I am in a state of mind that is restful, and open. The raindrops don't help me forget the horror of the world. Rather, their presence is a reminder that the world is precious. Moments of leisure allow me to see beauty in the world, the hopeful possibilities of human interaction. There is so much in the world that I want to hold on to, that is worth fighting for and organising around. So often it can feel like things are dire, like we've crossed some point of no return and must sit despondent, resigning ourselves to a terrible fate. Maybe I feel that way when I am tired, and it is rest and leisure that allow me to care again, to remember that there is something to care about. Leisure can be fierce, and passionate. And much as I think that everyone has to

235

discover the idiosyncratic rhythms and textures of their leisure for themselves, I don't think any of us will be able to experience a sustainable form of leisure in our lives without organising ourselves to contest economic oppression and political injustice. Sometimes leisure needs to be private, but it can't be privatised – after all, it is the fabric of social inequality that makes moments of leisure so provisional. I'm so tired of leisure belonging to the yachting classes, with their beaches and tennis courts. No. Give leisure back to the woman who has just put a child to bed. Return it to the bartender working an extra shift to pay for hormones. Let the people claim it, because it belongs to them.

Ask for help!

What stops me from asking for help? Yes there are people, institutions, bureaucracies, where to ask for something, even if it is something connected to your basic dignity, is a harrowing and often fruitless endeavour. But among my friends, people are kind, generous and helpful. They can also be busy, irritable, perhaps a bit intimidating. When I don't turn to them, when I don't ask for help, surely it is out of some misguided fantasy of being self-sufficient, of wanting to appear autonomous or keep up some kind of appearance of competence. But it is nicer to be helped! It is relaxing to admit my inadequacies! Let people step in, and laugh at how I am hopeless, and teach me how to do things I find difficult! Why are things that are relatively

easy to do so hard to learn? Undo the legacy of desperate individualism!

More cats in bed!

By which I mean, more time in bed. The cat likes to come and sit on me when I am watching films, reading or having a phone call with a friend. The weight of him is a seal of approval, as though he's saying: you're doing what you should be doing.

Every day he sets an example of rest. Follow the cat's example!

In the evening, the cat will come and sit in front of the computer screen, and ask me to stop work. Listen to the cat!

A friend said something so important the other day. She said that when she begins to feel burdened by her cat Uisce's needs, then she knows that the balance of her life is awry. How many times have I asked the cat to go away, because I don't have time to play with him? Playing with the cat is joyous, it is not an unreasonable demand from the cat, it is a lucky invitation. Play with the cat! Abandon the spreadsheet!

The cat never says: today I will not play, today I will postpone my meals, today I will not take a nap. Resting, visiting the scratching post, following the movement of pigeons on the windowsill, sniffing the air, stretching, cuddling, making sure one's paws are clean and hair is

looking fine, all these things are part of being a cat from day to day. Why shouldn't I live along the same lines? No more postponement of everyday things that offer sustenance and pleasure!

Be an amateur!

So often I stop myself from doing something because I'm not good enough at said thing, I'm not professionally trained or knowledgeable about the topic. But it would be an impoverished existence to do the same thing all the time, because surely there is no way to be good at everything, or to know how to do something before I've even tried it. Abandon these forms of thinking! There is so much more pleasure in being an amateur than in sitting with my legs crossed, arms folded in my lap. I will never be a professional tango dancer, ceramicist or dressmaker. Everything I like doesn't need to be turned into a second job, or, in the ghastly language of neoliberal economics, I don't have to turn my pleasures into 'supplementary income streams' – yuck! Maybe I can just be a good cook because it is a joy to have friends round the table, and make jam because I like seeing the jars lined up on the shelf, and maybe sometimes the marmalade won't set (this happened to the vanilla and lemon marmalade, sadly) and the bread will be too hard, but it doesn't matter because I'm an amateur, and I can stay one.

Besides, with the two things I'd like to spend most of

my time doing – writing and psychoanalysis – I feel like there is no way to do them except as an amateur, it isn't as though at some point I'm going to arrive at a formula or achieve a requisite amount of experience, I'll just keep having to improvise, to make it up as I go along, so I may as well embrace this instead of struggling against it. There is a place for experts and professionals in the world, and I admire them and benefit from their training. I'm very glad my dentist and doctor are professionals, for example. There is a place in the world for amateurs too, and just as some things are best done from expertise, others are most suited to love. Because isn't that what being an amateur really means, doing something out of love?

Pick risk!

I live in circumstances that put security and leisure into opposition. I'm living in a world that is frightened of rest, and threatened by creativity. Pick leisure! Pick risk! Pick these over and over again! I know that each time I'll feel foolish, and as I feel foolish I will also feel alive, and I will feel truthful. The things I am doing, that I want to do, will feel impossible. I'll never have enough courage, I'll always need more. I'll always be reaching after it, because courage isn't found, doesn't lie in reserve, but is always wrested, and seized, and it always feels something like a miracle. Some days I will reach further, and on other days I will stay in bed and need to make a list.

Remember the body!

Don't keep putting off all the things the body is asking for. The things it needs aren't so mysterious or irksome. To lie with a bolster underneath my knees. To take a hot shower. To rest when I'm tired. To eat when I'm hungry. And in return, my body offers its own guidance, a sense of how to proceed when thoughts have ceased to be helpful. Listen to the body! Not only when it is a flashing red light! Try not to turn the body into strings of data. There may be times when this is necessary, when I am in hospital with a failing heart. But the intelligence of the body is not adequately captured in metrics. So don't just hand the body over to the statisticians. Accept that I'll never fully understand its ways, but a bath is always a good idea. And when hurt or ill, remember that recovery is a shy animal, and it will not be bullied.

Remember the near pleasures!

I know the far pleasures – one day buying a long cashmere coat, one day learning how to sail, one day reading in a different language. I would like to remind myself of the near pleasures too, which I can forget in my longing for the far pleasures. Near pleasures are not the same as everyday pleasures, which are wonderful in themselves. An everyday pleasure is having two hot-water bottles instead of one, or having my tea in a small teapot and beautiful cup. A near pleasure is remembering to ask for some chips *inside* my

falafel wrap, or visiting a large Chinese supermarket and discovering a new dried-fruit candy (I am thinking of the jar of dried fingered citron I bought in Glasgow's West End, which is made from liquorice-infused *Citrus medica* var. *sarcodactylis*, also known as Buddha's hand due to the shape of the fruit). As soon as I start thinking of near pleasures, the coming weeks seem so full of promise. I want to go swimming in that pool I've never visited in Bellahouston Park, and I want to visit the apothecary for loose leaf tea. I've never been to the Tenement House museum, or the Charles Rennie Mackintosh tea rooms. Near pleasures involve a small risk, in that they may prove a bit disappointing, but that is equally true of far pleasures. But what is most disappointing is the deadening of days in the belief that all pleasures are far away, till work is done, till a lover is found, till an overdraft is paid off. No, that won't do. Seize the near pleasures now!

Surrender to the rotten days!

These are the days when my body feels like it is made of tar. Get out of bed? May as well slice stones with a pocket knife. The world is drained of inspiration and my faith in myself has found a new low to plumb. Yes, I could make myself feel better – isn't that the common advice? But what if something is taking shape in the dark? What if I need something that only these days can give me, frightening and unappealing as they are? Life would feel pretty weird,

pretty dead if the days stretched out in happy equanim-
ity. So maybe the black days have their place. Maybe they
are less terrifying if I don't resist them with such intensity.
Cancel all plans! Embrace the self-pity. There are things
in life that are difficult. There are things in the world that
bring grief. These deserve their due, too. I know at some
point I will want a shower. I will want a bath. I will want
some pasta. Till then, embrace the rotten days!

No more being 'too grown up' for things!

Coloured chalk is fun. As are crayons, felt-tip markers and
washi tape. Drawing is fun, even though I'm no good at
it (though the other day I drew the cat, and it came out
quite well, I suppose being in love with him helps). Playing
marbles is fun. It is joyous and pleasurable to be interested,
and so dull to be cool and standoffish. All sorts of insidious
things enter the home, mind and heart under the guise of
being grown up. Question these things. Fortunately, adult-
hood has brought a degree of autonomy. Don't just use this
to replicate the decisions of others – parents, teachers, neigh-
bours. Remember that you knew things as a five-year-old, as
a fourteen-year-old, that would stand you in good stead now.

Exile the phone! Bury the laptop!

Of course I can't just throw the phone away, can I? There
seems to be no avoiding it. I use the mobile for work, to

stay in touch with friends. I learn about events and protests from social media. And it persistently, consciously, subconsciously, makes me miserable. I stop reading when I have my phone around me all the time. I spend a whole evening scrolling through Instagram. I can be too busy for walks or for going to the shop to buy some fruit, but I pick up my phone when I'm stressed, or frustrated, and an hour passes, sometimes another. My phone does something terrible to time. It annihilates it, afternoons and evenings are drained of meaning. If large technology corporations are working hard to keep me on my phone, I need to think about how I'm going to respond. I find that when I don't look at my phone in the morning, when I read Henry James instead, I have much less desire to look at it during the day. The phone is compulsive, but it isn't very sophisticated. Once the circuit is broken, it can stay broken without much difficulty. It helps to treat it like a landline, or a desktop computer. To try and make sure it doesn't follow me everywhere. I should go to it, when I need it. The phone causes backache! The phone obscures pleasure! The phone is the enemy of leisure! And the laptop – the laptop doesn't need to come on holiday!

Write more letters! Write in notebooks!
Treasure the fountain pen!

When I walk, sometimes I think my mind is in my feet. When I write in my notebook, sometimes I find that

language is in my hands, and that writing can bypass conscious evaluation. This is a gift that screens can steal. This is enough reason to write by hand. There are other reasons too. Refilling a fountain pen with a favourite colour of ink makes a cherished break in the writing hours. It is a measure of ink time. To finish a notebook, and to set out to buy another one, this makes all kinds of delights possible, such as visiting a stationery shop, and then deliberating over lined or unlined pages, the colour and the pattern of the covers, whether it will be a small pocket-sized one, or a large hardback. On my last visit to a stationery shop I was looking for letter paper.

Language is so important, and so easily degraded. Every day so much violence is done to words. I read the news and I hear words made weightless in politicians' speech. I go to the doctor – she only has ten minutes for each of her patients. I have prepared myself, I condense my history, ambivalence, pain into nine minutes thirty-six seconds. When I walk out of the room, I am aching from the condensation of language. So I will give words their luxuries, for as long as I can – a nice pen, cream letter paper when I am writing to my friends. I'll copy out poems by hand and tape them to the wall. I'll doodle in my diaries, and I'll write stories. I'll sign the petitions. I'll put words on cardboard and take them to protests. If I am to have leisure, the liberty of my time, then I must have freedom in language, and truth.

*

And so goes my manifesto for leisure. It is not complete, neither is my defence of leisure. It is ongoing and provisional, sometimes adversarial. A friend sends a video of a bee he rescued. The wobbly exhausted bee, drinking from the palm of a hand, from a spoon, from a saucer, steadier by the frame. There should always be time to rescue a lost bee, I think. Milner pictures the fleeting, shy thoughts that led her so deep into her own mind as butterflies. *A Life of One's Own* emerges from her willingness to be absorbed by the movements of these winged creatures. Growing up, I spent so many hours bored, wandering, watching the *Danaus genutia*, or common tiger, settling on flowers. The common tiger looks much like the monarch butterfly, in the orange-and-black patterns of its wings. I didn't know its correct name then, neither did I know what was to happen in the coming years, the losses that were to follow. There was nothing remarkable about those hours, those butterflies, that looking at the butterflies. I didn't know then I would reach back to them, trying to remember what I knew then – how to be bored, absorbed, unconscious of time. I always knew I wanted to write, I said to my psychoanalyst. Always? he asked. And I said: Always.

A NOTE ON SOURCES, ITALICS
AND ARCHIVE VISITS

In this book I've used italics to indicate Milner's voice. I used quotation marks when I started writing but this felt strange, because I heard Milner's words within me rather than as something that came from without. The lines and passages I quote are also the ones I'd copied out in notebooks, texted to friends or taped to my desk. I read them in the Virago editions of Milner's books, in American reprints, and it was thrilling to reread *A Life of One's Own* in its first edition, published by Chatto & Windus. Under the editorship of Emma Letley, Routledge has reissued all of Milner's writing with notes and new introductions, and all extracts here are reproduced with the kind permission of Routledge and the Taylor & Francis Group. I'm obliged to Giles Milner for permission to range so widely through her words.

I spent many pleasurable hours in Marion Milner's archives, and I'm grateful to the archivist, Ewan O'Neill, for facilitating these visits. It seems fitting that I would lose my pretensions (and anxieties) about being a *real* or *serious* historian while consulting a psychoanalyst's archives. I learnt much that was interesting about Milner from her diaries and papers, but I discovered a whole lot more about myself through the reveries, associations and dreams that accompanied and followed these visits.

Below are the attributions for extracts taken from diaries held in the Archives of the British Psychoanalytical Society, quoted with permission:

p. 28: *fear will not let them put out to sea*

Marion Milner Collection, Archives of the British Psychoanalytical Society, P01-E-B-4

p. 55: *guilty in relation to myself*

Marion Milner Collection, Archives of the British Psychoanalytical Society, P01-E-B-36

p. 55: *become what they want me to become*

Marion Milner Collection, Archives of the British Psychoanalytical Society, P01-E-B-36

p. 55: *a good mother, a reliable worker, a considerate wife*

Marion Milner Collection, Archives of the British Psychoanalytical Society, P01-E-B-18

p. 57: *That he should have married me*

Marion Milner Collection, Archives of the British Psychoanalytical Society, P01-E-B-15

p. 139: *This feeling of the encroachment of other personalities*

Marion Milner Collection, Archives of the British Psychoanalytical Society, P01-E-B-39

p. 140: *Is it that I want something impossible from it?*

Marion Milner Collection, Archives of the British Psychoanalytical Society, P01-E-B-39

p. 212: *Pleased with myself at getting on so well*

Marion Milner Collection, Archives of the British Psychoanalytical Society, P01-E-B-41

I hope that readers finding their way to Marion Milner's writing through this book will discover and construct their own version of her, as I've had the good fortune to do over the years.

ACKNOWLEDGEMENTS

For their faith and insight, Željka Marošević and Eleanor Birne. Katherine Fry for her attentive edits. Barbara Taylor saw something early on in my writing that I didn't dare to see myself – thank you. James Morland, Charlie Williams, Clare Whitehead, Tasha Pick, Nisha Ramayya, Andrew Radford for having been such lovely colleagues. Sam Dolbear, Thomas Hastings and Christopher Law for reading parts of the book and offering encouragement. In Glasgow, Sam Keogh, Hussein Mitha, Niall Tessier-Lavigne, Jo Shaw for warmth and good communism. Everyone who invited me to a house party, protest, walk, singing circle – you made me feel so welcome. Francis Gooding for the gift of thinking with him. I can't imagine writing or loving or knowing what to wear without my angels of good counsel and inspiration: Natasha Silver, Hanna Schaefer, Carmen Wright, Minat Lyons, Hannah Proctor, Hannah Zeavin, Shikha Dilawri, Rasha Saba, Ida Roland Birkvad, Tanushree Kher, Kavya Murthy, Swathi Shivanand, Aaranya Rajasingam, Daisy Lafarge, Katie Keaveny, Lily Ní Dhomhnaill, Rachel Long, Aleana Egan, Akanksha Mehta – I love you so much and every day I feel lucky to know you.